EXPRESSIONIST PORTRAITS

MIT DEM GLAUBEN
AN ENTWICKLUNG
AN EINE NEUE GE
NERATION DER SCHAFFEN
DEN WIE DER GENIEBEN
DEN RUFEN WIR ALLE IU
GEND ZUSAMMEN UND
ALS IUGEND, DIE DIE ZU
KUNFT TRAGT, WOLLEN
WIR UNS ARM:UND LE:
BENSFREIHEN VERSCHAF:
FEN GEGENÜBER DEN
WOHLANGESESSENEN ÄL:
TEREN KRÄFTEN. KDER GE:
HÖRT ZU UNS: DER UN:
MITTELBAR UND UNVER:
FÄLSCHT DAS WIEDER:
GIEBT, WAS IHN ZUM
SCHAFFEN DRAENGT

FRANK WHITFORD

EXPRESSIONIST PORTRAITS

ABBEVILLE PRESS · PUBLISHERS · NEW YORK

TRANSLATION OF THE TEXT FACING THE TITLE PAGE:

WITH FAITH in evolution, and in a new generation of creators and enjoyers, we summon the young to unite—and as the young, the bearers of the future, we will wrest from the entrenched older forces the freedom to act and to live. To convey the creative impulse, direct and unfalsified, is to be one of us.

ERNST LUDWIG KIRCHNER
Programm der Künstlergruppe Brücke, woodcut, 1906

First American edition

Library of Congress Cataloging in Publication Data

Whitford, Frank
 Expressionist portraits.

 Bibliography: p.
 Includes index.
 1. Portrait painting, German. 2. Portrait painting—20th century—Germany. 3. Self-portraits, German. 4. Expressionism (Art). I. Title.
ND1317.6.W5 1987 757'.0943 87-1211
ISBN 0-89659-780-6

CONTENTS

INTRODUCTION

WHEN IN 1909 THE ARCHITECT ADOLF LOOS offered to help the young Viennese painter Oskar Kokoschka launch his career, he devised a plan intended to earn his protégé at the very least as much as he was then making from the design of postcards and other illustrated material. The plan was as optimistic as it was simple: Loos would persuade his wealthy clients and friends first to sit for Kokoschka and then to buy the portraits he painted of them.

Although Kokoschka was earning very little when Loos met him, the architect's promise to improve his finances with the aid of portraiture was rash. Kokoschka had thus far produced very few portraits, none of them commissioned, and they scarcely inspired confidence in his ability to achieve a convincing likeness, let alone a belief that he might in time learn to confect the kind of image a sitter might be pleased to recognize.

Loos nevertheless did succeed in persuading a number of people of varying celebrity and distinction to trust their features to an inexperienced artist who, although at Loos's insistence he dressed in great style, was lacking in the social graces. Loos hoped that these sitters would be moved to purchase the completed paintings. He hoped in vain.

This is hardly surprising. The celebrated scientist Auguste Forel, whom Kokoschka painted in 1910, was not pleased by an image of himself which hints at physical infirmity. In his autobiography he claimed that Kokoschka, 'who looked at me especially from behind and from the side, cared nothing for likeness, but only for the expression of moods!' Significantly, Forel also refers to other paintings which Kokoschka showed him at the time 'which ought to have been regarded from the standpoint of the psychiatrist rather than as works of art'.

OSKAR KOKOSCHKA
Auguste Forel, 1910

As far as we know, however, none of the sitters reacted as violently to Kokoschka's portraits as did a few of the Viennese journalists who reviewed the exhibition in 1911 in which several of these paintings were shown. According to the critic Arthur Roessler, Kokoschka 'brews up his paints from poisonous putrescence, the fermenting juices of disease; they shimmer gall-yellow, fever-green, frost-blue, hectic-red, and the substance binding them seems to be penetrating iodide of formyl, carbolic and asafoetida. He smears them on like salve and allows them to crust scabiously, to form scars. He paints the countenances of people who fade away in the stale air of offices, who are greedy for money, loll about in the expectation of happiness and amuse themselves coarsely. He paints their weevil-like skin, their suppurating flesh steamed in inward heat, softened by dissipation and distressed by disease. Possibly the clumsy portrayal of the disgusting impurity of spongy and porous, leathery and flabby, spotted and speckled, infirm bodies is nothing but the despairing expression of a soul in harrowing disintegration which looks at the world through calcified eyes. Depravity is the attraction of these pictures. They have a certain significance as manifestations of an epoch in decay; judged artistically, they are massacres in paint.'

Whatever contemporaries thought about such pictures, to later generations it is precisely their significance as 'manifestations of an epoch in decay' which gives them their force. The psychological tension, the intimations of mental and physical disorder, the sense of alienation and crisis, all of them conjured up by strange colours, exaggerated brushwork and rhetorical gesture, create in Kokoschka's portraits of this period a mood which, with the benefit of hindsight, characterizes an age in which the end of the world seemed (with some justification) to be imminent.

Several of Kokoschka's sitters were unnerved rather than offended by their portraits. One of them, Peter Scher, writing years later, recalled that, when first confronted by what the artist had done, he thought that the picture made him look like a convict: 'And there, once again, "the eye of God" revealed itself, for he did not know that some years earlier . . . I had spent twenty months in prison weaving straw mats.'

'The eye of God', the supernatural ability to see into the future or through the mask directly into the soul of another person, was often given credit for the uncanny psychological accuracy of Kokoschka's portraits. Some sitters felt that they grew to look more like their portraits with each passing year. One of them moved to a village with a church whose spire was almost identical to the one which Kokoschka had put into the background of her portrait years before. Perhaps Kokoschka, who repeatedly claimed that he had the gift of second sight, did possess some power beyond the ken of ordinary mortals. What is certain is that he possessed an uncommon sensitivity to moods and the

ability to guess at entire biographies in the lines of a face and the set of a pair of shoulders.

Intuition, insight, transcendence, were the hallmarks of a generation of painters and writers to whom the purpose of art was to make manifest a new, higher, transfigured reality. This was Expressionism. Its main principles were memorably formulated by the writer Kasimir Edschmid (1890–1966), a member of the same generation as Kokoschka:

'No one is in any doubt that the superficial reality which we perceive cannot be the truth.

'Reality has to be created by us. The true meaning of the object has to be uprooted. We must not be satisfied with the trusted, presumed, recorded facts; the image of the world has to be mirrored honestly, without falsification. But that image is in ourselves alone.

'Thus the entire world of the Expressionist artist becomes visionary. He does not see, he beholds. He does not portray, he experiences. He does not copy, he forms. He does not take, he seeks. Now there is no longer a series of facts: factories, houses, sickness, whores, screams and hunger. Now there is only the vision of them.

'Facts have significance only insofar as the artist's hand reaches through them to grasp at what lies behind.'

Unlike the scientist, the painter had at his disposal neither the microscope nor the X-ray camera to assist him in his search for a level of reality beyond common perception. He did have his feelings and his intuition, however, and came to believe that the path towards the higher truth began, as Edschmid suggested, within himself, with his subjective response to experience. It was not the topography of a particular landscape that he now wished to paint, rather the reactions provoked in him by the sight of that landscape. The resulting exaggerations of colour and form are the seismographic record of strong emotional events.

To the extent that it is a statement about the artist himself, every successful work of Expressionist art is therefore a kind of self-portrait. It is not surprising that the self-portrait was one of the preferred subjects of the Expressionists, and that it typically showed its creator in a dramatic, histrionic pose expressive of some moment of heightened emotion or visionary revelation. 'The centre of the world', wrote another Expressionist writer, Theodor Däubler, 'lies in every individual self.'

Precisely when and in what language the term 'Expressionist' was coined remains unclear, but its first recorded use in connection with contemporary art seems to have been in 1911 and in Germany. At the twenty-second exhibition of the Berlin Secession, modern French paintings by such artists as Braque, Derain, Dufy, Picasso and Vlaminck were shown. They were described as 'Expressionists',

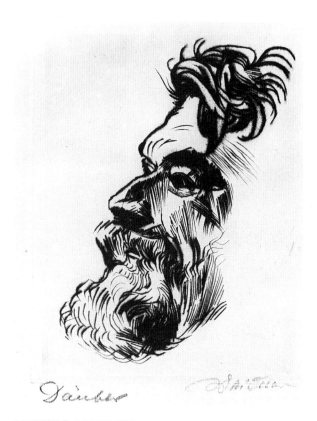

LUDWIG MEIDNER
The Poet Theodor Däubler, c. 1910

probably for no better reason than the fact that they were manifestly not Impressionists. The word was quickly adopted by journalists, and gained general currency as a synonym for all modern art, French, German or otherwise. Soon afterwards it came to be used of poetry, drama and music, too, and later still (and still more confusingly) of architecture and film.

Initially, therefore, the meaning of 'Expressionism' was highly imprecise. Its vagueness was exploited by muddle-headed critics who used it as a label to cover the gaps in their own thinking and by at least one dealer, the Berliner Herwarth Walden, who realized that new art was easier to sell if wrapped up in a slogan and therefore described everything on his books as Expressionist. When pressed for a definition, Walden somewhat lamely replied that Expressionism was a way of life ('*Expressionismus, das ist eine Weltanschauung!*').

For a time, the negative implication of the word 'Expressionism' (as a description of everything that was modern but not Impressionist) was clearer than any positive sense of an art concerned with the *expression* of feelings or ideas. Gradually, however, the notion of expression came to dominate, as did the belief that art expressive of the emotions was the peculiarly German contribution not only to modern art but to art history in general. Thus Grünewald and Altdorfer were Expressionists, as were such contemporary artists as Ernst Ludwig Kirchner and Emil Nolde who, it was argued, had revived a truly German tradition by making their work deeply spiritual and urgently expressive. By 1914 most German writers were using the word *Expressionismus* in this way.

This shift in meaning was not entirely for the better, since even the contemporary artists to whose work the term was now applied were by no means a homogeneous group pursuing obviously similar aims. Geographically distributed far and wide, very few of them were happy with the label that was applied to them. Nevertheless, all would have recognized themselves in Edschmid's statement. All were convinced that passionate intensity alone could open the door between common reality and higher truth. All believed that colour, unnaturally heightened or its effects dramatized in other ways, was the best means of conveying such intensity, and that, together with exaggerated forms and loose, energetic handling, it would enable them to reveal something of their own inner, spiritual lives.

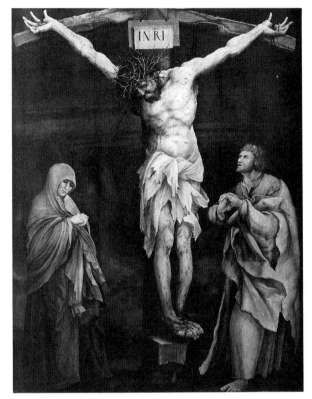

MATHIS GRÜNEWALD
Christ on the Cross between the Virgin and St John

IN SPITE OF numerous shared convictions, it would be better to speak not of a single Expressionism but of several closely related Expressionisms. One of these Expressionisms is the visionary kind exemplified by Kokoschka's early portraits and partly defined above by Edschmid. It was also the subject of a passage in a notorious essay, the *Confession of an Expressionist*, written by the poet Gottfried Benn in

1933 while he was still convinced by the claims of the Nazi Party. His observations about visionary Expressionism are no less valid for that.

'I said that in Europe between 1910 and 1925 there was hardly another style except an antinaturalistic style; there was also no reality, at most only fragments of reality. "Reality" was a capitalist concept, "Reality", that meant real estate, industrial products, mortgages, everything which could be given a price by merchants and middlemen. "Reality", that was Darwinism, international steeplechases and everything else reserved for the privileged classes. "Reality", that was war, famine, historical humiliations, lawlessness, and naked power. Spirit had no reality. It turned to its own inner reality, its own existence. . . . The method used to experience this, to possess this, was to intensify the creative power of the spirit, like something from India; it was ecstasy, a particular kind of spiritual intoxication.'

The affinities between antinaturalism and spiritual intoxication were perceived by several contemporary commentators with whose help we can distinguish another kind of Expressionism. In an essay first published in 1918 on 'The Religious Awareness of Expressionism', Eckart von Sydow maintained:

'The spiritual revolution in Central Europe which has the name "Expressionism" also seems to want once again to revive religious tendencies. This is quite extraordinarily surprising, for did not Nietzsche perform his greatest service by destroying God? And now . . . "atavistic" religious inclinations are becoming apparent in quite unambiguous fashion. Thus, Franz Marc has described his generation's problem as being the "mystic-inward construction" and thus quite consistently, the aim of today's moderns as being . . . "the creation of symbols of their times which belong on the altars of the coming spiritual religion and behind which the artist disappears". Kandinsky even speaks of the "divine language" which needs mankind in order to be directed to one man by another.'

The painters Franz Marc and Wassily Kandinsky were indeed deeply involved in religious beliefs of the most esoteric kind. Although apparently a devout member of the Russian Orthodox communion, Kandinsky was also drawn towards Rudolf Steiner and Anthroposophy. His first important book, significantly entitled *Concerning the Spiritual in Art (Über das Geistige in der Kunst)*, includes millenarian ideas, and some of his earliest abstract paintings were based on apocalyptic subjects such as the Flood and the Last Judgment.

More simple, perhaps, but no less fervent were Emil Nolde's religious beliefs which, although nominally Christian, are at points indistinguishable from pantheism. In 1909 he began to devote much of his energy to religious subjects, and a passage in his autobiography reveals the close affinities in Expressionism between the creative ecstasy and faith: 'Pleading in difficult times, stretching my arms

upward desperately praying for help, filled with intense yearning, or my hands spread out wide holding a most holy joy – that is how my pictures *Maria Aegyptiaca* and *Holy Night* were made. And in both of these women, who were filled with divinity, I experienced my inmost being.'

The object of Kandinsky's millenarian musings was the Golden Age (the spiritual revolution, in Sydow's apt phrase) whose imminent arrival was anticipated by the new artistic language he was in the process of creating. Kandinsky's descriptions of this Golden Age are extremely vague, but they reveal a profound dissatisfaction with the existing social order and with the dominant, materialist interpretation of reality.

Dissatisfaction similarly profound but more precisely articulated is at the root of another kind of Expressionism, the creation of artists and writers who believed that the new art did more than reflect a desire for a new society but actually helped to bring it about. The main, although

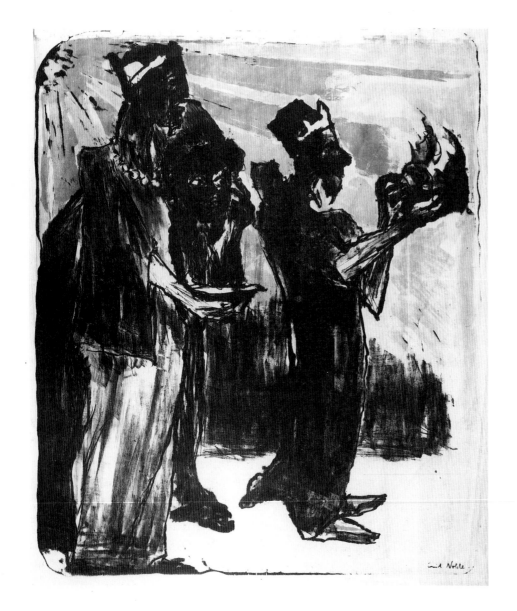

EMIL NOLDE
The Three Kings, 1913

by no means the only, forum for such views was the weekly journal *Die Aktion* which gave its name to this kind of Expressionism: Activism. One of the Activists, the poet Ludwig Rubiner, in a postscript to an anthology of political verse, asserted that 'The proletarian liberates the world from the economic past of capitalism; the poet liberates it from the emotional past of capitalism.' It was also Rubiner who, clearly distinguishing between Activism and those kinds of Expressionism chiefly manifested in formal innovation, described 'Our cry for the coming epoch in every land' as being 'the demand: *L'homme pour l'homme* instead of the earlier *l'art pour l'art*'.

Such 'hopes', 'demands' and 'cries' (all words central to the Expressionist vocabulary, and all usually declaimed as they are here in strident Expressionist fashion) were most clearly heard during the First World War and the ensuing revolutionary period, when socially radical Expressionism came into its own. The painters Max Pechstein and Ludwig Meidner were influential members of two organizations, the *Novembergruppe* (November Group) and the *Arbeitsrat für Kunst* (Working Soviet for Art), founded to co-ordinate the activities of left-wing artists and intellectuals, while Conrad Felixmüller tried to make membership of the Communist Party compulsory for everyone associated with the Expressionist 'Secession Group 1919' which he founded in Dresden.

Writing in 1919, Kurt Hiller maintained that 'The Activist is the enemy both of passivism and passéism. He learns nothing from history but the one thing: that it was made by chaps who did not bother about history. The Activist is a Futurist.' The term 'passéism' (*passatismo*) was indeed coined by the founder of the Italian Futurist movement, F. T. Marinetti, to describe the art and culture of the past, all of which had to be destroyed if artists were ever to do justice to their own machine age. Futurism had its political dimension, too: by 1916 the Futurists, delighting in verbal and physical violence, and campaigning noisily for the entry of Italy into the First World War, often sounded very like proto-Fascists. In 1912, this could not have been clear to any of those Germans who were intoxicated by Futurist painting when it was first exhibited in Berlin at the *Sturm* gallery, and by Futurist writing when they heard it declaimed by Marinetti at the same time.

Futurism left its mark on Expressionist literature (especially the ejaculatory poetry of August Stramm – all nouns and verbs – and the early prose of Alfred Döblin) and on painting. The angular, dynamic compositions as well as the subject matter of Kirchner's Berlin paintings, which draw on a range of uniquely urban experience, are obviously related to Futurism, and the artist whose work shares most with that of such painters as Umberto Boccioni and Carlo Carrà is Ludwig Meidner, whose writing as well as painting celebrates city life. But the Expressionist, Activist or otherwise, was never entirely a

MAX PECHSTEIN
Vignette for Propaganda Leaflet, 1919

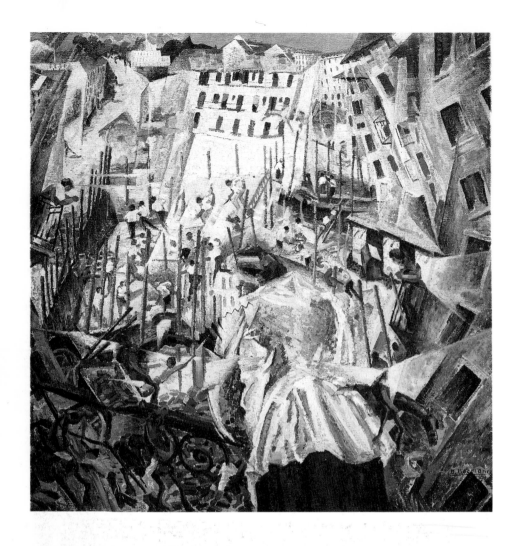

UMBERTO BOCCIONI
The Street Enters the House, 1911

Futurist. Far from wanting to eliminate the past, he revered certain moments of it – not least the Middle Ages – and was fascinated by all that was 'primitive'. In many ways, too, the Expressionist looked back to Romanticism, with its cult of originality and its fascination with the grotesque, the unconscious and the malign. He was in love with the big city – a Futurist theme – but also saw it as a trap. Thus, the public places in Kirchner's cityscapes are populated exclusively by whores and their customers, and in Meidner's work the city is the location of apocalyptic disasters.

The importance for all the Expressionists of powerful feelings powerfully communicated, and their search for authenticity in everything they did, led them to an appreciation of various kinds of primitive or primitivistic art, art that they believed to be uncorrupted by highly refined, over-cultivated and above all well-mannered European standards. Kirchner, and the other artists in Dresden who in 1905 founded the *Brücke* (Bridge) group, were inspired by the example of Gauguin, studied Oceanic art and artefacts in the local ethnographic museum, made their own woodcarvings in emulation of them and decorated their studios in an attempt to intimate the flavour of a primitive way of life. Emil Nolde, briefly a member of the *Brücke*, even

went on an ethnographic expedition in 1913–14 which took him through China and what is now Indonesia to New Guinea and back, painting and studying as he went. Max Pechstein, another *Brücke* member, also went to the South Seas and lived for about a year on the island of Palau. The *Brücke* group's communal life, close and almost incestuous working conditions, and attempt to dissolve individualism in a group identity, reflected a desire for a primeval 'community' and 'brotherhood' (two more key words in the Expressionist vocabulary) in a microcosm of an ideal society.

Kandinsky, a Russian based in South Germany, was interested in primitivism of another kind: folk art, especially the kind of painting on glass widely practised in Bavaria and mostly used for the making of votive pictures attached to wayside calvaries. Children's art was also admired by the Expressionists, some of whom were equally fascinated by the drawings of the insane which, they believed, expressed the inner life with a force and an immediacy of which the trained, sophisticated artist was tragically incapable. The major reason Kandinsky admired Arnold Schoenberg's paintings so much was that the composer's powerful emotions seemed to emerge more forcibly through an unpractised and clumsy technique than they would have done had Schoenberg been technically adept.

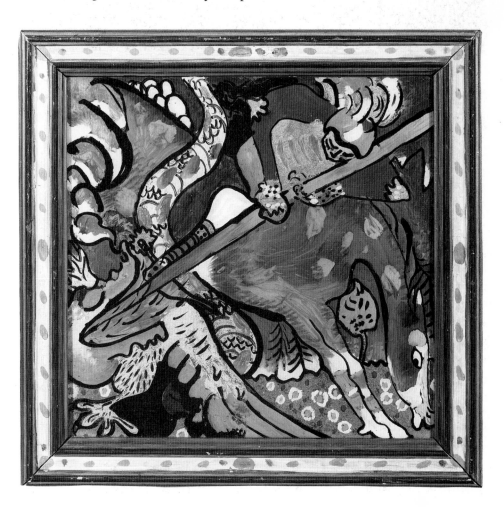

WASSILY KANDINSKY
St George I, 1911

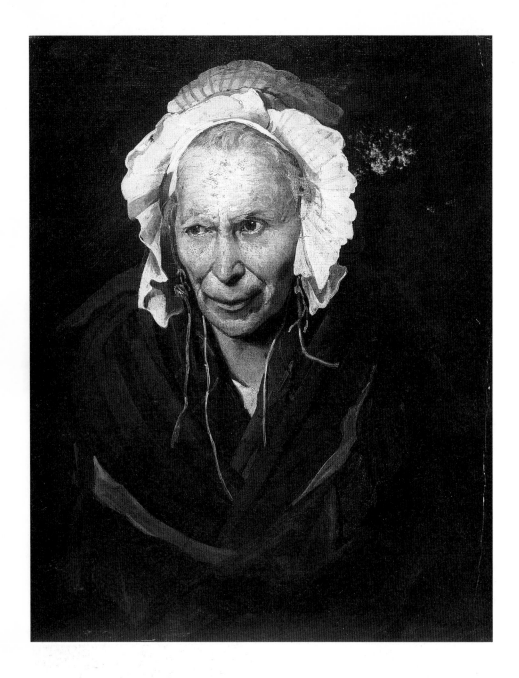

THÉODORE GÉRICAULT
The Mad Woman, 1821–24

THE PORTRAIT in the nineteenth century had undergone a series of profound changes. Géricault's portraits of the mentally ill announce the beginning of a new approach to the art. These are people of no distinction whatever whose only interest is provided by their abnormality. By choosing to paint people who are interesting not because of their social status or achievements but because of their peculiarities, Géricault shifted the emphasis from the public to the private persona. The portrait painter was no longer the servant of the sitter, employed by him to define his identity, he was now someone who painted other people because they interested him.

After Géricault the portrait changed in other ways. The invention of photography transformed (and to some extent eliminated) its

traditional market. In the hands of the academic artists, it nevertheless maintained its age-old function as an assertion of the subject's existence, identity and social position; but the Impressionists and their associates found new artistic uses for it. Manet's portraits are frequently an excuse for a bravura description of costume. His likeness of Zola is so imprecise in its treatment of the face and so much bound up in the details surrounding the figure – all relevant to the interests of the painter rather than the writer – that it has even been suggested that Manet portrayed not Zola but himself. Whistler's famous portrait of his mother is actually entitled *Arrangement in Grey and Black No. 1*, thus emphasizing that the true subject of the picture is more a study in tonal contrasts than a likeness of a particular person.

Although the Impressionists produced many pictures of people, both singly and in groups, very few of them can be regarded as portraits in any meaningful sense. The people Monet paints are neither more nor less important than the trees, clouds or any other part of the nature they inhabit. Even a Renoir executed long after the Impressionist period and intended to function as a formal likeness is sparing in the information it conveys about the personality and interests of the sitter. We can see that Ambroise Vollard was a connoisseur from the little Maillol sculpture he

Below left:
EDOUARD MANET
Emile Zola, 1867–68

Below right:
JAMES ABBOTT MCNEILL WHISTLER
Arrangement in Grey and Black No. 1:
Portrait of the Artist's Mother, 1872

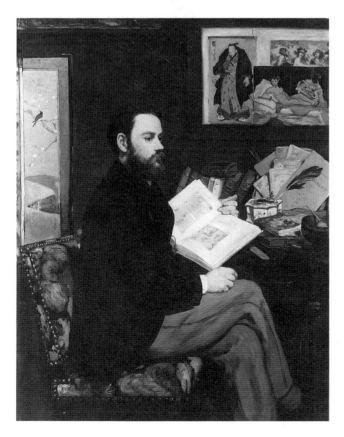

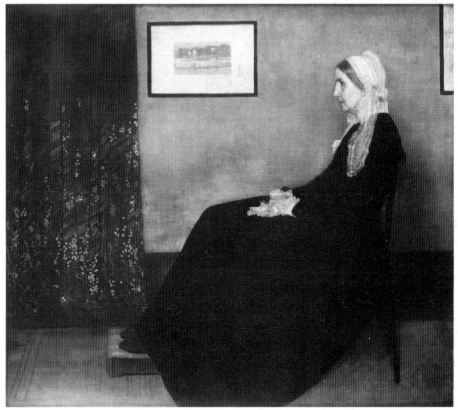

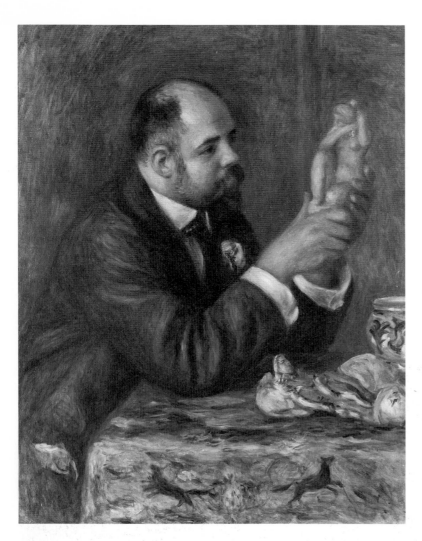

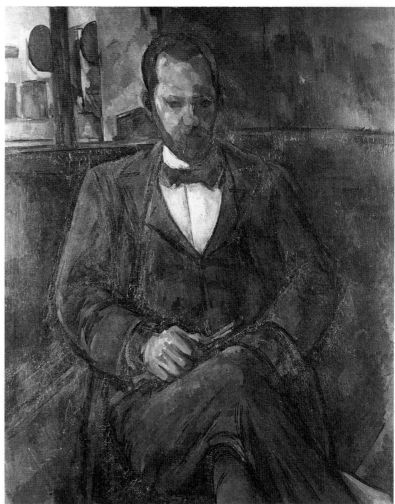

is holding; we can see that he had a beard and was balding; but that is all. For all it tells us about the man who was Renoir's dealer and who dominated the Parisian art market at the turn of the century, it might just as well be a still-life.

That remark is even more apposite of another portrait of the same sitter by another artist on Vollard's books, Paul Cézanne, who painted the dealer in 1899. The result provides even less information about Vollard's personality than the Renoir. Here, as in most of his portraits, Cézanne is more concerned with locating the exact position of the knee, with relating the shape of the head to the shoulders, and with other purely pictorial and formal problems, than with suggesting the appearance of the features of the man he is depicting, let alone revealing how he sees his character and personality.

The direct forerunners of Expressionist portraiture belonged to the generation which followed the Impressionists: Gauguin and Van Gogh, Munch and Ensor. The ideas of Symbolism were in the air, with its other-worldly emphasis on the uncommunicable and the inscrutable; but Van Gogh, writing in 1890, laid a robust emphasis on directness and expressive intensity:

Above left:
AUGUSTE RENOIR
Ambroise Vollard, 1908

Above right:
PAUL CÉZANNE
Ambroise Vollard, 1899

'What excites me most in my profession, much, much more than anything else, is portraiture, modern portraiture. I endeavour to do this through colour. . . . You see, I *should like* . . . to paint portraits which a hundred years from now will seem to the people of those days like apparitions. Thus I do not attempt to achieve this through photographic resemblance, but through our impassioned aspects, using our science and our modern taste for colour as a means of expression and of exaltation of character.'

In his portrait of his friend Dr Gachet which exists in two versions the sitter appears to be suffering from some disabling depression ('as ill and distraught as you or me', Vincent told his brother), an appearance created largely, although by no means entirely, by colour – a combination of naples yellow, eau-de-nil and yellow ochre in the face, ultramarine and cerulean blue in the body and background, and

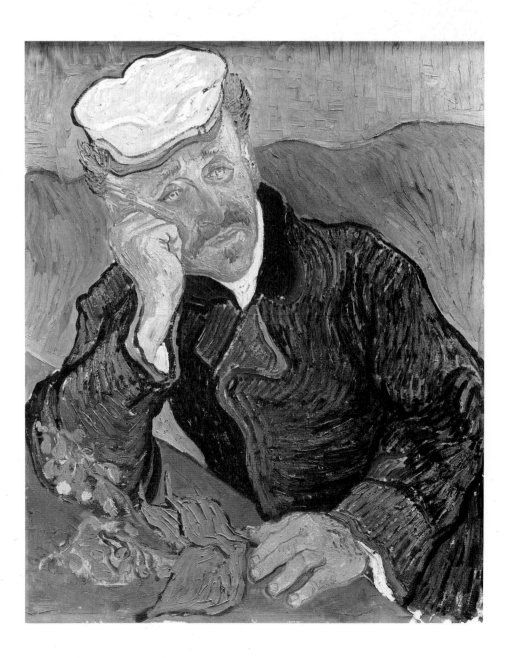

VINCENT VAN GOGH
Dr Paul Gachet, 1890

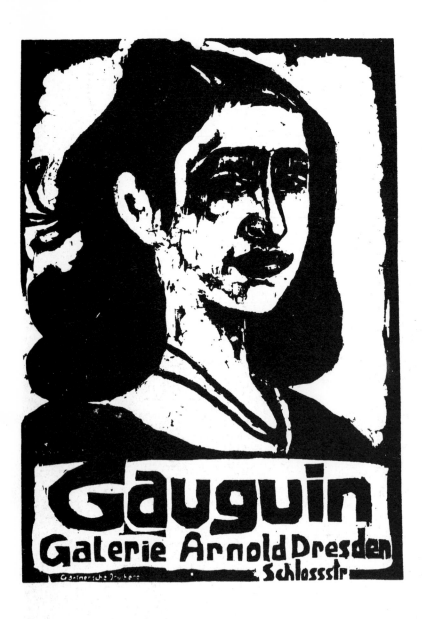

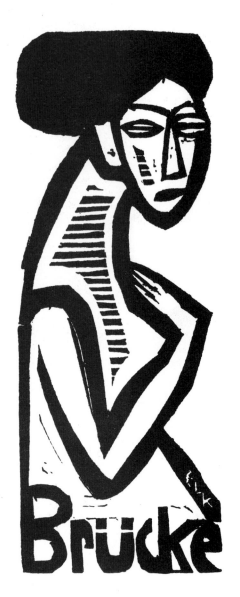

viridian green and scarlet in the table cloth. Almost as important in conveying the mood, however, is the restless brushwork and the sharp tilt of the body towards the left which creates an imbalance expressive not so much of the spiritual imbalance which Van Gogh sensed in his subject but of his own precarious state of mind. It is a portrait of Gachet, but it is also and more importantly a portrait of the artist himself.

Van Gogh's friend Gauguin served as a model to the Expressionists for a variety of reasons. He had discovered the qualities of primitive art. He was a flamboyant bohemian, disdainful of convention. The heavy contours and generous areas of a single, bright colour, which are the dominant features of the decorative style he called Synthetism, reappear in variously modified forms in the work of several German artists. Not least, Gauguin's revitalization of the moribund art of the woodcut was of enormous influence, especially on the members of the

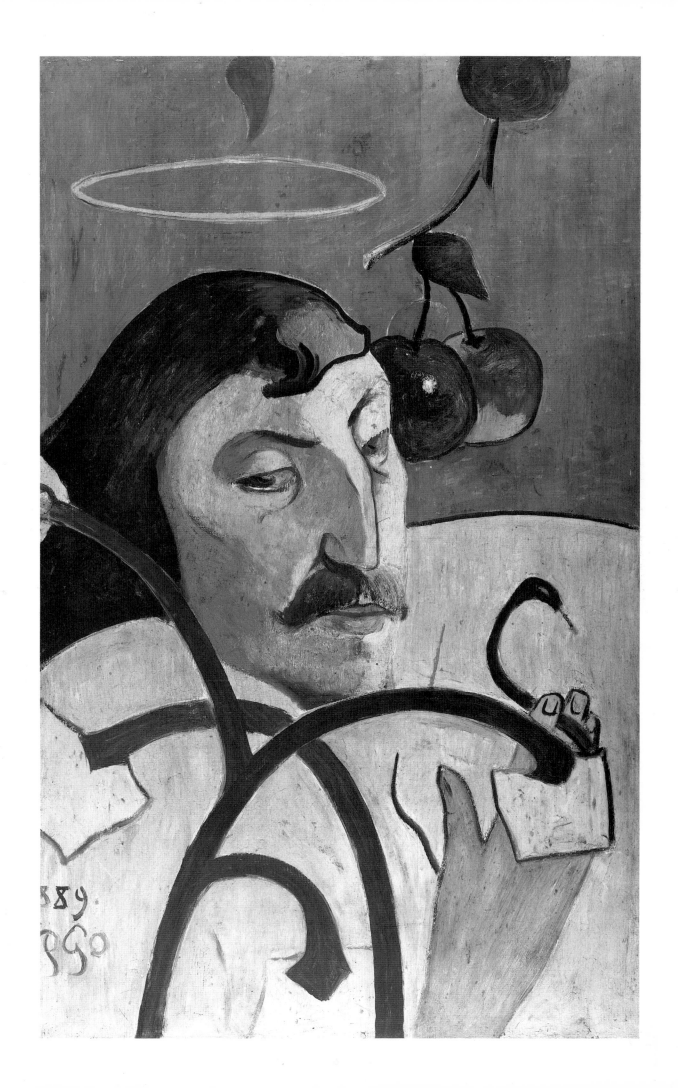

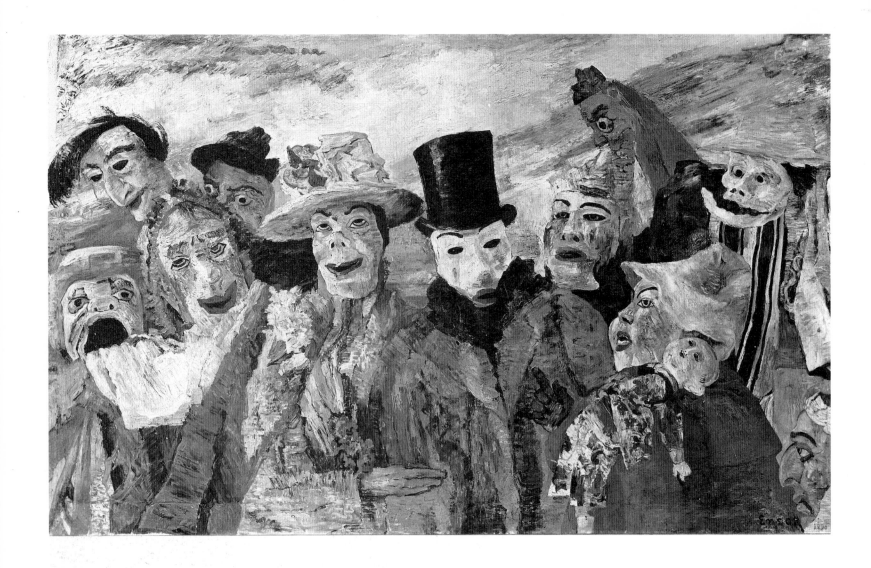

Brücke, who produced some of their best work in this bold, graphic medium.

JAMES ENSOR
Intrigue, 1890

Ensor, the eccentric recluse of Ostend, owed his place in the Expressionist pantheon to his ability to suggest the uncanny and the sinister in the midst of the mundane, and to the disturbing waywardness of his imagination. His paintings of people wearing carnival masks, or with skulls instead of faces, are by turns frightening and funny. For Ensor, as for Van Gogh and Gauguin, colour was the most important expressive means.

Edvard Munch, whose reputation was initially far greater in Germany than in his native Norway, was almost as important for the Expressionists as Van Gogh, both for his paintings and his prints. Early work by Kirchner betrays the extent of his debt to the Scandinavian, who was also one of the very few modern artists for whom Kokoschka publicly expressed his admiration. The influence of Munch's prints can be seen very clearly in both the woodcuts and lithographs of Emil Nolde. Munch's art is more than a mirror of his disturbed inner life; it is

also the record of the attempts to come to terms with it. No matter what the ostensible subject of a painting by Munch – whether a portrait, a landscape or a figure composition – the true subject is usually an inner one, the melancholy, the sense of loneliness and alienation evoked by the contemplation of the person or scene. 'Nature', wrote Munch shortly before his nervous breakdown in 1908, 'is not only what is visible to the eye – it also shows the inner images of the soul – the images on the back side of the eyes.'

This is a statement which might have been made by Van Gogh or any of the German Expressionists. Munch differed from Van Gogh, however, in the methods he employed to paint 'the inner images of the soul', as a self-portrait of 1895 shows. There is as authentic an evocation

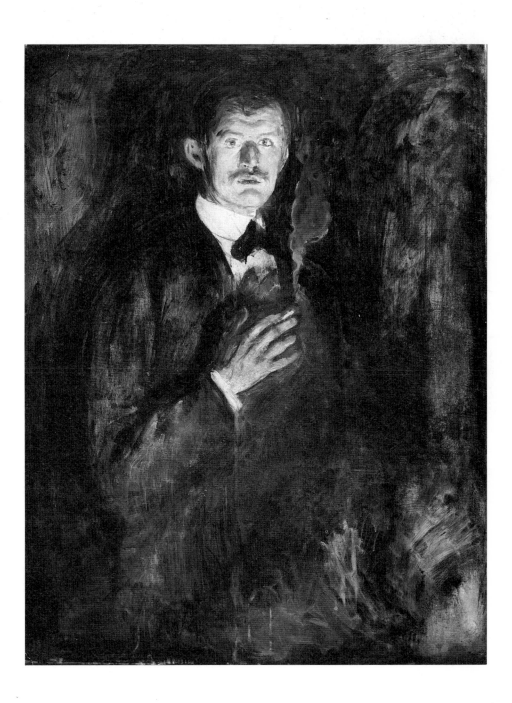

EDVARD MUNCH
Self-Portrait with Cigarette, 1895

of mood and mental tension as in Van Gogh's portrait of Gachet, but colour plays a much less important rôle than does extreme tonal contrast. The quality of the paint is mean and thin, where in the Van Gogh it is rich and creamy. Formal distortions are also minimal in the self-portrait. Much of the dramatic effect is created by the extraordinarily placed light source which, it is claimed, was intended to suggest hellfire, a literary device of a kind quite usual in Munch's *oeuvre* and a trait which betrays the links between Expressionism and Symbolism. The image seems so insubstantial that it suggests not solid flesh but some ghostly manifestation conjured up from the smoke of the cigarette.

For all these artists the portrait held a special significance. None of them was a portraitist in any traditional sense, trained to capture a likeness and earning his living from commissions. Each of them would paint someone only because he was moved to do so, because he was fascinated by a particular personality and believed that he might better understand it if he tried to fix it in paint. All these artists also painted and drew themselves repeatedly, not only because they were their own cheapest and most readily available models, but because they wanted to discover more about their own identity.

IT WAS IN GERMANY and Austria that the new kind of portrait, introduced by Géricault and modified by Van Gogh and Munch in the nineteenth century, was carried into the twentieth. Nowhere else in Europe was the portrait treated with such seriousness as in the German-speaking countries, or by so many artists of the first rank. Why was it precisely there that the new kind of portraiture flourished? Is it coincidental that Vienna, the city in which Sigmund Freud redefined the nature of the human psyche and Arthur Schnitzler introduced the inner monologue to literature, should also have produced the extraordinary portraits of Richard Gerstl and Oskar Kokoschka which themselves hint at a new understanding of personality and mood? Is it equally coincidental that portraiture should have become a vital force in Germany, a country whose social structures were paternalistic, authoritarian and consequently hostile to individualism?

Kokoschka enjoyed his major successes not in his native Austria but in Germany, where there existed a larger and less geographically concentrated public for experimental and difficult art. By 1910, when Kokoschka first visited Germany, there were also many more artists working in unconventional ways than there were in Austria. These modernist Germans were not all located in one city and they did not all work in obviously similar ways. None of them devoted himself exclusively to the portrait or any other subject. Nevertheless

Kokoschka saw enough of the work of these Germans during his stay in Berlin in 1910 to be well aware that he had something in common with them.

Had Kokoschka been in Berlin five years before there would have been no sign of a sea change in German art. It was in 1905 that the *Brücke* was founded in Dresden, but it took its members, the first of the modernists in Germany, at least two years to discard their provincial outlook and to introduce the brilliant, clashing colours and distorted forms that are among the major characteristics of Expressionism. In 1905 Emil Nolde, although only a little later admired by the young *Brücke* painters for the startling brightness of his palette, still employed the kind of heavy impastoes and intimate domestic subjects which betrayed his debt to late Impressionism. Not until 1909 did Nolde work in a way that was thoroughly Expressionist.

In 1905 the modernists of Munich, led by Kandinsky (who had lived in Germany since 1896), were still assimilating foreign influences, above all the French Neo-Impressionism of Seurat and Signac – more for its use of primary colour than for its cool approach to the structure of painting. By 1910 they had become aware of Robert Delaunay's experiments with colour and were themselves working in ways that were adventurous and individual. Kandinsky was on the point of expelling all recognizable subject-matter from his work in order to work with colours and forms alone, which he described as his 'non-objective' manner.

The Munich artists who in 1911 showed their work in an exhibition romantically called *Der Blaue Reiter* (The Blue Rider) were internationally minded and fond of theories, the more esoteric the better. While Kandinsky believed abstraction to be the artistic language of the future, the only vehicle suitable for the expression of the deepest feelings, his closest friend Franz Marc attempted to paint the world as he imagined it might be seen by animals, creatures whose total, pre-lapsarian innocence enabled them to perceive true reality beyond the dross of solid matter. The result was a series of animal paintings whose angular forms and non-descriptive colours derive from Delaunay's Orphism. Only in the last year of his life did Marc take the logical but daunting step, abandon the animal subjects and produce abstract pictures.

By no means all those Germans who by 1910 had arrived at or were on the threshold of artistic maturity were interested in the portrait. Kandinsky produced none worthy of the name; Marc executed very few and then only early in his career. Alone among the Munich modernists, Alexei Jawlensky (like Kandinsky, a Russian) paid as much attention to the human face as he did to the landscape, treating it initially in brilliant colours and dynamic brushwork derived from French Fauvism and then as the basis of a long series of grave abstractions. These paintings

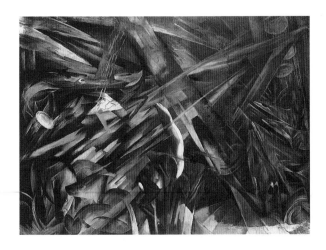

FRANZ MARC
The Fate of Animals, 1913

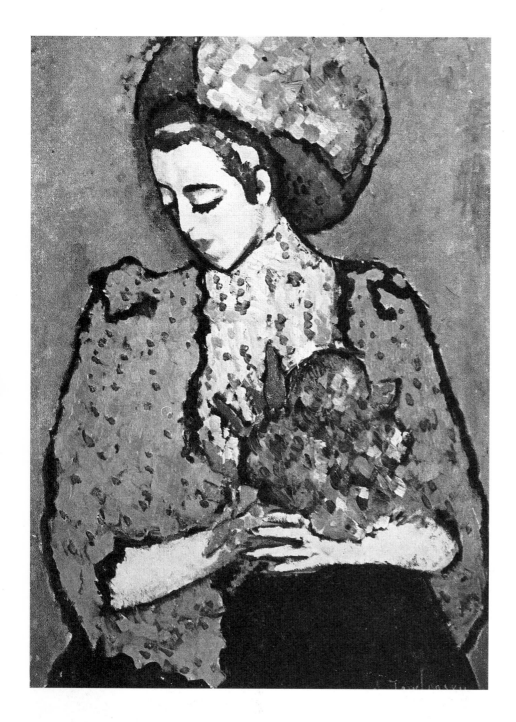

ALEXEI JAWLENSKY
Girl with Peonies, 1909

are entirely Expressionist in intention but they are not portraits in any meaningful sense.

However, in Germany and in Austria, most of those artists who by 1911 were being described as Expressionists devoted at least some of their energies to portraiture. For Kirchner, Heckel and the other *Brücke* painters the portrait was but one of a range of subjects. It was that for Nolde, too. Although both Kokoschka and Meidner painted other subjects (Meidner's apocalyptic landscapes are among the most extraordinary works in all of modern art) the portrait was their major concern. It is in their work that the Expressionist portrait can be seen in its most characteristic early form, where psychological insight and the

portrayal of mood combine to create something that is essentially new in the history of portraiture.

Among Expressionist portraits those of painters, writers, members of the art world, musicians and performers predominate. The period was remarkable for the cohesion and richness of German cultural life. In Berlin and Vienna especially, bonds of friendship, co-operation and mutual inspiration united people who were creative in every imaginable way. Painters such as Kokoschka wrote plays; composers such as Schoenberg painted. 'Official' portraiture as such was incompatible with the new style, and writers, musicians, architects, and painters were the Expressionist painter's natural sitters, his portraits a reflection of his own social world.

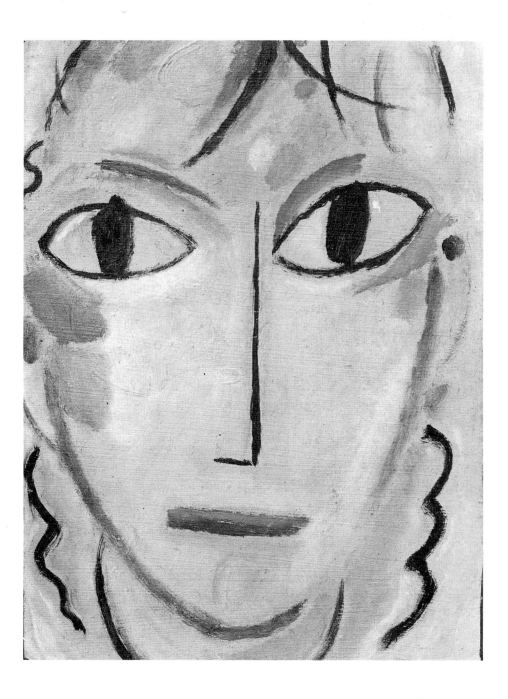

ALEXEI JAWLENSKY
Astonishment, 1919

IT IS OFTEN SAID that Expressionism did not survive the First World War. Some of its greatest talents were victims of the slaughter: if they were not actually killed (as Franz Marc was) they were so deeply affected by what they saw and felt that the power of their vision was diminished. Many painters, among them Meidner, Heckel and Schmidt-Rottluff, never managed to approach in their post-war work what they had achieved before 1914, and it is equally true that little of Kokoschka's painting of the late 1920s ranks in quality with what he produced in the brief space between 1909 and 1915. The fight seems to have gone out of Expressionism, beaten out of it, perhaps, by the war itself which in its excesses must have seemed to many like an Expressionist nightmare.

To many younger artists, moreover, Expressionism itself, with its marked subjectivity and cult of personality, seemed a symbol of the cultural disease which, they believed, had caused the First World War. What was needed was not an art which shunned the outside world and sought refuge in the self but one which squarely confronted real problems: an art which sought reality not on a metaphysical plane but under its nose, on the streets, in all aspects of life, however mundane. The Dadaists, whose artistic nihilism was born of the experience of war, asked:

'Has Expressionism fulfilled our expectations of an art that canvasses our most vital concerns?

'No! No! No!

'Have the Expressionists fulfilled our expectations of an art that brands the essence of life into our very flesh?

No! No! No!'

To begin with, however, the political debates of the post-war years gave Expressionism a new lease of life. Pechstein and Meidner were merely the best-known among scores of artists who believed that pre-war Expressionism, with its emphasis on brotherhood, community and the new man, had prepared the way for a new Germany made possible by military defeat.

When in 1920 a group of armed political demonstrators gathered outside the Zwinger in Dresden (where one of the world's greatest collections of Old Master paintings is housed), a rifle went off by mistake, damaging a painting by Rubens. Kokoschka (now a professor) wrote an open letter to the inhabitants of Dresden urging them to refrain from such action since art, unlike political disputes, is eternal. This provoked an instant reaction among members of the younger generation, who saw in Kokoschka the chief example of a once avant-garde artist emasculated by success and the Establishment.

The noisiest of those younger artists were two Berlin Communists and Dadaists, George Grosz and John Heartfield, who published a pamphlet attacking Kokoschka called *Der Kunstlump* (The Artistic

Guttersnipe). This expressed the view in colourful terms that Kokoschka, like Expressionism in general, was an irrelevance, part of a past which ought to be at least forgotten if not actually expunged.

Grosz, whose work had gone through an Expressionist phase during the war, was represented in an exhibition staged in Mannheim in 1925 and called *Die Neue Sachlichkeit* – the New Objectivity. To many, including G. F. Hartlaub, its organizer, it marked the death of Expressionism. Indeed, the subtitle of the exhibition was 'German Painting since Expressionism', and it was its organizer's declared aim to bring together 'works by those artists who over the last ten years have been neither Impressionistically vague nor Expressionistically abstract, neither sensuously superficial nor constructively introverted. I want to show those artists who have remained – or who have once more become – avowedly faithful to positive, tangible reality'.

That may have been Hartlaub's intention, but the most superficial glance at the contents of the exhibition is enough to raise doubts about the validity of its title. True, some of its contributors worked in a style which dealt soberly and unemotionally with often trivial visual facts taken from a familiar world. Others, however, in spite of their attention to detail and an assiduously cultivated technique, introduced clearly subjective elements into their work which betrayed their debt to a movement which, although much changed, was decidedly not dead.

Some years before the *Neue Sachlichkeit* exhibition, Grosz had written an essay about his own 'new' pictures which criticized the 'anarchism of Expressionism' and described his attempt to 'give an absolutely realistic picture of the world', but what he understood by reality was a view of the world as subjective as anything Expressionist. He still depended on Expressionist devices for conveying the 'vision' of facts, such as distortion, caricature and heightened colour.

Another subscriber to the idea of *Neue Sachlichkeit*, by virtue of his participation in the 1925 show, was Max Beckmann, who even before the war had attacked Expressionism in general and the metaphysical theories of Marc and Kandinsky in particular. As a consequence of the mental breakdown brought on by his experiences during the war, Beckmann's attitude had changed, however, and so had his style. Although decidedly not Expressionist in its attention to detail and finish, Beckmann's painting of the early 1920s employs 'Gothic' distortions and emotive subjects which are much closer to Expressionism than to his own earlier work. Although he attacks 'false, sentimental and swooning mysticism' in the *Creative Credo* which he published in 1920, Beckmann also stresses the importance of city life, transcendental reality and the rôle art might play in a new religion.

Otto Dix, who had been a member of Felixmüller's Expressionist group in Dresden in 1919, also exhibited at the *Neue Sachlichkeit* exhibition. Although the highly Expressionist formal traits in Dix's

early work subsequently yielded to a painstaking style derived from the Old Masters, his portraits continued to reveal personality and character through exaggerated gesture, caricature and dramatized colour in a way that is entirely Expressionist.

Expressionism has had a curious history. Itself more an unattainable aspiration than a style, it lived on in Germany in the two successor movements that most vehemently denounced it as an outworn relic. The adherents of Dadaism and of *Neue Sachlichkeit* were mostly former Expressionists themselves. Dada is unthinkable without Expressionism's longing for a clean sweep, its claustrophobic hatred of the pre-war bourgeois world. And as for *Neue Sachlichkeit*, the works by Grosz, Beckmann and Dix in this book reveal just how much of a misnomer its 'objectivity' or 'matter-of-factness' could sometimes be. Expressionism can now be seen as the major German and Austrian contribution to twentieth-century art; it is also responsible for the survival of the portrait in modern painting.

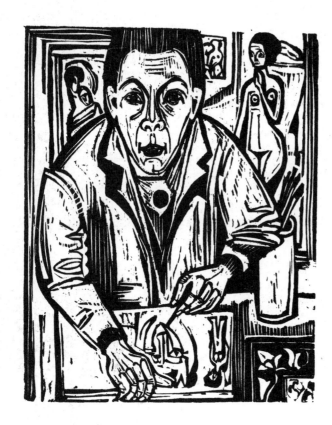

ERNST LUDWIG KIRCHNER
Self-Portrait, 1921

PLATES
AND COMMENTARIES

1

THE SELF-PORTRAIT

2

THE ARTIST'S WORLD

PAULA MODERSOHN-BECKER

Self-Portrait with Amber Necklace, 1906

ON 9 APRIL 1906, Paula Modersohn-Becker wrote to her husband Otto from Paris: 'How much I have loved you . . . I *cannot* come to you *now*, I *can't* do it. I don't want to meet you anywhere else, either. There is much that was yours, that was a part of me that has now left me. I have to wait and see whether it returns or something else takes its place.'

This desperate letter is from a woman torn between the desire for artistic self-expression and an acute sense of responsibility to her husband. He was a provincial painter living in an artists' colony in Germany. She had discovered Paris and modernism.

Paula Becker (1876–1907) was born in Dresden, studied first at the art school for women in Berlin and then privately with Fritz Mackensen in the North German village of Worpswede, where in 1889 her teacher and three others had founded an artists' colony dedicated to the pursuit of poetic Naturalism. Continuing her studies in Paris in 1900, Paula Becker discovered Cézanne's work at Vollard's gallery. Cézanne's influence and that of other living French artists gradually began to affect her style and subject matter. She was the first German painter to understand fully the importance of French painting since the 1880s and to accommodate in her own work the bright colours, creamy impastoes of paint and primitive directness (bordering on naïveté) of such artists as Gauguin and the Nabis.

Advanced art meant little to the man she married in 1901, the painter Otto Modersohn (1865–1943), a founder-member of the Worpswede colony whose second wife she became. Although difficult, their relationship was preserved by a strong mutual affection. She repeatedly wanted to get away, above all to Paris, not because she found her husband's larger reputation stifling but because she wanted to make her own way. Finally she returned to have Modersohn's child, only to die less than a month after the delivery of a daughter.

Paula Modersohn-Becker has often been described as an early Expressionist. In her understanding of French art she anticipated and influenced the Expressionists; however, she lacked their characteristic self-obsession, was not driven to dramatize her own image, and produced pictures that are calm and weighty rather than febrile and brittle. In this self-portrait there is a quiet confidence, an affirmation of her nature as a woman, and a directness so honest that it is disarming.

In 1909, two years after her tragic death, her work was exhibited (together with that of Gauguin's former friend Emile Bernard) at the Galerie Arnold in Dresden and at the Paul Cassirer gallery in Berlin. By then it had become clear how remarkable she was, not only to artists but to the general public, for whom she remains one of the most popular of twentieth-century German painters.

1
THE SELF-PORTRAIT

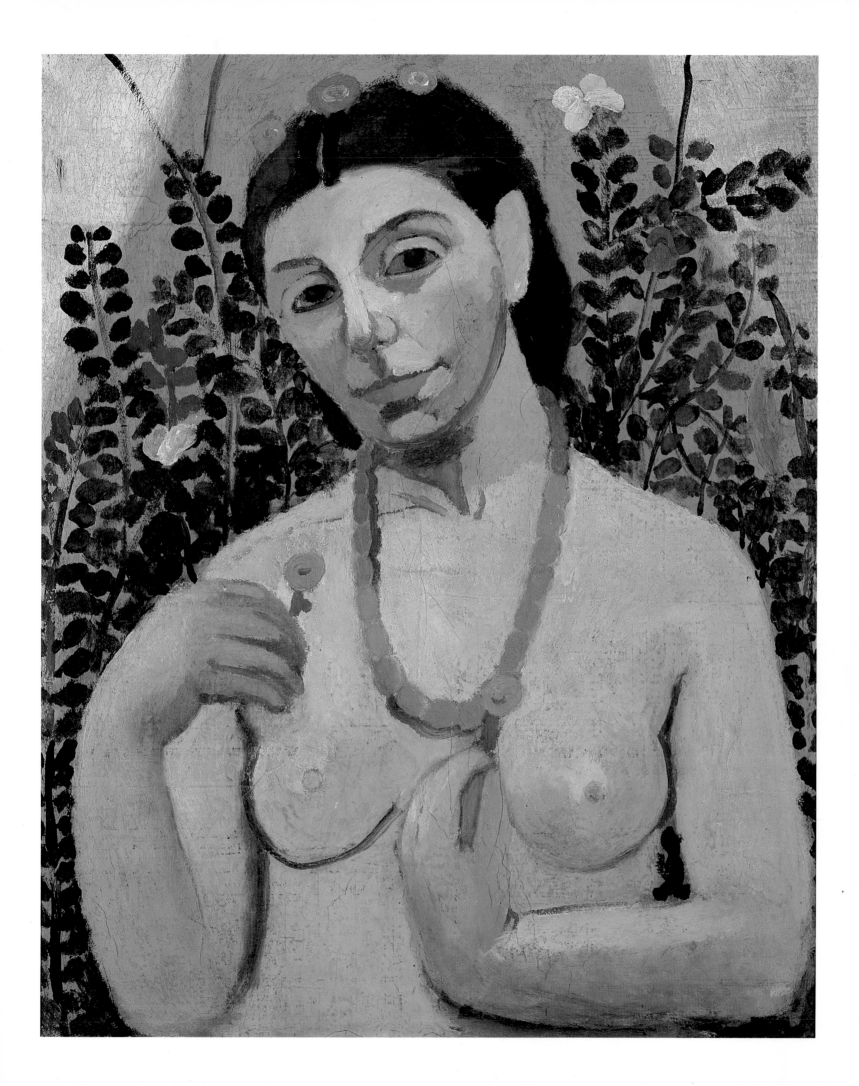

RICHARD GERSTL

Self-Portrait Laughing, 1908

THIS UNNERVING IMAGE was one of Gerstl's last pictures. In his brief life Gerstl (1883–1908) painted landscapes and portraits which anticipate in several important respects the work of Schiele, Kokoschka and even Soutine, above all in their use of heightened colour, dramatic effects of light and loose handling to convey extremes of emotion and highly charged atmospheres.

Gerstl's life is the stuff of opera, the art form he loved more passionately perhaps even than painting. Possessed of a talent as wayward as it was original, Gerstl shunned the company of other artists. A friend of musicians, he was especially close to the composers Zemlinsky and Schoenberg. He lodged with the latter and may even have taught him to paint. He certainly had an affair with Schoenberg's wife. When she ended it, he went to his studio, destroyed all the pictures that were there, stabbed himself in the chest with a butcher's knife and then, with what strength remained, hanged himself. He did all this in front of the mirror he had used to paint this and all his other self-portraits.

Enough of Gerstl's work remains to demonstrate that he was not merely the earliest but also the most original of the Viennese Expressionists. Not that anyone knew it for fully twenty-three years after his death. While he lived he rejected the few opportunities to exhibit that presented themselves, and his work was not shown in public until 1931. Even now little of it can be seen in public collections, and by comparison with Kokoschka or Schiele he is still virtually unknown.

It is said that, as a student at the Vienna Art Academy, Gerstl was briefly influenced by the flat decorative painting of Gustav Klimt. He quickly became his own man, however, creating his mature style apparently out of nothing. The only artists for whom he expressed any admiration were the Dutch and Spanish Old Masters and Van Gogh, who had only recently become known in Vienna.

Gerstl was convinced that he had genius. He also believed that a lack of public recognition provided proof of this. For Gerstl a painting that gave pleasure could not be any good, which explains why he once destroyed a picture which a visitor had praised. For him, as for the younger Egon Schiele, his own image and what it betrayed of his inner life was his most important subject. None of Gerstl's self-portraits, not even the one which shows him full length and naked, is as disturbing as this painting which is at once manic and vulnerable, mocking and hurt. It is easy to believe that it was quickly followed by suicide.

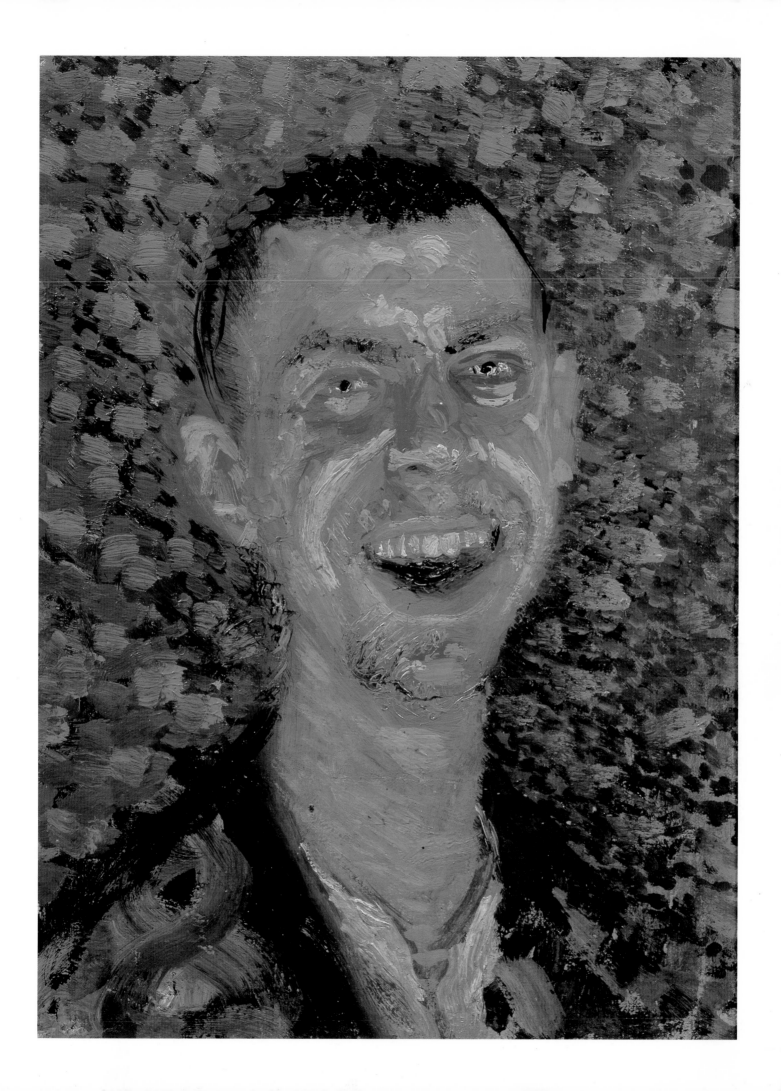

ERNST LUDWIG KIRCHNER

Self-Portrait with Model, 1910/1926
The Drinker, Self-Portrait, 1915
The Painter, Self-Portrait, 1919–20

THESE THREE SELF-PORTRAITS unmistakably mark three stages of Kirchner's troubled life: youthful confidence brimful of the joy of life and painting; a state of abject and disabling despair; the achieving of a precarious balance before the final descent into the abyss.

Although the first picture was substantially repainted during the 1920s, its conception remains essentially that of the period when Kirchner (1880–1938), living in Dresden, first matured as an artist. It confronts us with the assertive and optimistic young man who in 1905, with three friends, had founded *Die Brücke* ('Bridge'), a group grandiloquently but, as it turned out not vaingloriously dedicated to the thorough renewal of German art.

The potent juxtaposition of complementary colours on the painter's dressing-gown, the bold hues distributed throughout the picture and the large generous shapes which provide it with a structure help create a positive mood, while the frontal pose, the pipe and the young model almost cowering behind the masterful artist convey the impression of a robust bohemian life which for him (if not for the model) is enjoyable, relaxed, yet seriously creative. The model was either Fränzi or Marcella, one of the two pre-pubescent girls whom Kirchner and the other *Brücke* painters often had pose for them.

The second self-portrait could not be more different. All that remains of the earlier confidence is the brightly coloured costume, here a Peruvian jacket rather than a dressing gown. After leaving Dresden for Berlin in 1911 Kirchner had suffered a number of setbacks. Denied the recognition he thought was his due, he developed an exaggerated notion of his worth and slipped into paranoia. Taken further to the edge of madness by the outbreak of war and his own mobilization, Kirchner experienced a major crisis. Early in 1916 he entered a sanatorium, the first of several in which he would seek treatment during the next few years.

The Drinker was originally called *The Absinthe Drinker*, presumably as a conscious allusion to similar images of hopelessness and despair in French art. It was painted in Kirchner's Berlin studio, 'while day and night the military trains screeched past my window'. He may have been on leave from his training camp in Halle, or he may already have been released from the army on health grounds, when he produced this nightmarish image.

By comparison with *The Drinker*, the third picture radiates peace. Painted after the war was over, and while Kirchner was living in the mountains above Davos in Switzerland, it employs colours as bold and bright as those employed in the *Self-Portrait with Model* but potentially less harmonious. Nevertheless Kirchner has allowed very few harsh notes to creep in. We see the artist working in a room in the old farmhouse which he and his mistress Erna Schilling had rented from a peasant family.

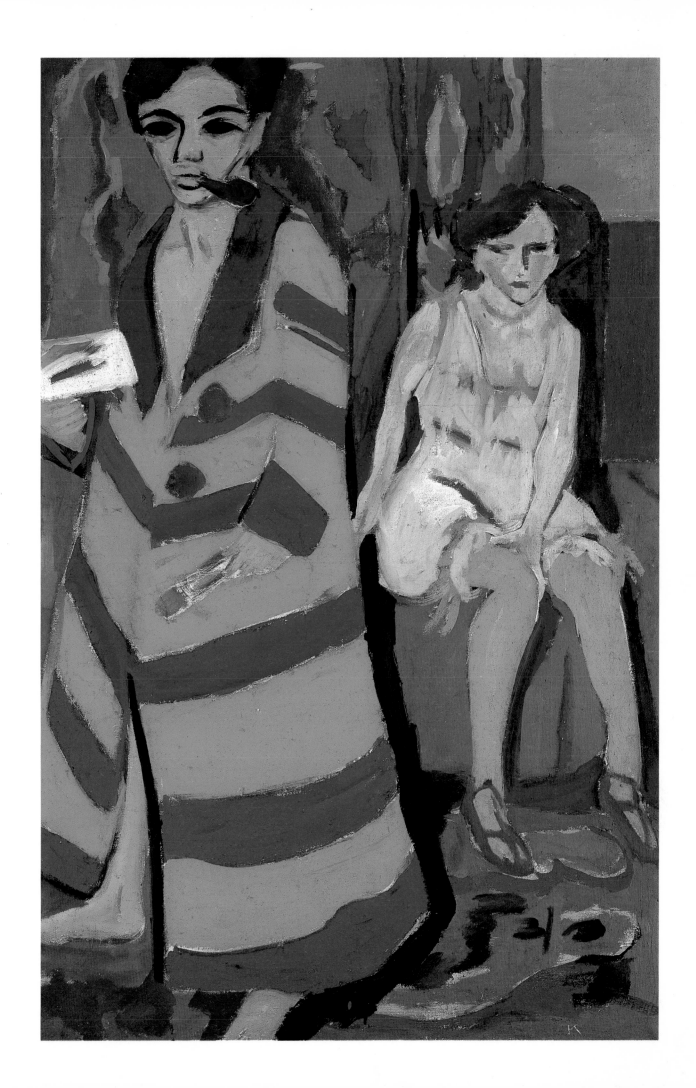

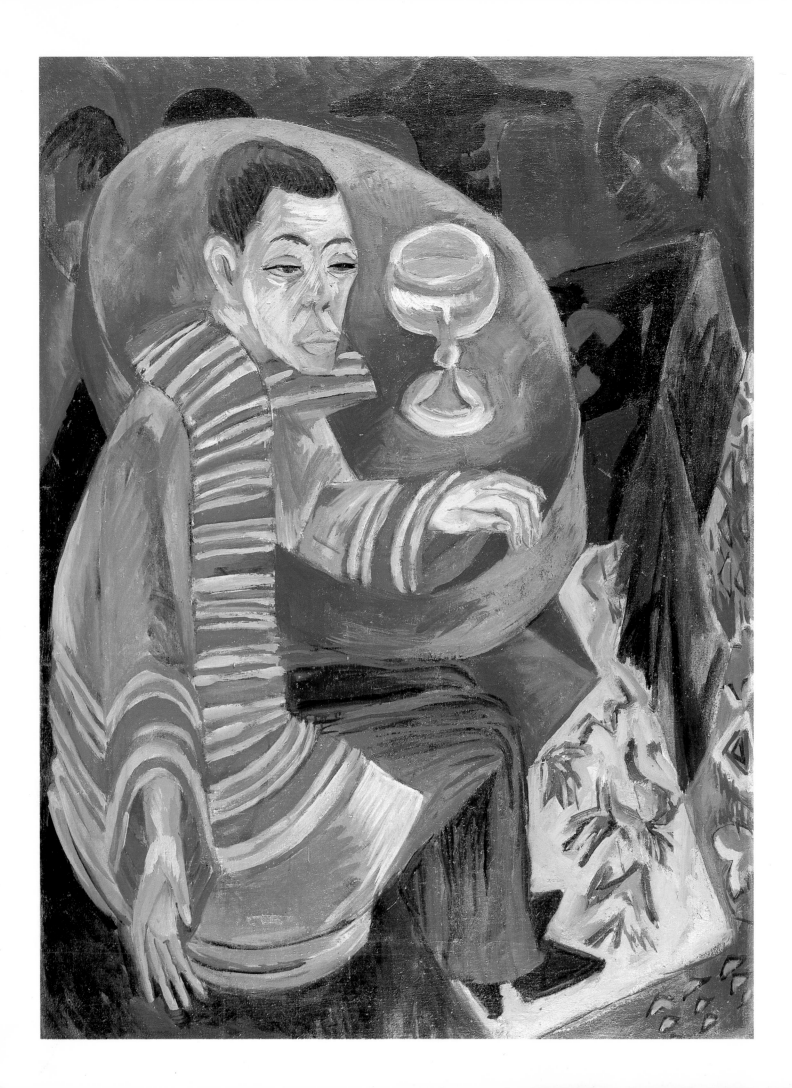

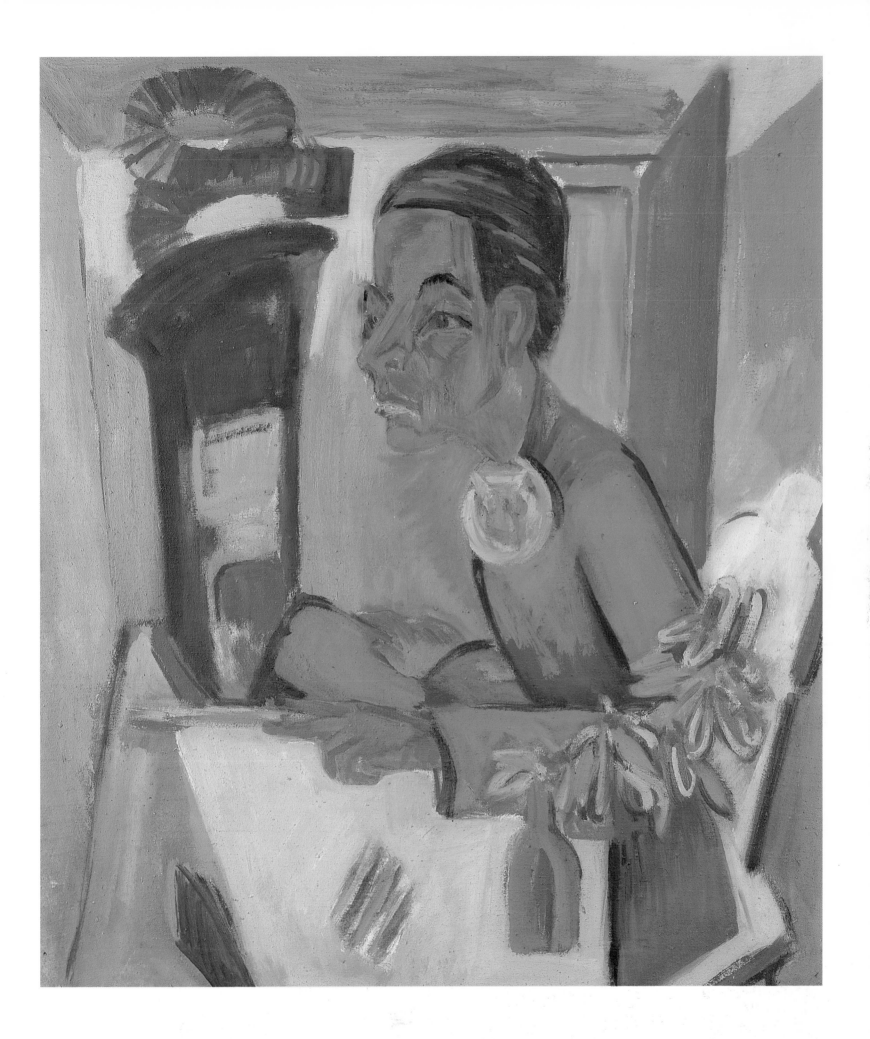

OSKAR KOKOSCHKA

Self-Portrait (Poster for 'Der Sturm'), 1910

SAVAGE AND SACRILEGIOUS, this self-portrait bears most of the hallmarks of Expressionism. It is bold, wilfully crude and powerfully arresting. It presents the artist himself as suffering, yet enjoying his pain, and anxious to share his feelings with an audience. The simplicity of the image, the brilliant use of three colours and the bold, idiosyncratic lettering make this one of the greatest posters of the twentieth century.

Kokoschka (1886–1980) left Vienna for Berlin in the early spring of 1910. His patron Adolf Loos had arranged for him to work for a new literary and artistic weekly in the German capital, called *Der Sturm* ('The Storm'), founded and edited by Herwarth Walden. Kokoschka was so busy drawing illustrations for *Der Sturm*, writing reviews of circus and cabaret performances, and sweeping out the office, that he had little time to savour Berlin, a modern, brash city quite unlike Vienna. But the experience was of enormous benefit to him.

The artist, whose style had changed radically during the eighteen months before the move to Germany, discovered that the atmosphere in Berlin was more favourable to unconventional art and behaviour than in Vienna, a city which had treated him by turns warily and aggressively. *Der Sturm* brought Kokoschka's work to the attention of an increasingly appreciative audience. It published for the first time the text of the artist's drama *Mörder, Hoffnung der Frauen* ('Murderer, the Hope of Women') together with illustrations drawn especially for it which, in their graphic nervousness, their suggestion of physical wounds and mental distress, share much with this early self-portrait.

Although Kokoschka did keep his head shaved when he was in Berlin, the self-portrait on the poster is obviously very stylized. The distress in which he portrays himself was more imagined than real in 1910 – in spite of the cold and hunger to which Walden's miserable wages condemned him. However, when he returned to Vienna at the end of 1910, expecting that recognition in Germany would be followed by recognition at home, Kokoschka quickly began to experience a range of emotions almost as extreme as that suggested and exploited by his paintings. He was hurt by the savage attacks of a few critics and he was introduced both to hopeless misery and extreme ecstasy by Alma Mahler, the composer's widow, with whom he had a passionate and stormy affair.

In the war on the Eastern front in 1915 Kokoschka survived a bullet in the head and a bayonet in the lung. He liked later to cite this poster as evidence for his second sight: the wound to which he points is roughly where he was in fact to be wounded.

OSKAR KOKOSCHKA
Illustration for *Mörder, Hoffnung der Frauen*, 1910

KUNSTANST. ARNOLD WEYLANDT BERLIN S.O.

OSKAR KOKOSCHKA

Self-Portrait, 1917

DURING 1917 KOKOSCHKA was repeatedly ill. Since August 1915 he had been suffering from the effects of head and chest wounds administered by Cossacks in the Ukraine and since August 1916 from shellshock, the result of a grenade exploding in his vicinity on the Italian front. It was a wonder that he had continued to live, let alone work, yet he did so with scarcely diminished energy.

At the end of 1916 Kokoschka went to Dresden to convalesce, and it was there that this picture was painted. In Dresden he produced several other major canvases (among them the group portraits *The Exiles* and *The Friends*), and a major revision of one of his plays, *Sphinx und Strohmann* ('Sphinx and Strawman'), now called *Hiob* ('Job'), which he designed and directed in 1917. He also had time to travel to Sweden to look at an exhibition in which his work was represented. While there he was unsuccessfully treated for the disturbance to his sense of balance caused by the bullet in his brain and had an affair with the Swedish aristocrat who subsequently married Hermann Goering.

Neither that affair, nor the less frantic liaison in Dresden with the actress Käthe Richter, lessened Kokoschka's depression, the feeling that, as he wrote to his friend Albert Ehrenstein, 'my strength and youth are gone, not to mention my health'. Little of that depression is reflected in this self-portrait, which, with its dreamy expression and tilted head, suggests the man gifted with second sight, the visionary that Kokoschka always claimed he was, rather than the man psychologically damaged not only by war but by the trauma inflicted by Alma Mahler.

Although the rhetorical device of the attitude of the hands is reminiscent of Kokoschka's pre-war portraits, much else is new. The paint is now rich and creamy, the worm-like brushmarks restless, the colours assertive. For a few years all of Kokoschka's paintings, both landscapes and portraits, were in this new and lively style.

By 1917 Kokoschka had become famous and successful. He had secured a lucrative contract from the most astute of the Berlin dealers, Paul Cassirer. Two of his plays had been published and others performed by famous companies. Museums, among them the Städel in Frankfurt, had purchased his paintings. Two years later he became a professor at the Dresden Art Academy. Some said it was the beginning of the end: the rebel, the 'chief savage' of pre-war Vienna had sold his Expressionist soul. Certainly few of his later paintings possess the power of this self-portrait, which shows Kokoschka as he always wanted to be seen: in communion with supernatural forces.

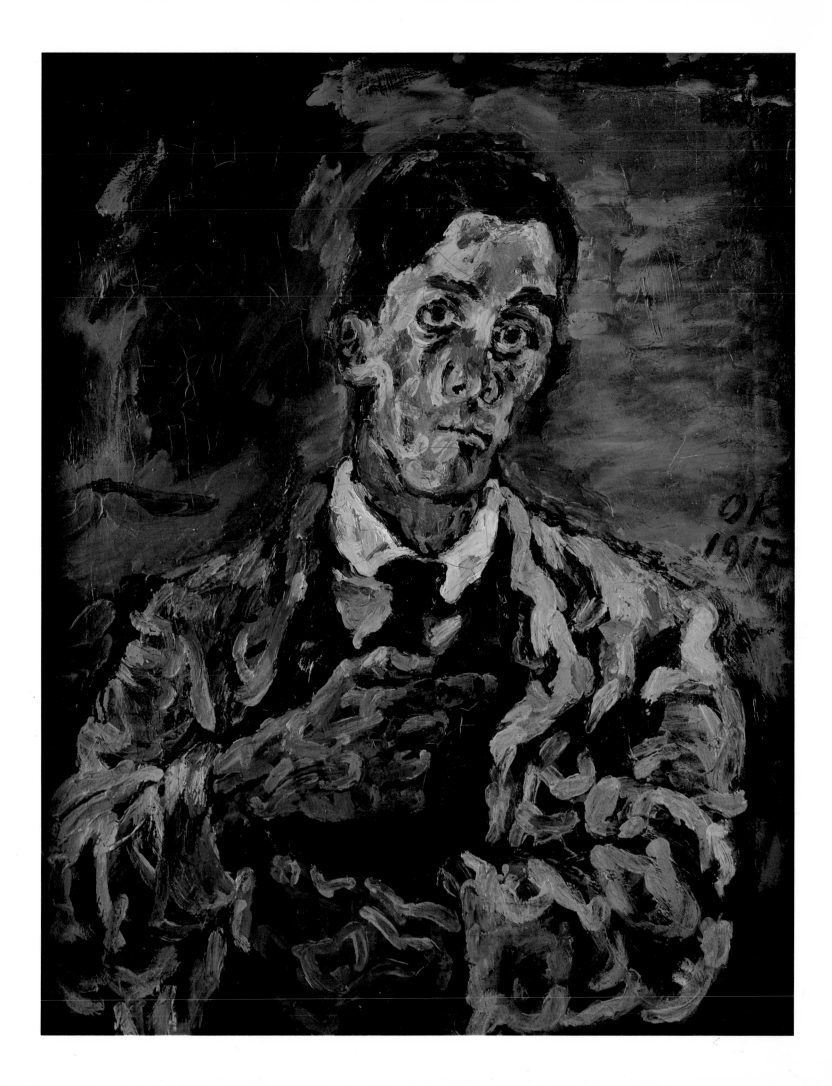

EGON SCHIELE

Self-Portrait Pulling Cheek, 1910

EXPRESSIONISM WAS ABOVE ALL about the self; and no Expressionist was as self-obsessed as Egon Schiele (1890–1918). He painted – and above all drew – himself repeatedly in poses both contorted and relaxed, both naked and clothed, thoughtful and aggressive, despairing and exultant. He depicted himself as St Sebastian in a hail of arrows, and in a monk's habit with tonsured head. He even showed himself masturbating. That he liked sometimes to show himself together with a mirror is entirely appropriate.

Yet Schiele's fascination with his reflection is not an uncomplicated self-love. It is deformed, often grotesquely, by self-loathing. The presence of the actor Schiele is always felt in the exaggerated poses, and the emotions are exploited in order to engage the sympathy of an audience, but the problems caused by the dialogue with the self are real enough.

In this chalk and wash drawing the pose and the facial expression are obviously histrionic, although the look of the eyes, distorted by the hand pulling at the cheek, may be a punning allusion to the artist's name. *Schielen* means 'to squint', and critics hostile to the artist used the word often when discussing Schiele's unconventional vision.

Four years younger than Kokoschka, Schiele also grew up in Vienna during the declining years of the Habsburg Empire, when modernist art did its best to draw to the attention of the complacent the cracks in the old, familiar and trusted façade. Like Kokoschka, Schiele took portraiture, which in the hands of Klimt glamourized and eroticized social status, and used it to investigate not merely the human personality but the psyche *in extremis*. In Schiele's portraits, especially his self-portraits, we are confronted by man at the end of his tether, made distraught by the libido, driven to despair in his search for love. We are reminded that Schiele's Vienna was also the Vienna of Freud.

Kokoschka was subsequently dismissive of Schiele's talent. He accused him of plagiarism (for which there is little evidence) and pornography (for which there is more). Such bitter personal enmity carried even beyond the grave is characteristic of many Expressionists.

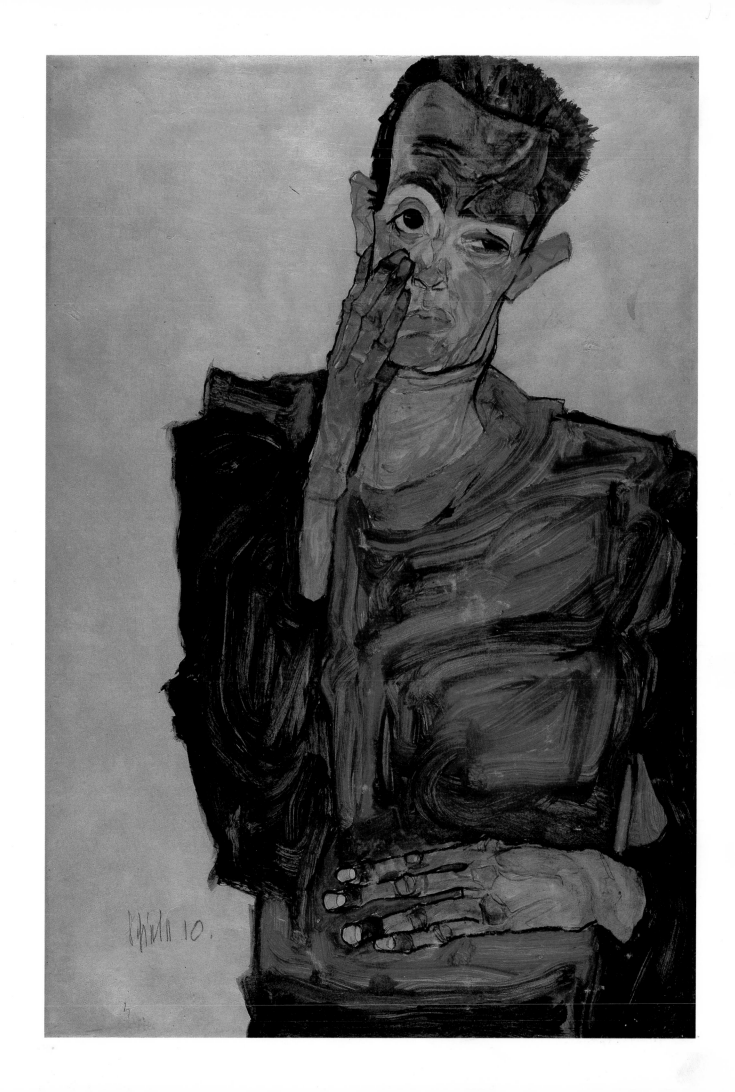

EGON SCHIELE

The Family, 1918

ALTHOUGH AN ANONYMOUS MODEL is said to have posed for the female figure, this monumental and moving painting shows Schiele himself as founder of a family. In fact Schiele never became a father. His wife became pregnant early in 1918, when this picture must have been painted, but died before giving birth, a victim of the worldwide influenza epidemic which, it is said, was responsible for more deaths than the 1914–18 war. The same epidemic – so bad in Vienna that trams had to be converted into temporary hearses – also killed Schiele himself.

The painting has a curiously, and prophetically, melancholy atmosphere. It is like a secular Holy Family: the parents seem vulnerable, lost, adrift in a void. Schiele called the work simply *Crouching Couple*; his friend, the painter Anton Faistauer, gave it its present title and in his interpretation asserted that 'Here, for the first time, a human face gazes out from one of Schiele's pictures. . . . The body is strongly built, a human organism is at work within it, the breast curves round a heart that beats. Who could ever have thought about the heart and lungs when faced by his earlier pictures? Here life has suddenly gained strength and has built a body round itself . . . a body swollen with vitality and organs from which a soul mysteriously looks out.'

Faistauer has pinpointed a significant change that had occurred in Schiele's work since 1915. In place of hysteria and shrill declamation we have sympathy and sensitivity. That same change can be seen in Schiele's drawings of women, too. They are as frank as ever, but their desperate sexual urgency has gone.

There is no doubt that the change was the result of Schiele's marriage in 1915 to Edith Harms, one of two sisters from a solid, bourgeois family who lived in the house opposite the artist's studio in Vienna. Edith had a calming effect on him, transforming him from a youth obsessed by sex into an adult aware of responsibilities.

The work of Schiele's last years, for all its prodigious technical skill and the natural grace of its every graphic mark, is neither as arresting nor as effective as the earlier work. In spite of the occasional masterpiece such as *The Family*, there is a gradual diminution in the power of Schiele's art to disturb. Significantly, the number of self-portraits declines during this last period of Schiele's life. In Expressionism it is self-obsession and not love for someone else that is the source of great art.

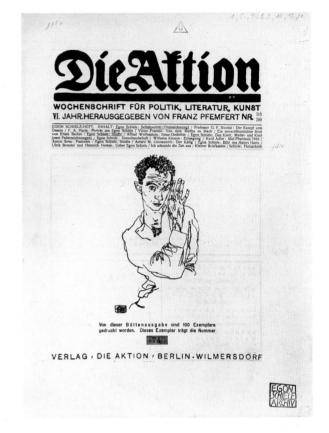

EGON SCHIELE
Cover of Schiele issue of *Die Aktion* 1916

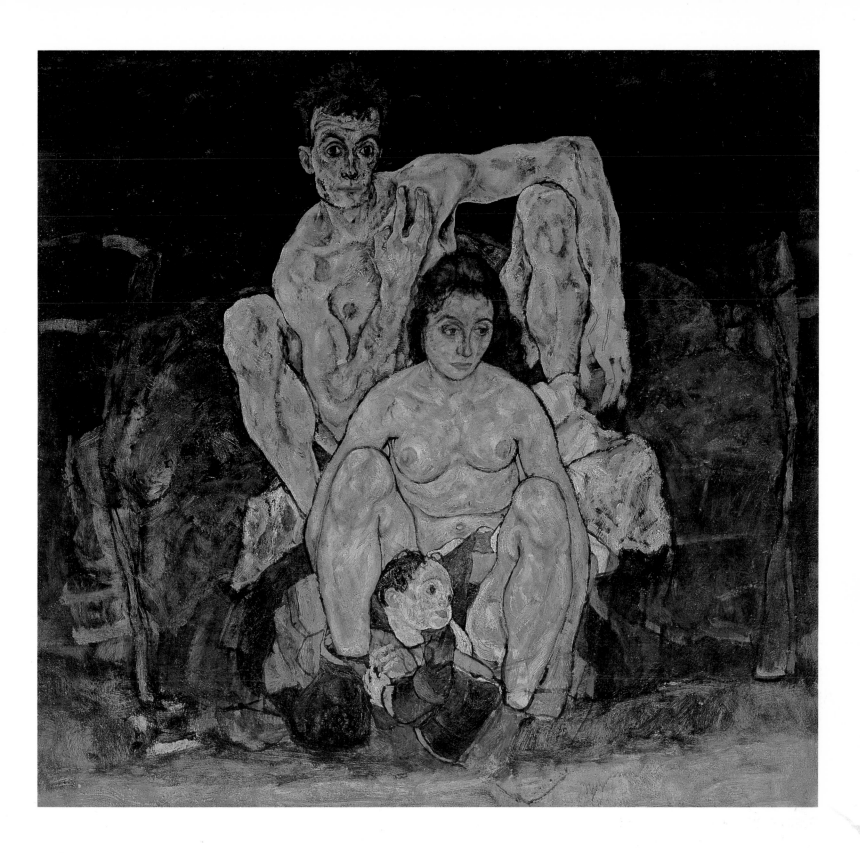

LUDWIG MEIDNER

My Night Visage, 1913

HAVING CONCEDED that 'Expressionist' is not very useful as a purely stylistic description, Willi Wolfradt writing in 1920 went on: 'One of the leading contemporary artists must be described as an Expressionist if only for the sake of the phonetic vitality of the word: Ludwig Meidner. Everything he does is expression, eruption, explosion. Here the volcanic epoch has spewed out . . . the lava of history with irresistible force from its hottest crater.'

Although he belonged to neither of the major Expressionist groupings and sought the society of more writers than painters, Meidner (1884–1966) is in some ways the archetypal Expressionist. He was a visionary, communicating the force of what he saw by means of dramatic colour and emotionally charged brushwork. He invested so much of himself in his work that his genius was quickly exhausted: the paintings of the period 1911–16 are far superior to anything from the remaining half century of his life. His two major subjects were the modern city and the portrait, especially the self-portrait, which he tackled in every medium except sculpture. He was also versatile, one of the several Expressionists gifted in more than one art: he was an outstanding writer of prose poems in which the extremes of emotion that are so obvious a feature of his paintings find expression in a declamatory tone of voice produced by onomatapoeia and broken syntax.

This, one of the best of many marvellous self-portraits, was painted at night. It was most often when working by candlelight that Meidner had his visions, when his painting hand seemed to be led by some supernatural agency.

The strongly directional brushmarks make it seem as though the head is at the centre of an electrical field and the sulphurous yellow, acid green and crimson – colours obviously suggested by the look of his face in the guttering candle – combine to produce an uncanny atmosphere.

When he saw this painting again, thirty-one years after executing it, Meidner was deeply moved. He described it later as 'a wonderful, ecstatic self-portrait of myself [*sic*] which is as intense as an old Gothic master. When I saw it . . . I began to cry.'

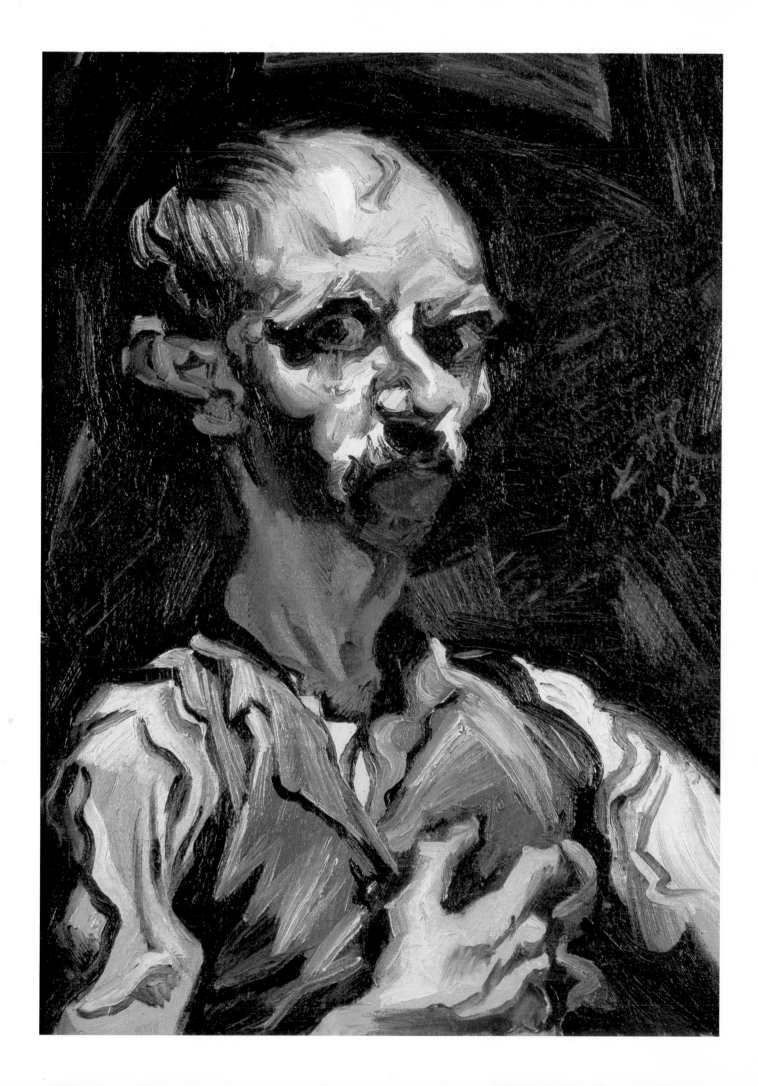

LUDWIG MEIDNER

I and the City, 1913

MEIDNER'S TWO MAJOR SUBJECTS are combined in this extraordinary self-portrait. The shuddering panorama of a restless city, the windswept clouds, the splintered, heaving forms of the buildings, rise like a fevered dream behind the tilted head of the artist who, his face transfixed with astonishment, seems intoxicated with his own imaginings. There is no more memorable image of the Expressionist relationship between the artist and a reality transfigured by his dreams.

Meidner, impressed like several Expressionists (such as Kirchner) by the Italian Futurists' discovery of the modern metropolis as the crucial subject for art and literature, depicted it in a series of visionary, apocalyptic landscapes. He shows it collapsing, torn apart by earthquakes, inundated by tidal waves or bombarded by comets and meteors. Significantly, he himself appears in several of these horrifying and exhilarating paintings as a tiny figure fleeing for his life.

In an important essay, 'An Introduction to Painting Big Cities' (1913), Meidner not only argued that the city was the 'true home' of artists but also described in typically vehement language what the city meant to him: 'A street does not consist of tonal values but is a bombardment of rows of windows, rushing balls of light between vehicles of all sorts and of thousands of vibrating spots, scraps of humanity, advertising signs and threatening, formless masses of colour.'

In an even more lyrical passage from his prose poem *Im Nacken das Sternemeer* he describes what happens when he ventures forth into the city and hurtles 'headlong along the pavements':

'The screams of clouds echo around me, burning bushes, a distant beating of wings, and people shadowy and spitting. The moon burns against my hot temples . . . The city nears. My body crackles. The giggles of the city ignite against my skin. I hear eruptions at the base of my skull. The houses near. Their catastrophes explode from their windows, stairways silently collapse. People laugh beneath the ruins . . . In beds incredible events take place . . . Office girls wait for their lovers. They masturbate out of boredom.'

Irresistibly seductive, yet fatally dangerous, the great modern city occupies as important a place in Expressionist writing as it does in Expressionist painting. Its presence was also – as in Fritz Lang's *Metropolis* of 1926 – to haunt the Expressionist film.

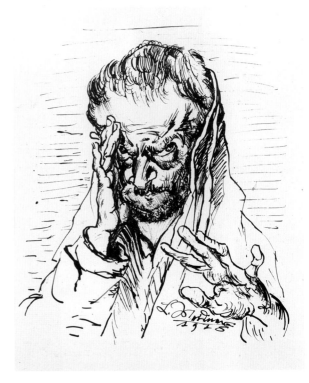

LUDWIG MEIDNER
Self-Portrait as a Prophet
(Self-Portrait with a Prayer Shawl), 1918

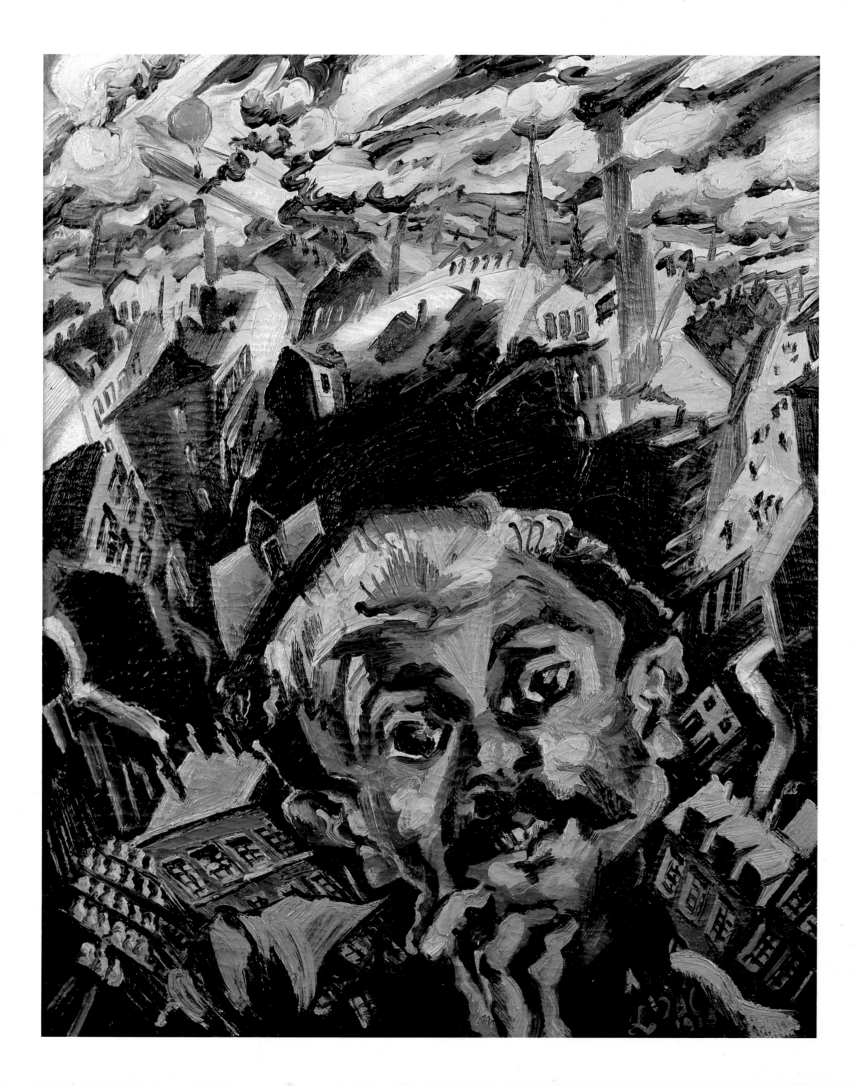

OTTO DIX

Self-Portrait as a Soldier in a Red Shirt, 1914

DIX (1891–1969) WAS NOT A MEMBER of the Expressionist generation which came to artistic maturity before 1914: on the outbreak of war he was still a student in Dresden. By then he had seen and become interested in both Van Gogh's work and Expressionism, a style with which Dresden felt itself especially associated, not least because of the founding there of *Die Brücke* in 1905.

When war came Dix quickly volunteered, anticipating great adventures. The fragmented forms, violent handling and harsh colour harmonies of Expressionism, together with the dynamic structures of Futurism, then very popular among young German artists, were to provide him with a language in which he would speak of his experiences as a soldier.

He had a worse war than many. He served as a battery sergeant-major in the heavy artillery in France, Flanders and Russia. Drawings in pencil and ink depict in stylized, angular form explosions in trenches, the desolate quagmires separating the front lines, and star-shells illuminating corpses which hang like dead birds on the barbed wire.

Dix also drew and painted himself, here with a hunted yet defiant look in his eyes. But this self-portrait dates from the period when he was still in training, when he had not yet seen action and the destructive power of machines, when he was still looking forward to great adventures.

There is, therefore, an artificial pathos about this portrait (and also the one on the *verso* which shows Dix wearing uniform and a spiked helmet or *Pickelhaube*) which is entirely Expressionist. The self is dramatized in expectation rather than as a result of irresistible feelings. The huge, assertive signature on the right adds greatly to the effect of this egocentric performance and provides a suitable counterweight to the face which looks the other way.

The great strength of the picture derives from the brilliant colours and the energy with which they were applied. It is as though Dix wanted to do violence to the paper which has barely managed to withstand his aggression: once Dix made a drawing of himself actually whipping a canvas.

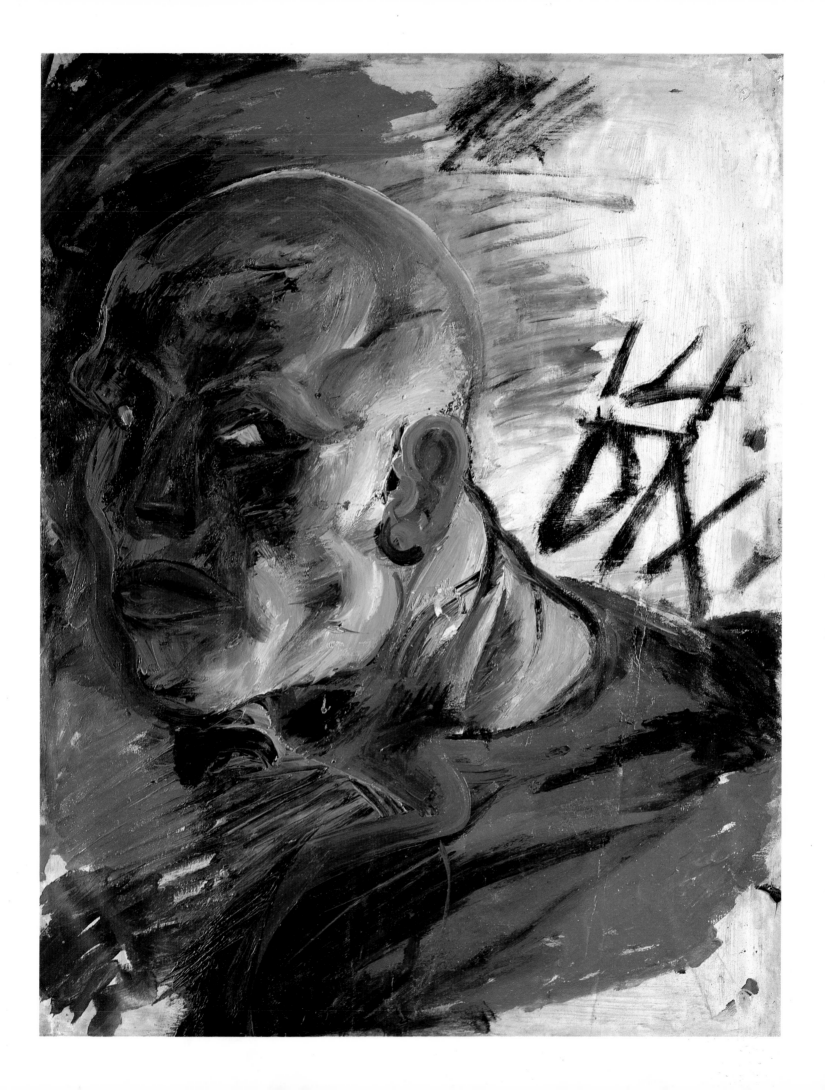

OTTO DIX

To Beauty, 1922

RELEASED FROM THE ARMY after Germany's capitulation, Dix returned to Dresden where he resumed his studies, now at the Art Academy. The most famous teacher there was Kokoschka who had been appointed in 1919: not that one of the most famous Expressionists in Germany taught Dix, who in any case would probably have learned little from him. Dix had outstripped many of his teachers in experience and most of them artistically.

Memories of war continued to haunt Dix's imagination, and for a time Expressionism seemed to be the most appropriate language in which to give them form. In 1919 Dix, Conrad Felixmüller and several other young artists founded the 'Dresden Secession Group 1919'. All of them were Expressionists and all of them were more or less of the political left.

Soon after, however, Dix turned against Expressionism, which he now regarded as self-indulgent and lacking in objectivity. 'Enough art was being produced by the Expressionists,' he ironically observed much later. 'We wanted to see things absolutely naked, clearly – almost devoid of art.'

The move away from Expressionism which can be discerned in Dix's work from 1920 is clear in this self-portrait in which the dapper, well-dressed, brushed and scrubbed painter stands surrounded by a window-dresser's dummy, a dancing couple, a woman modelling a corset, a waiter and a black jazz drummer called Tom Buxton, in whose top pocket is a handkerchief like the American flag. Dix himself seems cool and detached in the once imposing but now seedy interior of what is both a night club and a brothel. In his hand he holds a telephone, not only a relatively modern technological marvel but also vital in such establishments as this as a means of making assignations from table to table. He also seems entirely at home. We know that he was a superb dancer, especially in the American idiom that was now so popular in Germany. He was so good, indeed, that at about the time he painted this picture he considered dancing professionally as a means of earning a living.

In spite of Dix's professed intentions and his appearance here (anything less like a bohemian Expressionist painter can scarcely be imagined), hints of the earlier style remain. The scene is more dreamlike than real, and for all Dix's attention to detail he employs distortions that verge on the grotesque.

Of course the scene is not intended to be viewed as a fragment of reality. It is an allegory. Dix presents himself as a resolute unmasker, as someone able to penetrate the façade of appearances and reveal the truth. Here it is conventional beauty that he is probing, showing it to be a seedy if seductive lie.

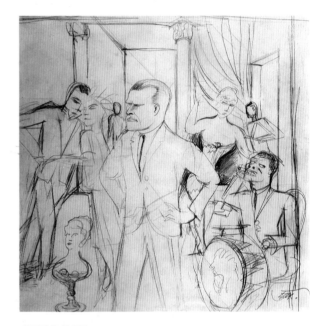

OTTO DIX
Jazz Band (To Beauty), 1922

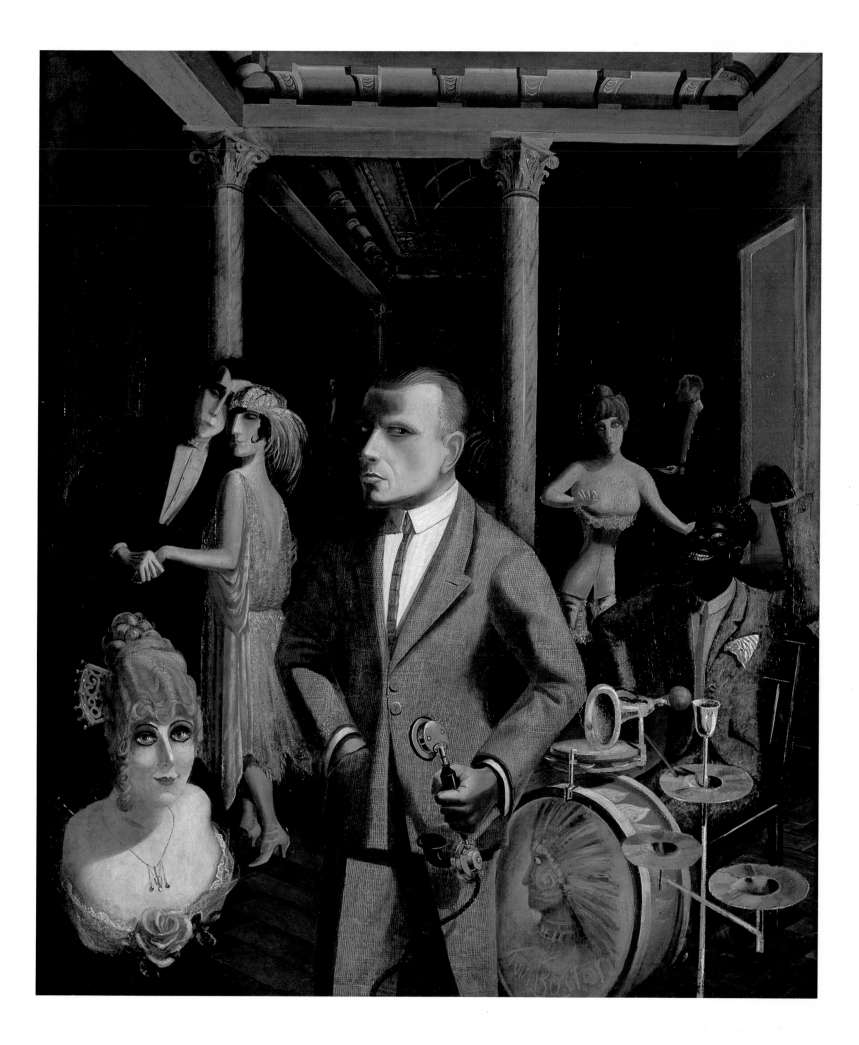

MAX BECKMANN

Self-Portrait as Medical Orderly, 1915
Self-Portrait with a Red Scarf, 1917
Self-Portrait in Tuxedo, 1927

'FOR ME THE WAR IS A MIRACLE.' Beckmann (1884–1950) wrote those chilling words in April 1915 when he was serving as a medical orderly in the operating theatre of a German field hospital in Belgium. His letters home at this time are peppered with such words as 'wonderful' and 'exciting'.

For Beckmann, who before 1914 had established a reputation as the painter of disasters and battles, the war must indeed have promised the ideal opportunity to soak up powerful experiences before transforming them into art, especially since to him, as a student of Nietzsche, war was beyond Good and Evil and, like everything else in life, 'wonderfully changeable. . . . Everywhere I find the deep lines of beauty in the sorrow and the enduring of this dreadful fate'.

This self-portrait, which was begun not long after those words were written, reveals that Beckmann's hunger for experience had already given way to uncomprehending pain. Indeed, the suffering that he witnessed, the result of a typhoid epidemic among the front-line troops as well as of bullets, shells and grenades, rapidly precipitated a nervous breakdown. In June 1915 Beckmann was moved to Strasbourg to convalesce. Although the word 'Strassburg' appears under the signature here, the painting was probably done later in Frankfurt, where Beckmann went to make a new start. 'For the first time,' he later wrote of this picture, 'what I had been experiencing in war comes out here.'

The look of pained puzzlement gives way in the self-portrait of 1917 to fear. Beckmann now seems more like a man pursued, forced to paint without interruption before some nameless fate catches up with him – or rather forced to paint as his only defence.

Ten years later he had apparently regained control of himself and external forces. Successful now, he confronts us solidly and squarely like one of his own 'new priests' who 'must appear in black suits or, at festive ceremonies, in tails . . .'. Although the confidence which this picture radiates is stronger than anything we can find in any other self-portrait, these three paintings reveal much of Beckmann's psychological development between the moment when the war seriously undermined his faith in his own image of himself and the later moment when Beckmann's life was changed again by the arrival of the Nazis and his subsequent emigration. The impression of growing confidence after disabling despair is not entirely reliable. The four-square, tuxedo-clad look was as much of a charade as any of the other *personae* Beckmann assumes in other self-portraits, the clown, for example, or the cabaret performer. Each points to the transience of human experience and the misleading nature of appearances. As Beckmann wrote in his diary on 8 January 1946, after seeing photographs of these pictures, 'In any event I carry the face of the time like no one else. That is certain.'

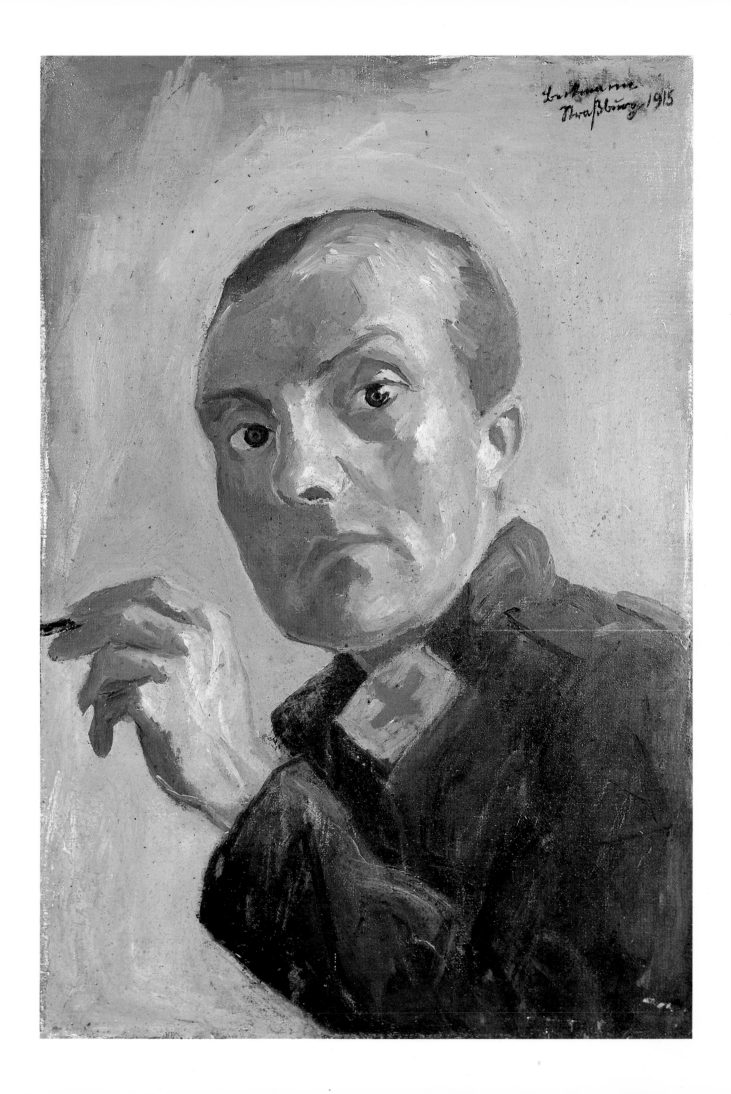

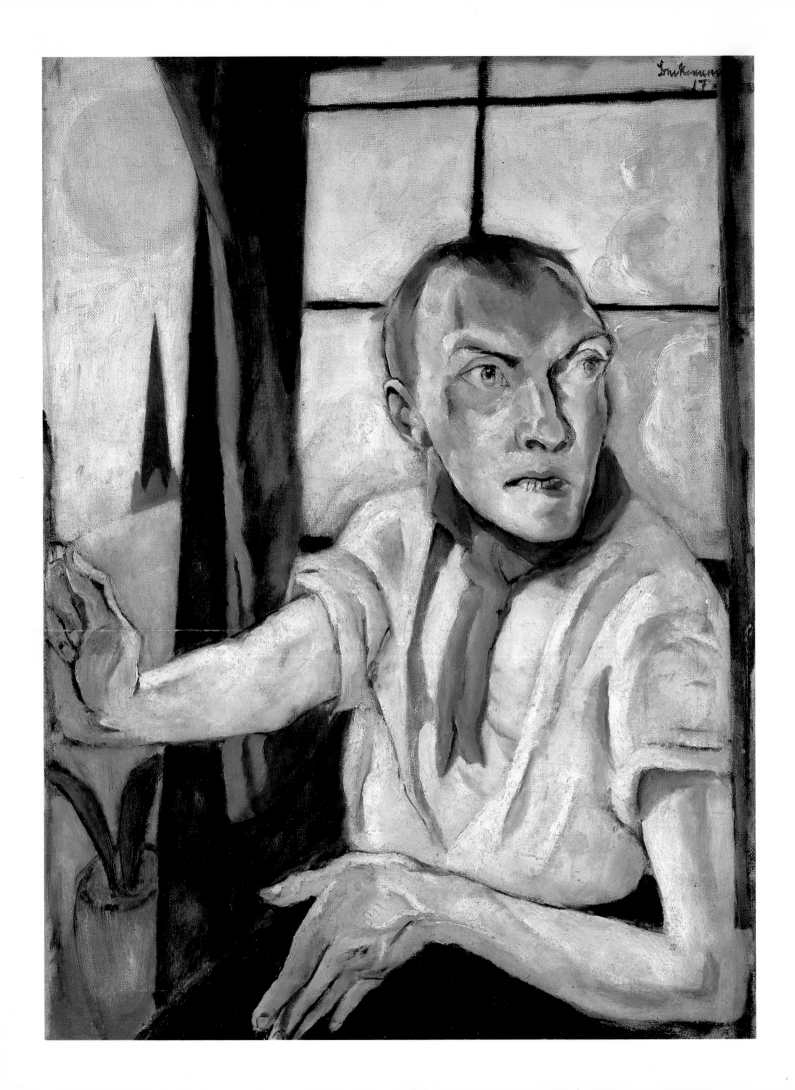

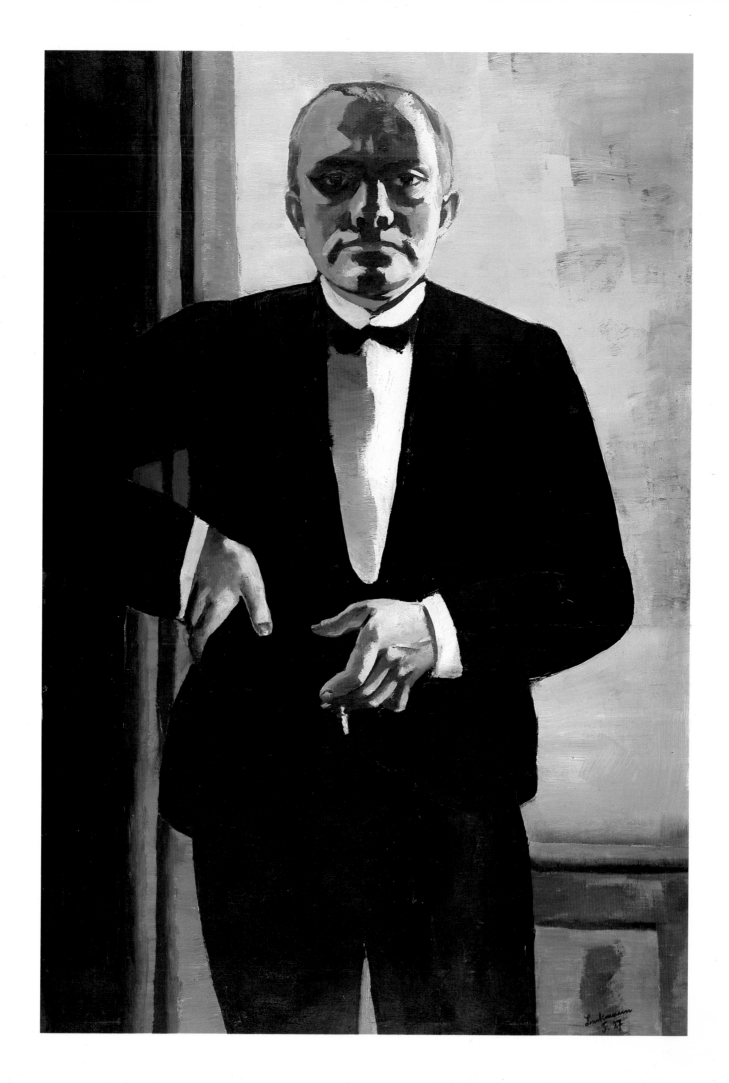

EMIL NOLDE

Self-Portrait, 1917

BORN IN THE NORTH SCHLESWIG VILLAGE of Nolde, Emil Hansen (1867–1956) adopted the name of his birthplace as a pseudonym in 1901. This was presumably because Nolde sounded more German – and less Danish – than Hansen. He was a nationalist throughout his long life (he was almost ninety when he died at Seebüll, also in North Schleswig), a fact which makes some aspects of his art easier to understand, if some of his theories no more attractive.

Trained as a woodcarver, he matured as a painter relatively late. By 1906 his style looked advanced only by comparison with that of most of his contemporaries in Germany. Even in the eyes of the *Brücke* painters whom he joined in 1906 he seemed extraordinarily daring. But their attempts to brighten and dramatize their palettes were still feeble by comparison with his late Impressionist and heavily impastoed manner.

Not until 1909, when he took up religious subjects following (and perhaps as a result of) a serious illness, did Nolde introduce a startlingly new and dissonant note into his work. He painted Christ's Life and Passion in a way which undeniably expressed deep feelings but did so by employing distortions, crude, mask-like faces and stridently clashing colours which to many seemed sacrilegious.

These paintings are certainly primitivistic. Nolde knew a great deal about primitive art, admired primitive societies, and was outraged at what he saw of the activities of colonial missionaries. His notions of primitive cultures contributed to his theories of racial purity and to his nationalism. Believing that the party with views closest to his own was the Nazi Party, he became a member early, discovering his mistake only later when, together with all the other unorthodox and experimental artists in Germany, he was declared to be a 'degenerate artist', forbidden to exhibit and even to paint.

The broken, energetic brushwork and relatively subdued colour of this painting harks back to Nolde's earlier style, before 1909, when hints of Impressionism at one remove persisted. Already fifty years old, he stands, apparently transfixed by the sight of some object beyond the painting. The pale blue eyes and the single, dramatic light-source help create an uncanny atmosphere.

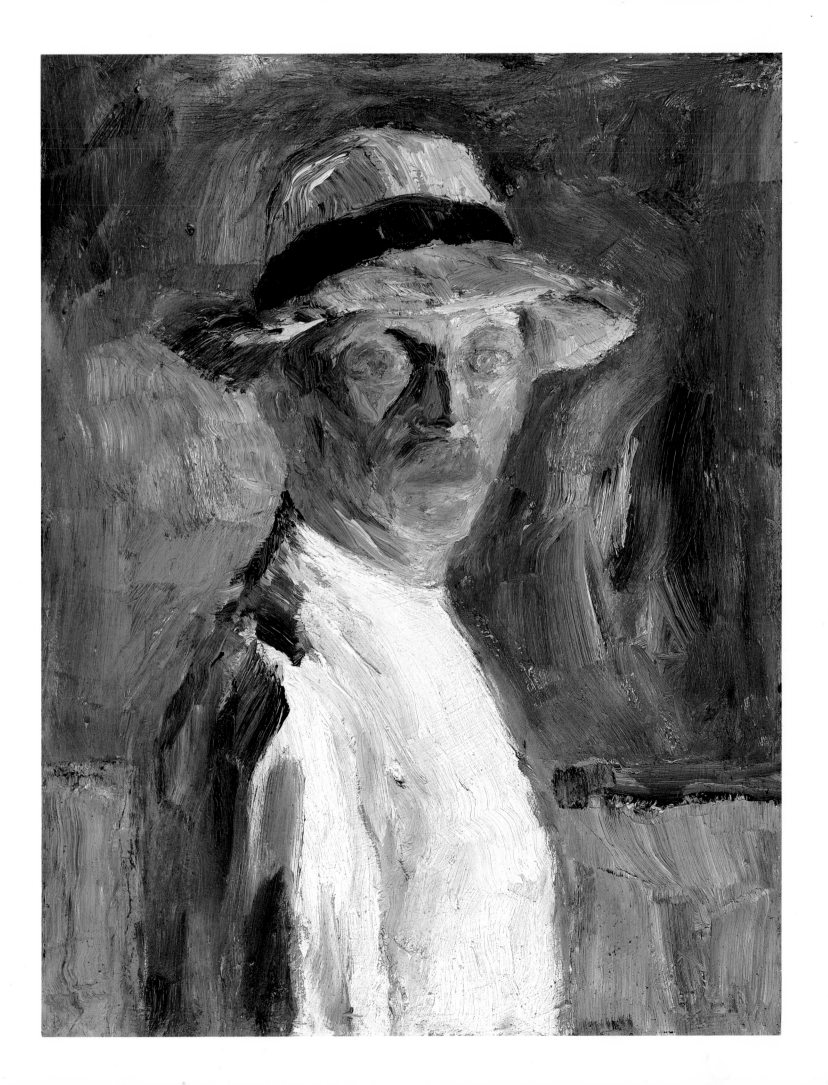

CONRAD FELIXMÜLLER

Self-Portrait with Wife, 1918

BORN IN DRESDEN, the son of an industrial blacksmith, Conrad Felix Müller (1897–1977) was a prodigy who from the age of twelve studied the violin at the local conservatory, decided at fourteen that he preferred to become a painter and, after three years at the Dresden School of Arts and Crafts, had his first exhibition at I. B. Neumann's gallery, one of the best-known and most successful in Berlin.

That was in 1914. Opposed to the war, increasingly political (and Republican), Felix Müller, as he continued to sign himself until about 1918, managed to avoid conscription until 1917, when he was obliged to join the army as a medical orderly. Before that he had been active in Expressionist circles. He illustrated Schoenberg's *Pierrot Lunaire* and painted the composer while still a student. He became friends with Ludwig Meidner, and, while he was lodging for several weeks in the studio that was legendary for its filth as well as for its parties, each artist painted the other. He also worked briefly for *Der Sturm* and other Expressionist papers, as well as editing his own, *Die Menschen* ('People').

There was one Expressionist weekly in Berlin which during the First World War became at least as famous as *Der Sturm* and, in radical circles, more influential. *Die Aktion* ('Action'), founded by Franz Pfemfert in 1911 and edited by him until it ceased publication in 1932, was far more political than its rival. Pacifist, revolutionary and utopian, it insisted that art and literature had a rôle to play in the political struggle and saw Expressionism as the artistic equivalent of radical Socialism. Those writers who shared this conviction and were published by Pfemfert became known as Activists.

Felixmüller began to work for *Die Aktion* and quickly became one of its leading illustrators, making woodcuts which betray the influence of Cubism and Futurism as well of such artists as Karl Schmidt-Rottluff whom he especially admired. In 1918 Felixmüller took the inevitable step and joined the newly founded German Communist Party – he remained a member until about 1926 – and a year later was instrumental in founding a group of young and politically active artists, the 'Dresden New Secession Group 1919'. Based on the example of the Berlin November Group, which Felixmüller also joined and whose name commemorated the month in which the abortive German Revolution began, this was the last major Expressionist grouping. Otto Dix, then a close friend of Felixmüller, was a member, as were less well remembered late Expressionists such as Lasar Segall and Konstantin Mitschke-Collande.

Felixmüller married the aristocrat Londa, Freiin von Berg, in 1918 when both were relatively young. They enjoyed a long and happy marriage, and Londa Felixmüller appears repeatedly in images of domestic life – like this woodcut – which rival in quantity and quality the political, socially committed work which Felixmüller produced at the same time.

CONRAD FELIXMÜLLER
Self-Portrait with Wife, 1918

Farbiger Holzschnitt E. Felixmüller

KÄTHE KOLLWITZ

Self-Portraits, 1905, *c*.1920, 1934, 1938

DURING THE FIRST WORLD WAR Käthe Kollwitz (1867–1945) commented in her diary on an article she had just read about future developments in art. The author 'opposes Expressionism and says that the German people will have even less use for inflated studio art than ever after the war. What they need is Realism [*Wirklichkeitskunst*]. My view entirely . . . The genius can probably run ahead of the crowd and look for new paths, but the good artists who follow the genius – and I count myself among them – must create the connection that has been lost.'

In spite of her hostility to Expressionism, Kollwitz shares more than a little with her younger, Expressionist contemporaries. Her ability urgently to communicate powerful emotions, especially hopelessness and despair, through the quality of line and through dramatic juxtapositions of black and white, are the most obvious of the characteristics which she shares with the Expressionists.

Kollwitz was not much interested in portraiture other than in making likenesses of herself. She repeatedly drew her own image, always without the faintest trace of vanity, creating a graphic autobiography that is one of the most moving personal documents left by any artist.

In 1905 she was thirty-eight and had been married for fifteen years. Already one of the most successful printmakers in Germany, Kollwitz felt herself pulled between her creative drive and her responsibilities to her husband and sons. Her husband was a doctor in one of the poorest working-class districts of Berlin, and Kollwitz's encounters with his female patients – undernourished and often physically abused by their drunken husbands – had a marked effect on her art and on her view of life.

When war came her already pessimistic philosophy was quickly confirmed. Her favourite son, Peter, was killed in Flanders in 1914, and she never fully recovered from the loss. Images of death, bereavement and suffering multiply in her work during the following years, and in self-portraits she appears increasingly melancholy: not quite resigned but almost broken by despair.

Even had she looked for one, there never was even a chink of light in the spiritual darkness. She became one of the first victims of Nazi cultural policy after 1933, when she was expelled from the Academy of Arts in Berlin. In 1942 her grandson, named Peter for his dead uncle, was killed on the Russian front. She had to live through the war without experiencing its end. She died on 22 April 1945, only days before the German collapse.

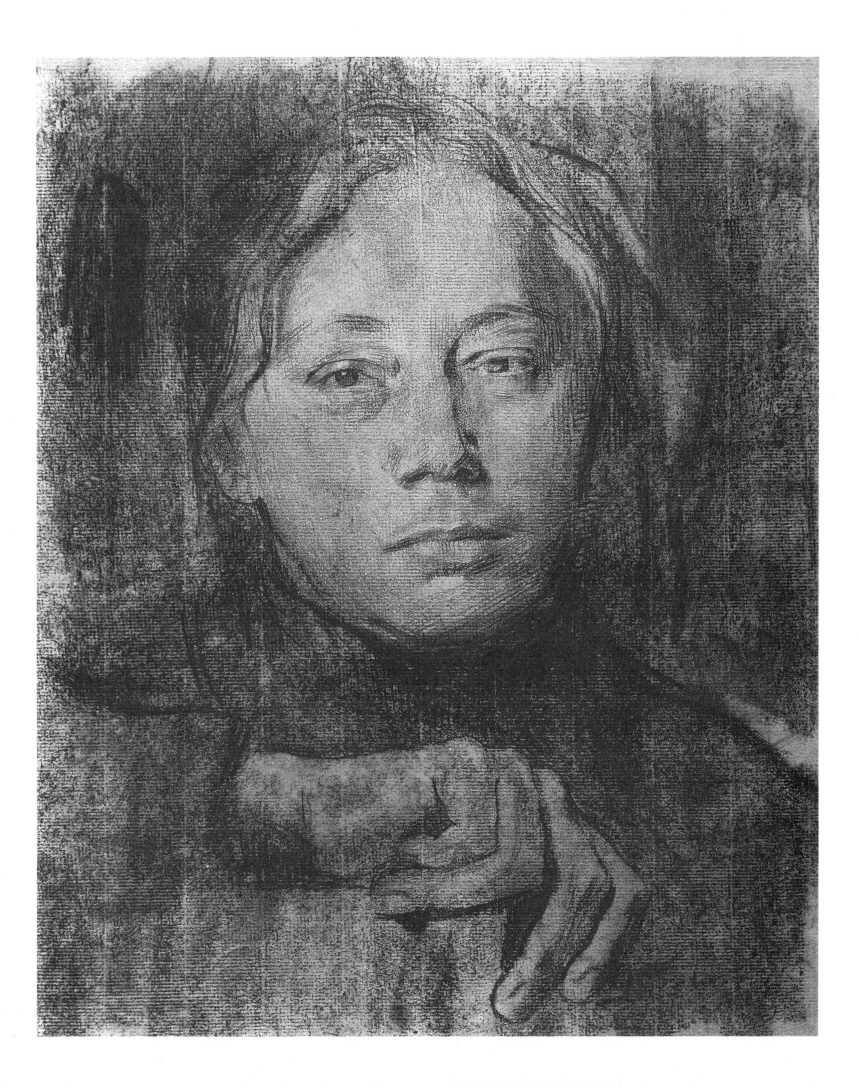

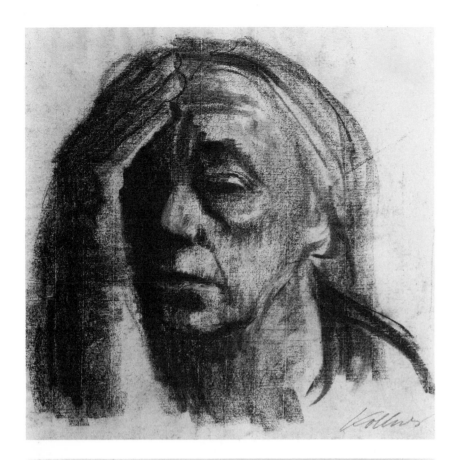

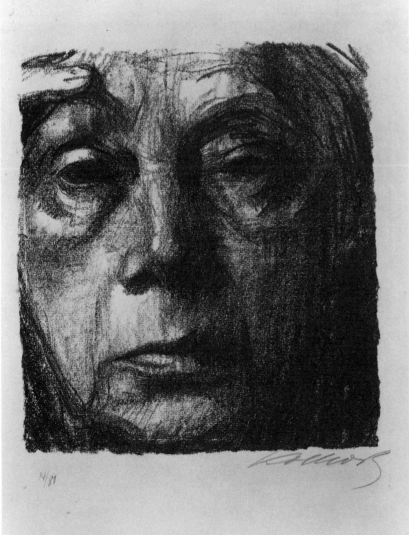

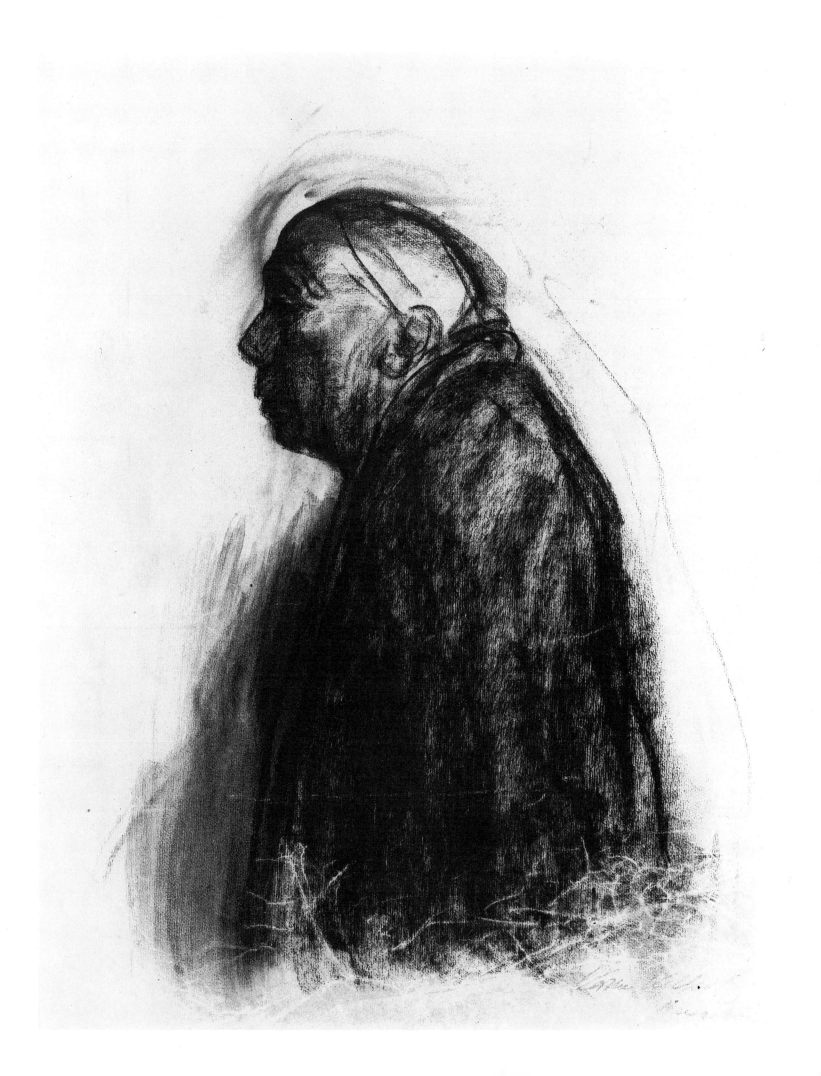

EMIL NOLDE

Sombre Head (Self-Portrait), 1907

'DRESDEN, 4 FEBR. 06. I shall come straight to the point – the artists' association *Brücke* which is located here would consider it a great honour to welcome you as a member. . . . Now one of the aims of the *Brücke* is to draw to it all revolutionary and vital elements – that is what the name *Brücke* means . . . in this way we want to express our gratitude for your storms of colour.'

Nolde accepted this invitation from the group of young Dresden painters previously unknown to him. Although he refrained from participating in their group activities, such as communal life-drawing and painting, Nolde did move to Dresden for a time. Often Heckel, Kirchner and Pechstein would visit him in the evening: 'Whatever we said and talked about during those evening hours is forgotten, but it went on far into the night, as we sat, merry and cold in our small room up there – so cold that Heckel, lying under the bed, would cut off splinters from the slats so that these, put in the stove together with the chopped up boot-jack, gave us a modest amount of heat.'

Such a bohemian life did not appeal for long to a man old enough to be the father of all of his *Brücke* colleagues; after eighteen months he resigned.

What Nolde brought to the group and what the group contributed to his art in return is difficult to calculate. He was certainly a more mature painter than they, more daring in palette and handling. But it seems likely that he learned much about print-making from them. Certainly it was in 1906 that a great surge of creativity occured in Nolde's graphic production and that he produced the first of many masterpieces in every technique from etching to wood engraving.

This dark, dramatic and even Satanic visage – plainly a self-portrait – daringly exploits lithography's potential for the printing of large uniform areas of a single tone, but the effect of this print, relying entirely on the startling contrast of black and white, is more like that of a woodcut.

There exists a two-colour state of the same print, in which the mysterious and disconcerting light effects are modified by the addition of touches of violet; but in its monochrome form it is a classic instance of the power which the Expressionist artists – who in painting relied so heavily on intensity of colour – could evoke in printmaking from the stark encounter of artistic absolutes.

Many of them believed, in fact, that graphic art occupied an especially eminent place in the history of German art because there were affinities between the positive qualities of line and bold contrast provided by the print and a peculiarly German sensibility. Thus the members of the *Brücke* devoted as much time to graphic art as to painting, partly because they wanted to emulate the great German masters of the medieval period and the early Renaissance, in their view the last German artists who, because they resisted all foreign (and especially Italian) influence, could be regarded as truly great.

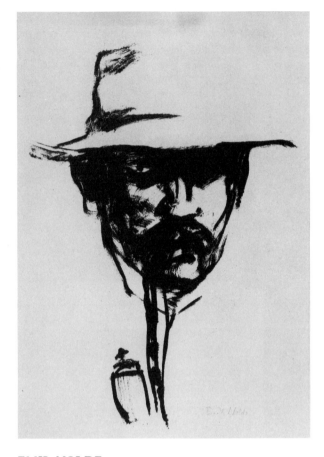

EMIL NOLDE
Self-Portrait, 1906–07

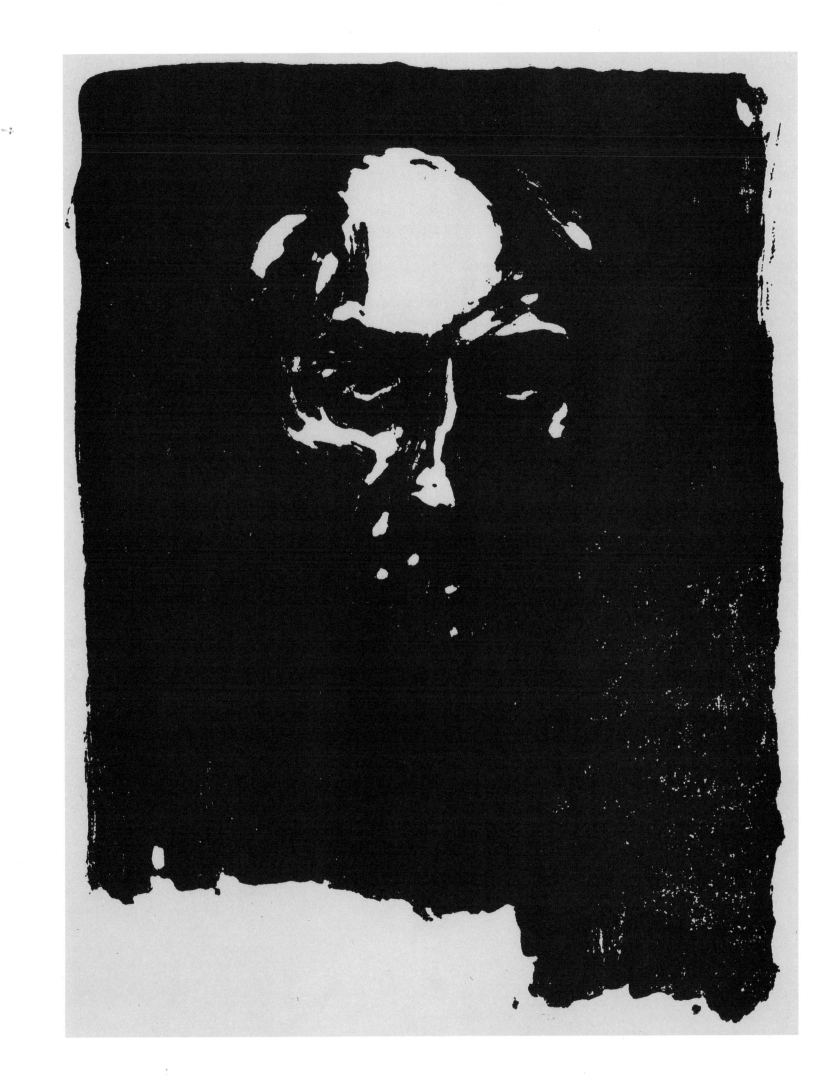

EMIL NOLDE

Self-Portrait, 1911

ALTHOUGH EXECUTED six years earlier than the self-portrait in oils (page 61), this engraving might almost be a companion piece. In fact it makes a pair with a portrait of Nolde's wife, Ada. Both are in drypoint: the image is engraved directly into the plate with the aid of a needle and without benefit of acid. The print which results has a distinctively harsh and brittle look.

In 1911 Nolde went to visit Ensor at Ostend, thus paying homage to one of the painters who, as early as 1888, had anticipated Expressionism. In 1912 Nolde finally settled in North Schleswig, although he spent every winter in Berlin until 1940 when bombing made a continuation of the practice unwise.

In 1913 and 1914 he was an official artist with a government ethnographic expedition which travelled to New Guinea (then a German colony) by way of Russia, China and Borneo. He thus came to know at first-hand several of the primitive societies he admired. He also collected, often under dangerous conditions, material for many paintings of 'savage' people and rituals which he completed at home. Occasionally Ada Nolde would stand guard over her sketching husband, a shotgun cocked in anticipation of the attack of some wild beast. On its return the expedition was surprised in the Suez Canal by the declaration of war and some of its equipment, including work by Nolde, was confiscated by the British. Several years later paintings by Nolde came to light in a Customs warehouse in Plymouth.

Nolde, together with most of the other painters of his generation, vehemently denied that he was an Expressionist: 'A German artist – that I am!'

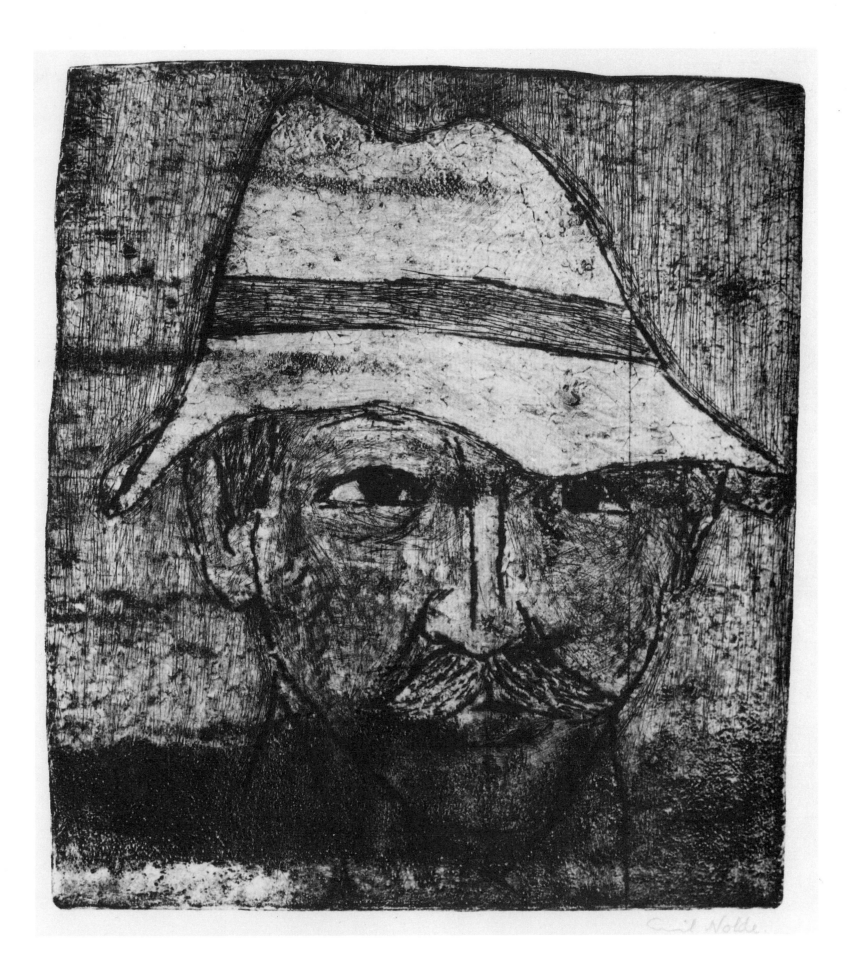

Emil Nolde

EGON SCHIELE

Self-Portrait drawing a Nude Model in front of a Mirror, 1910

LEGEND HAS IT that Schiele was incapable of passing a mirror of any size without stopping and looking at himself in it. One of Johannes Fischer's photographs of the artist, taken in 1915, shows him gazing intently at his own, slightly dandified reflection in what was the most important piece of furniture in his studio. In this drawing the mirror brings together Schiele's two most important subjects, himself and the female nude. He has not indicated the frame, but what is real and what reflection is clear. We sit in the artist's place behind his model's back. Curiously, while she seems to look at herself admiringly, he looks away from what he appears to be drawing.

In the spring of 1910 Schiele left Vienna, where he had enjoyed some modest success since ending his studies at the Art Academy the previous year, for Krumau (Ceský Krumlov), a town in southern Bohemia. He went with a friend, the stage performer Erwin Osen (of whom Schiele made a series of outstanding drawings), and Osen's mistress, the exotic dancer who called herself Moa. To judge from other drawings of her, she was probably the slender, self-confident woman looking at herself here.

It was during 1910, both in Krumau and Vienna, that Schiele produced some of his most disturbingly frank erotic drawings, both of himself and female models, many of them young girls on the threshold of womanhood. This drawing (which is somewhat softer than most of those made in 1910) exploits some of the conventions of pornography: the provocative pose, the sideways glance, the hat, stockings and other accessories, the dark eyes and the hand placed on the hip so as to draw attention to the pubic hair.

This work is unique in Schiele's *oeuvre* because it shows him in the act of drawing together with the subject of his drawing. We are therefore forced to identify with him and to consider him as an artist. In his other work we are expected to relate directly to the subject, as voyeur, even as potential lover.

EGON SCHIELE
Erwin Osen, 1910

PAUL KLEE

Meditation (Self-Portrait), 1911

'ART DOES NOT REPRODUCE THE VISIBLE; rather it makes visible.' This ringing statement, with which Paul Klee's 'Creative Credo' begins, is a memorable description not only of Klee's artistic aims but of the belief on which all Expressionism depended. For all that, Klee (1879–1940) can scarcely be described as an Expressionist. His work is too controlled, cerebral, playful, ironic – and above all too various – to be accommodated by a single term of any kind, let alone one which implies the dominance of feeling over intellect.

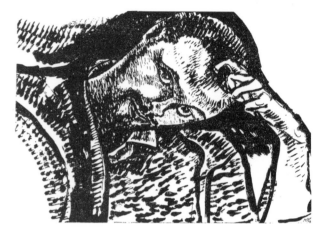

PAUL KLEE
Young Man Resting (Self-Portrait), 1911

Nevertheless Klee did belong to the circle around Kandinsky in Munich before the First World War (they had first met as students in Franz von Stuck's class at the Munich Academy in 1901); he did contribute to the second *Blaue Reiter* exhibition in 1912 (which was entirely devoted to graphic art); and one of his drawings was reproduced in the almanac which, edited by Kandinsky and Marc, gave both exhibitions their name.

At that time Klee was little interested in painting, content to exploit the prodigious gifts for drawing which, together with a remarkable talent for music (he played the violin with the Bern city orchestra from the age of ten), manifested itself at a very early age. Not until he discovered Robert Delaunay's paintings of coloured discs and windows and, in the spring of 1914, experienced the clear sunlight and saturated colours of North Africa during a short visit to Tunisia, did Klee begin to paint seriously and, with that, to achieve a relatively late artistic maturity.

There are very few portraits in Klee's *oeuvre*: most of them were executed before 1920, and only the earliest of these are portraits in any conventional sense. In the three self-portraits illustrated here, the earliest is the most conventional, while the least conventional – *Meditation* – is the most expressive and, because it says something about Klee's creative method, also the most Expressionist.

Klee produced an enormous amount of work at the Bauhaus, where he taught during both its Weimar and Dessau phases, at the Düsseldorf Academy, where he was appointed Professor after he left the Bauhaus, and in his native Switzerland where he returned after the Nazis came to power in Germany. His work is so various that it is difficult to discern any logical pattern or development in it – at times it seems as though he worked concurrently in three or four styles – but his aims remained essentially the same as they were when he wrote his 'Creative Credo'. On the last picture he ever painted, *Composition with Fruits*, 1940, he wrote the words 'Must everything be conscious, then? Ah, I believe not!'

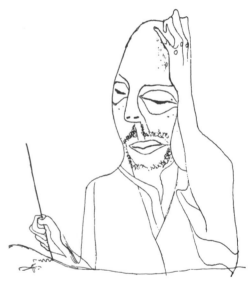

PAUL KLEE
Self-Portrait, 1919

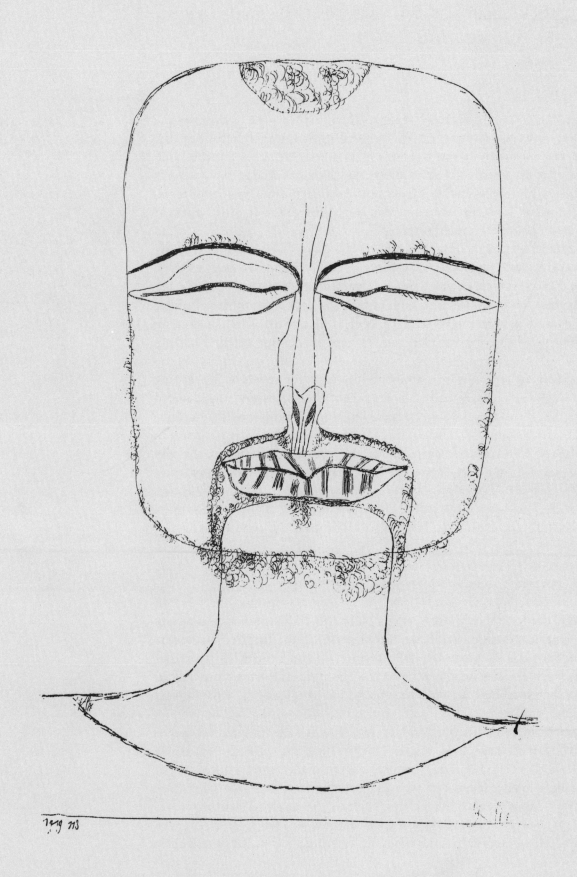

OSKAR KOKOSCHKA

Man and Woman at the Crossroads (Meeting), 1913
Man and Woman, 1914
Self-Portrait, 1914

IT WAS IN 1912 that Kokoschka met Alma Mahler, the widow of the composer, reputedly one of the most beautiful women and certainly one of the best society hostesses in Vienna. He was at a low ebb in his fortunes and, although already twenty-six years of age, still inexperienced and awkward in many ways. She, who had an infallible eye for genius and potential fame, began an affair with the painter which lasted for the next three years. It dominated his life for much longer.

Kokoschka's letters to Alma Mahler reveal a man who was permanently obsessed and also by turns ecstatic, miserable, jealous and, on occasion, even deranged. She also left an indelible mark on his art. He not only painted her portrait singly and together with him, but she also appears in other paintings, drawings and prints. For several years it is as though Kokoschka were incapable of portraying any woman without giving her Alma Mahler's features.

This difficult relationship also forms the basis for much of his writing during the same period. In 1913, at the height of their liaison, he produced lithographic illustrations for his poem *Der gefesselte Kolumbus* ('Columbus Bound') which suggest that he was already fearful of the way the affair would end. Alma is 'The Woman' (see page 154), the eternal Eve for whom the man is searching and by whom he will be ruined. But she is also the Virgin Mary who offers solace. The Man, obviously Kokoschka himself, thus becomes Christ who must inevitably suffer a horrible death. But the symbolism is multi-layered and confusing. He is also Columbus, the conqueror of new worlds, who is bound by the woman. 'My Columbus ventures out not to discover America but to recognize a woman who binds him in chains. At the end she appears to him as a love-ghost, moon woman.'

The lithographic cycle *Bach Cantata* (which dates from 1914 but was first published two years later) also employs biblical and other literary imagery to weave together an allegory of Kokoschka's personal life. Inspired by the text (*O Ewigkeit – Du Donnerwort* – Oh Eternity – Thou Fearful Word) rather than by the score of the cantata (Opus 60), the cycle ends with the sacrificial death of the man. The man and woman here, too, are clearly the artist himself and Alma Mahler.

The self-portrait with which the cycle begins is a lithographic version of the dark *Self-Portrait with Brush*, also of 1914 and now in the Kniže Collection, New York. That painting, one of the most impressive of Kokoschka's many self-portraits, was probably intended as a Christmas present for Alma Mahler. She never received it. Soon after Christmas 1914, largely at her prompting, Kokoschka volunteered for a crack cavalry regiment. He sensed only dimly that she had already decided to end their affair.

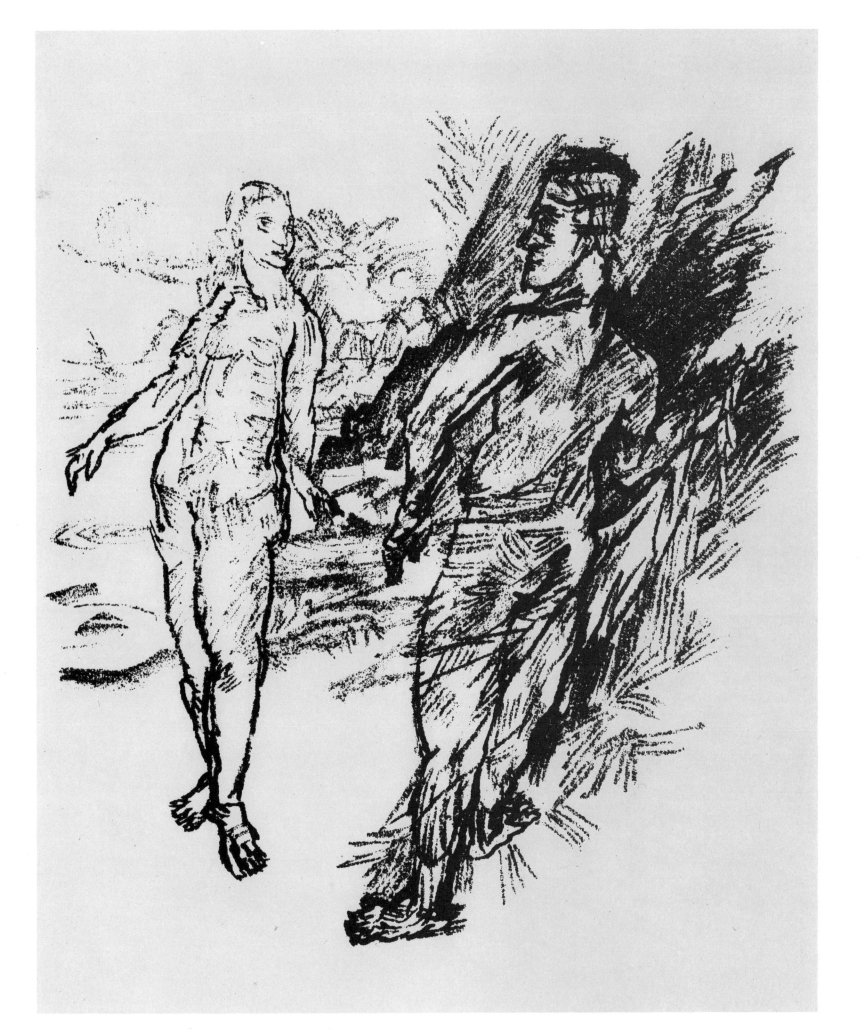

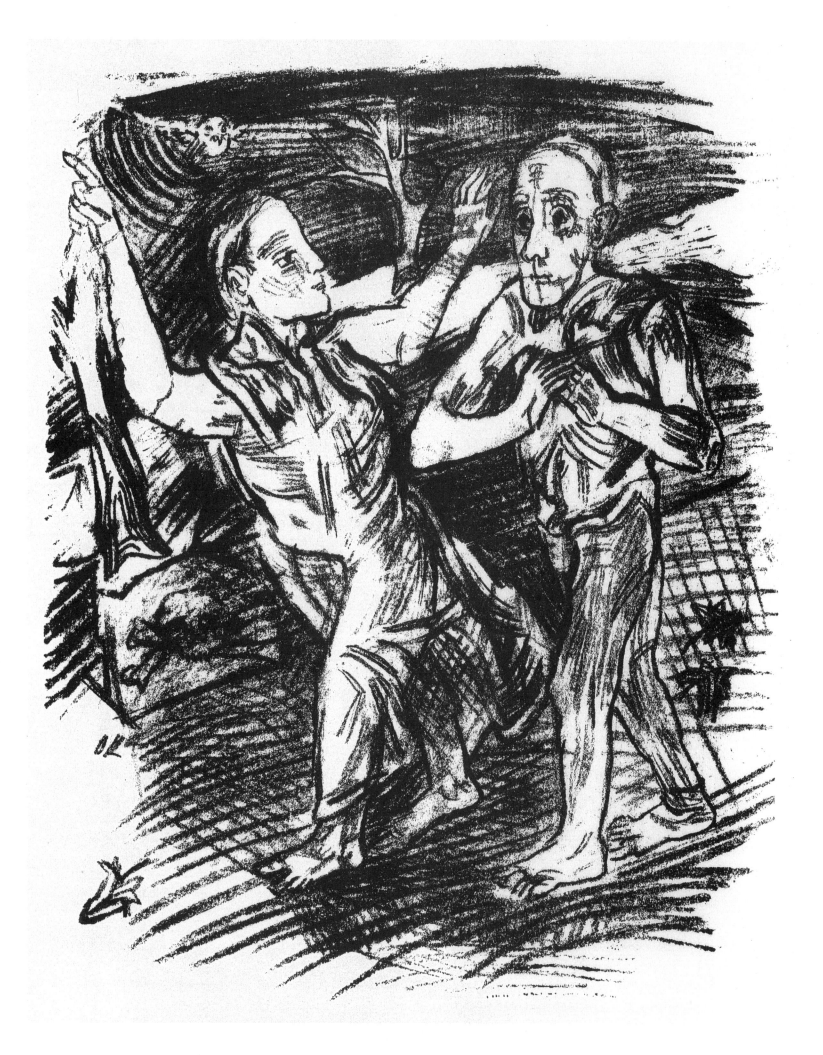

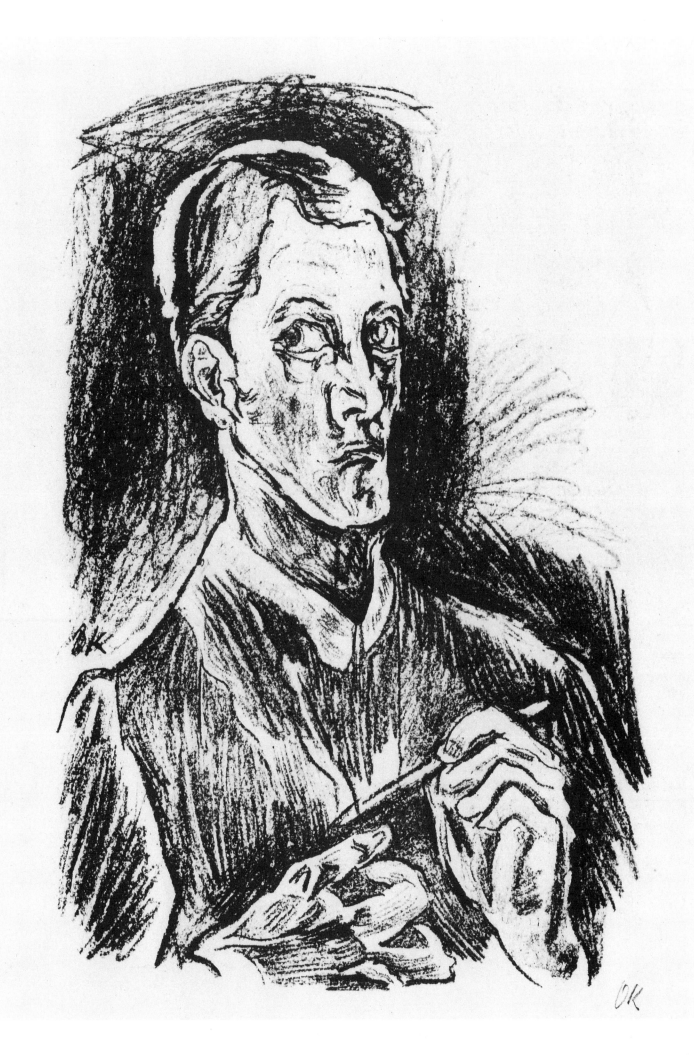

KARL SCHMIDT-ROTTLUFF

Self-Portrait, 1913
Self-Portrait I, 1914
Self-Portrait, 1916

KARL SCHMIDT (1884–1976), born in the village of Rottluff near Chemnitz (now Karl-Marx-Stadt), added the name of his birthplace soon after he decided to become an artist and realized that such a common family name was an avoidable obstacle to his achieving a reputation. He must have taken the decision early in 1905, when, as a student of architecture at the Dresden Polytechnic, he was introduced to two others from the same faculty, Ernst Ludwig Kirchner and Fritz Bleyl, by his friend Erich Heckel. They all wanted to be painters rather than architects or engineers. So did Karl Schmidt, and together they founded *Die Brücke*, abandoning their studies for a precarious existence as, initially at least, plainly inexperienced and immature artists.

Little of Kirchner's early work has been preserved, but what remains, together with contemporary work by Heckel, makes it clear that during the first year of the group's existence Schmidt-Rottluff was the most accomplished and advanced of all its members, both as a painter and printmaker. He produced the earliest pastiches of Van Gogh, which are even more vehement than the models on which they were based. Although heavily reliant on the example of *Jugendstil* (the German variety of Art Nouveau), his early woodcuts are technically impressive and exploit the kind of dramatic contrasts of black and white of which he later became a master.

Schmidt-Rottluff matured as a painter around 1910, by which time his landscapes, the subject in which he initially specialized, were distinguished by carefully structured areas of brilliant, flatly applied colour usually enclosed by heavy, dark contours. The effect is reminiscent of stained glass and contributes greatly to the beauty of what must be regarded as among the strongest examples of early Expressionism.

By the end of 1911 Schmidt-Rottluff was permanently based in Berlin, as were Kirchner, Heckel and Pechstein who had joined the *Brücke* in 1906. The initial, suffocatingly narrow and unrealistic aims of the group, which included the cultivation of a common style, had already loosened considerably, and in Berlin they loosened still more. Schmidt-Rottluff's work now departed even further from the styles being variously developed by his friends. In painting, his brilliant palette gave way to earth colours, and his forms became more rounded and less decorative.

These woodcut self-portraits, executed at the height of Schmidt-Rottluff's powers as a graphic artist, clearly exhibit his ability to make bold and direct statements in the least tractable of print media. The areas of imperfect cutting actually contribute to the expressive power of these images.

KARL SCHMIDT-ROTTLUFF
Male Head, 1917

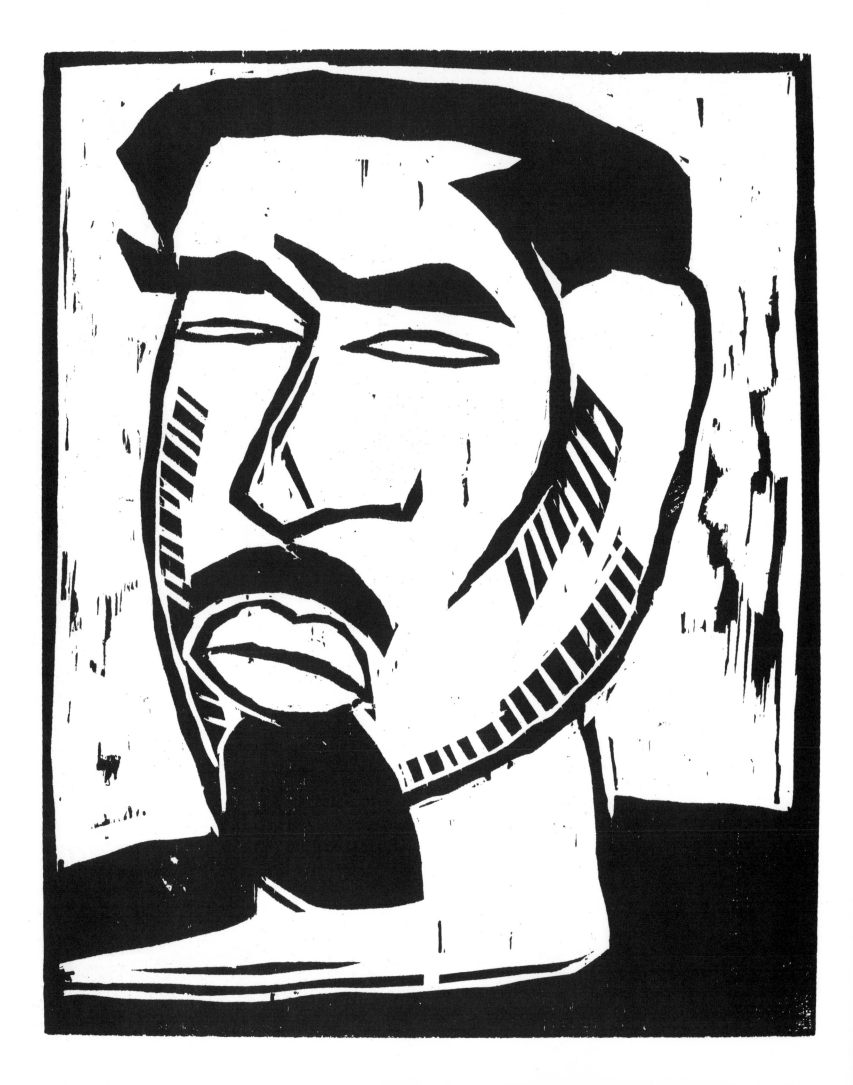

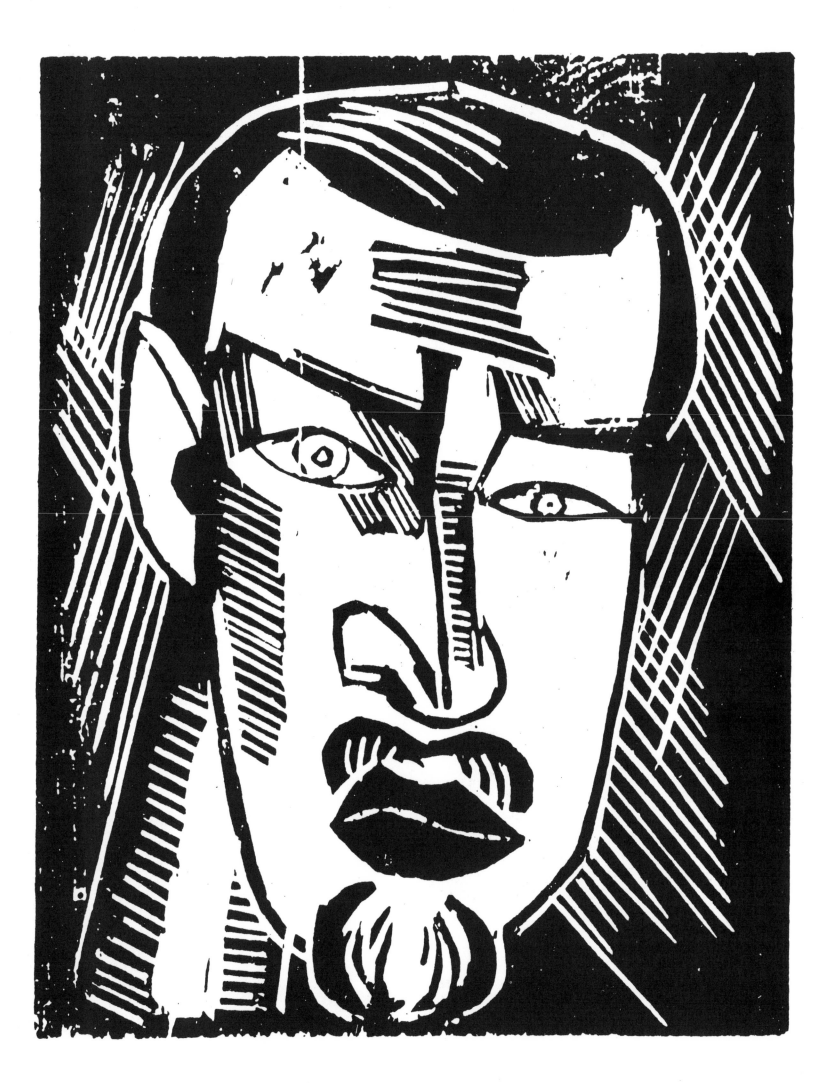

KARL SCHMIDT-ROTTLUFF

Self-Portrait, 1914

WHETHER OR NOT Kirchner discovered the attractions of primitive art as early as 1904, all the members of the *Brücke* were regular visitors to the ethnographic museum in Dresden, and their prints betray the influence of exotic art from 1906 at the latest. The idea of the primitive influenced their lifestyle, too, especially in the way they decorated their communal studio. All of them made carved wood sculptures in emulation of exotic originals.

Schmidt-Rottluff's work in this medium rivals Kirchner's. Apart from Kirchner, he was also the member of the *Brücke* who absorbed primitive influences with the greatest profit. Because Germany possessed more colonies in the Pacific than in Africa, its ethnographic collections were richer in Oceanic than African art. Yet Schmidt-Rottluff grew increasingly interested in African tribal carving, and this interest can be seen in both his sculpture and prints. It is especially clear in this splendid self-portrait woodcut, with its mask-like features represented by a few bold, massive strokes.

Although his first prints were lithographs, a technique which, together with etching and drypoint, he continued to use throughout his life, it was to the woodcut that Schmidt-Rottluff devoted most of his considerable energies. It was clearly his preferred graphic medium: of the five hundred or so prints he made more than three hundred are woodcuts. As well as portraits and self-portraits he also produced landscapes, figure compositions, and some memorable religious subjects inspired by his experiences during the First World War.

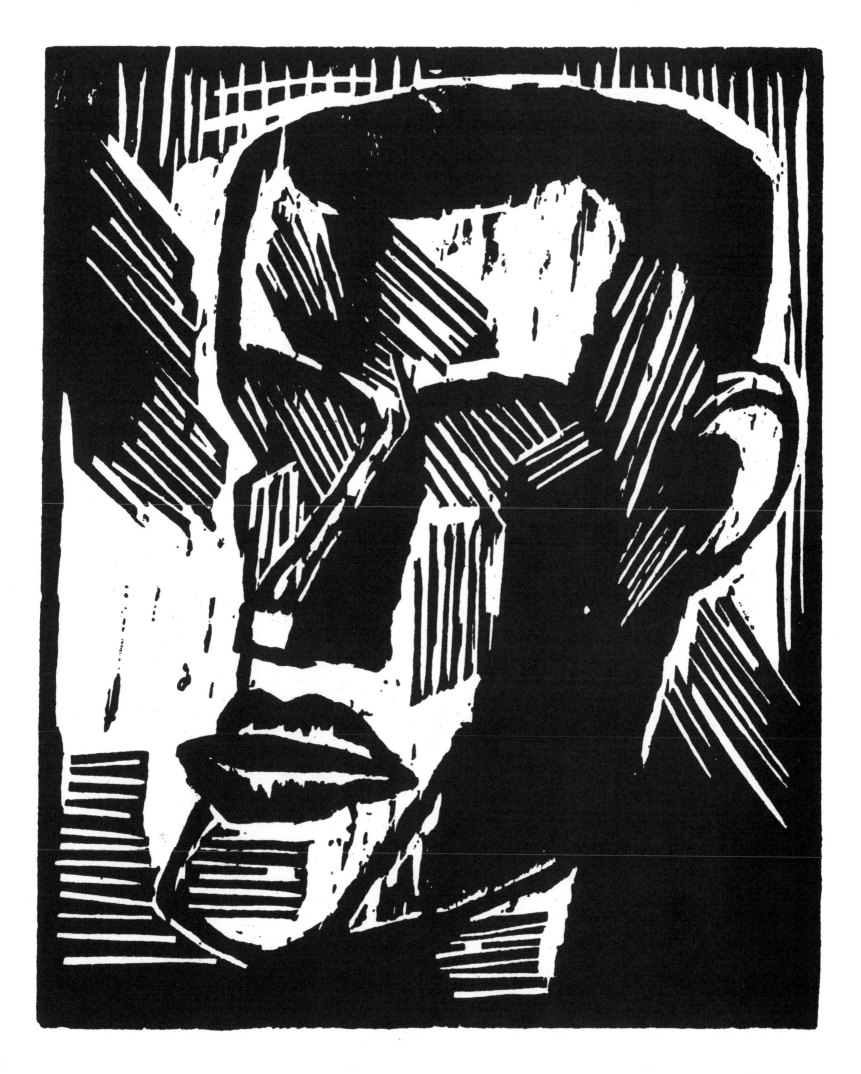

OTTO DIX

Self-Portrait in a Fragment of a Broken Mirror 1, 1915

'EXPERIENCE AT ANY PRICE . . . that is why I had to go to war. I also had to experience someone beside me suddenly falling over, dead, hit squarely by a bullet. I had to experience all of it quite exactly. I wanted to. After all, I'm not a pacifist, am I? Perhaps I am an inquisitive person. I had to see everything for myself. That's the kind of Realist I am, you know: I have to see everything with my own eyes in order to confirm that it's really like that. . . . You see, I'm just someone bound up with reality. . . . I have to experience for myself all the unfathomable depths of life; that's why I went to war and that's why I volunteered.'

And so the Faustian thirst for powerful experience drove Dix to war. With a copy of the Bible and Nietzsche's *Thus Spake Zarathustra* in his knapsack, Dix arrived at the front for the first time in the autumn of 1915. He might have had time to paint during the repeated *longueurs* of trench warfare, but the conditions in which he and his companions were forced to live were scarcely conducive to painting. So Dix drew. He drew the trenches, he drew his fellow soldiers and he drew scenes of horror and destruction. Among the drawings which he described as 'Reports from Hell' is a series of remarkable self-portraits which are by turns wry, mocking and grim. The most extraordinary of them are the two heavy chalk drawings which record the moment when, possibly shaving, he saw his face in a piece of broken mirror. The less detailed and consequently more remarkable is illustrated opposite. This rudimentary, schematic visage is like both a mask and a skull, simultaneously a *memento mori* and a reflection of the 'brave face' demanded by the trying circumstances in which Dix found himself. Trapped by the irregular, enclosing shape, it is also like a secular Veronica, an impression in sweat of the artist's suffering.

The second self-portrait illustrated here conveys a different, more ironic mood. It must have been made on the Russian front near Gorodniki, where Dix served in the summer and autumn of 1917.

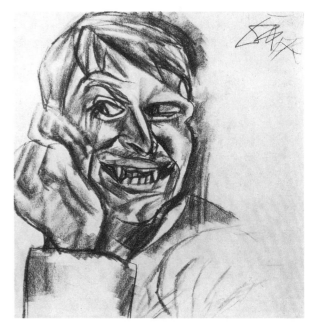

OTTO DIX
Self-Portrait, Grinning, Head on Hand, 1917

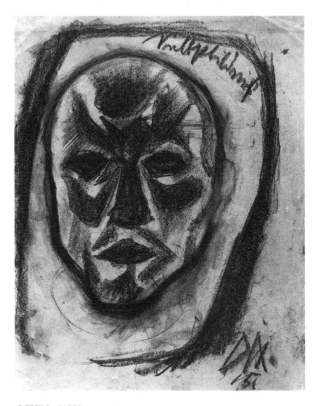

OTTO DIX
Self-Portrait, 1915

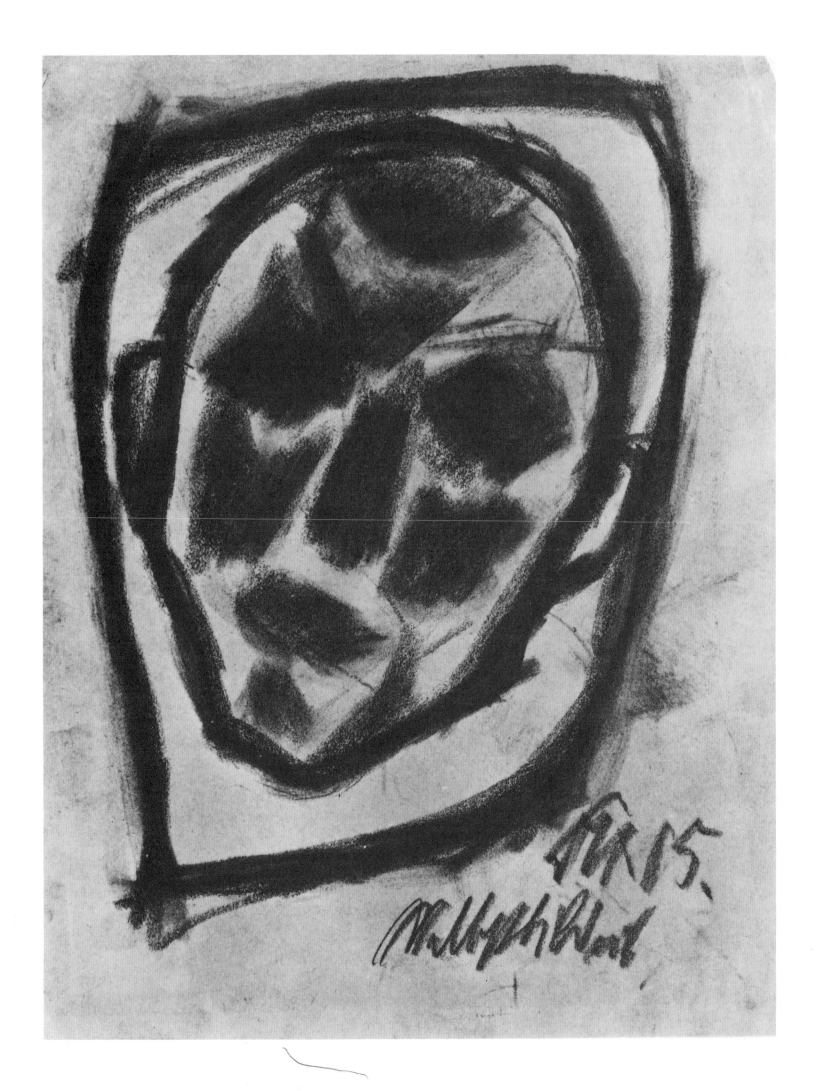

ERNST LUDWIG KIRCHNER

Self-Portrait, 1915
Head of the Sick Man (Self-Portrait), 1917
Self-Portrait under the Influence of Morphine, 1917

As TESTIMONY TO THE spiritual decline and crisis of personality which Kirchner experienced after he was invalided out of the army in 1915, these three self-portraits are almost unbearably eloquent.

In the first, a drawing, he stares warily out at the spectator, deeply injured, tired but by no means vanquished and still confident of his identity. Executed at about the same time as *The Drinker* (p. 38), it is also roughly contemporary to the illustrations Kirchner made for Chamisso's *Peter Schlemihl*, which the artist, obviously thinking of himself, later described as 'the life-story of a paranoiac, that is to say of someone whom some event or other makes aware of his own infinite smallness.'

By 1917, Kirchner was heavily, and increasingly, dependent on alcohol and other drugs. Having been treated in a sanatorium at Königswald in Germany for a psychosomatic partial paralysis whose nature was never satisfactorily diagnosed, and dosed with narcotics in the hope of suppressing suicidal tendencies, he went to Davos in Switzerland for further treatment. Despairing, irresolute, he soon returned to Berlin where in March 1917 his friend and patron Eberhard Grisebach visited him: 'He sat in a very low armchair beside a small, hot stove in a sloping, yellow-painted attic. Only with difficulty, and aided by a stick, could he stand up and totter across the room.'

It was probably in Davos, where Kirchner returned in May for treatment, that the second image, a woodcut, and the morphine-drawing were made. Each speaks in a different way of the misery that this egocentric, once arrogant and now self-pitying artist was enduring. The woodcut makes him look like some scrofulous vagrant at the end of his tether, while the drawing, one of the most disturbing images made in this century, is nothing less than horrific. It was made, as Kirchner admitted, at a moment of the greatest influence [of the drug] "unconsciously" . . . without my knowing anything about it, so that I was surprised when, awakened by something or another, I found new works lying around me.'

It seems to be characteristic of the mechanisms of inspiration in Expressionist art that they operate best at unrepeatable moments of crisis, when conscious control is undermined by extremes of experience. Kirchner, like many others, produced his best work during the First World War, when he was mentally and emotionally at his least stable. Only after the war was over and Kirchner was released from the threat of renewed mobilization did his condition dramatically improve. He lived on, but felt increasingly oppressed by what he perceived as onslaughts on his reputation, both in Germany and elsewhere. In 1938, aware of what was happening to his art at the hands of the Nazis, he took his own life.

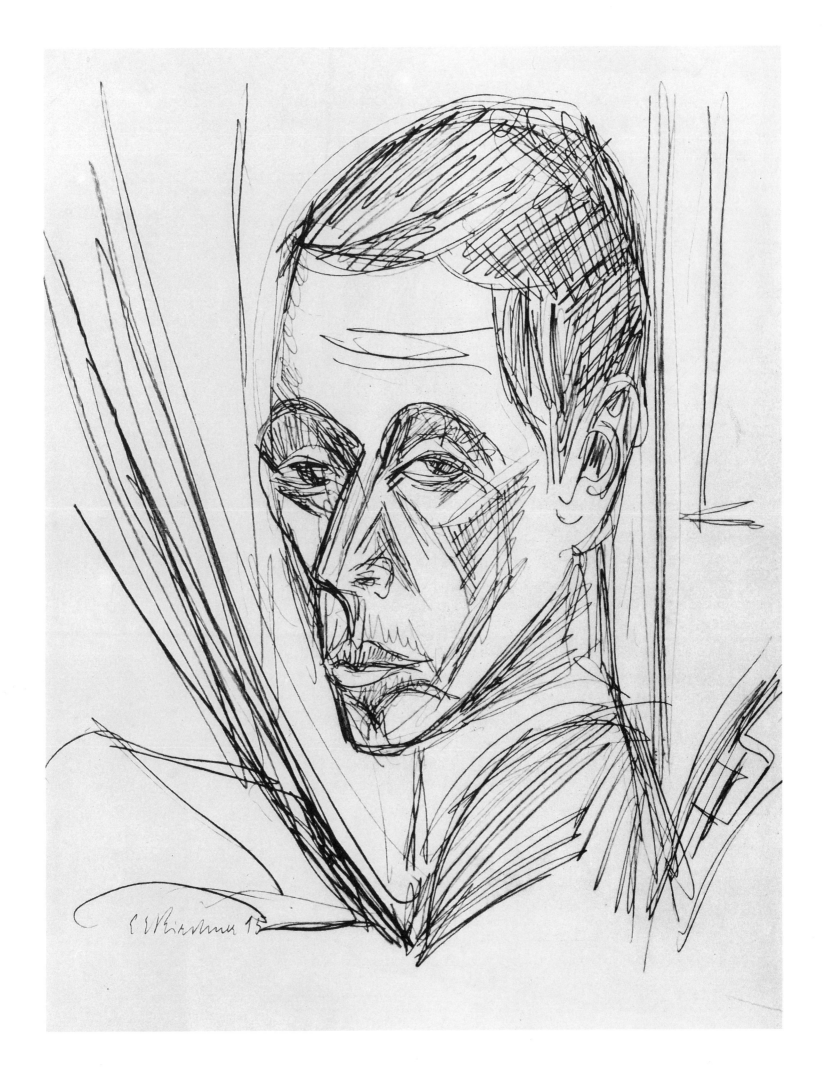

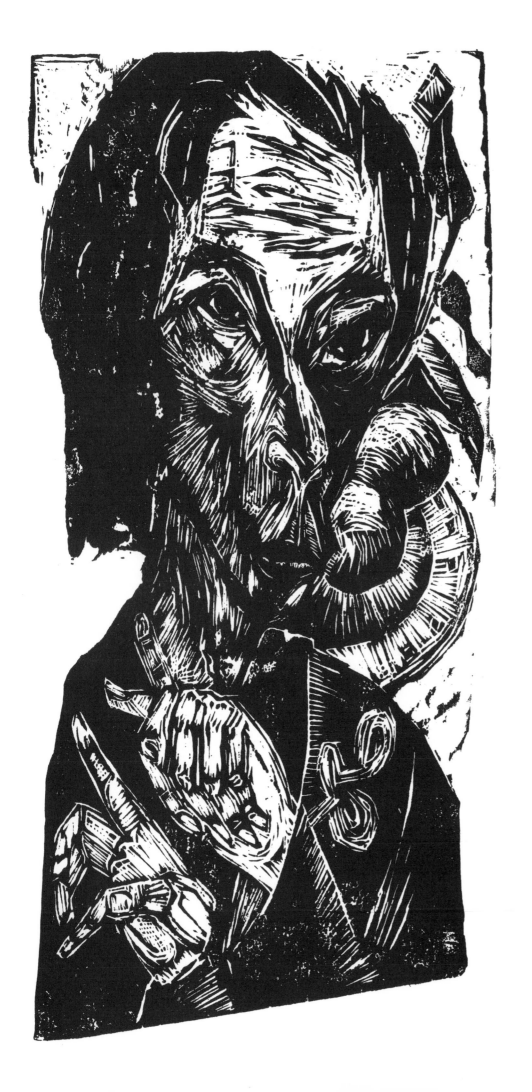

LUDWIG MEIDNER

Self-Portrait, 1916

MEIDNER DREW AND PAINTED HIMSELF with a frequency and fascination for his own changing moods and features unusual even in the company of such obsessive self-portraitists as Kirchner, Kokoschka and Beckmann. From works of every period he stares out at us, ugly, questioning, exulting, wry, melancholic, waiting for inspiration. The emotion is never the same; as in caricature, it is expressed by an exaggerated use of line, by bold contrasts and by special emphasis on eyes, mouth and hands. Here, in what is the most remarkable of his self-portrait drawings, he is apprehensive, as though staring at the source of his visions in anticipation of a revelation.

Meidner was in many ways the archetypal Expressionist, not least in his versatility. Closer to poets and writers than to painters (although he was the centre of an enormous circle of artists in Berlin), he was himself an extraordinarily gifted writer, producing prose poems whose ecstatic, exaggerated and rhythmic language is always memorable if not intelligible. He would have liked to be a more conventional poet: 'I always loved poetry but I couldn't rhyme. It was only enough for prose, be it said for poetic prose.' That poetic prose puts Meidner in the ranks of the very best Expressionist writers.

One of the most interesting of Meidner's prose poems is *Im Nacken das Sternemeer*, a title which might be translated as 'The Sea of Stars at my Heels'. This self-portrait, in pen and ink over chalk, was made as one of the illustrations for it. Here is a relatively sober and straightforward passage, one in which translation can capture at least a little of the flavour of Meidner's writing; it is also, appropriately enough, about the art of drawing: 'We have loved drawing from way back, we stupid, playful, laughing humans. From the first charming stammerings of primitive people to Kokoschka and Hermann Huber; from Raphael's disciplined style to the pornographic doodles on our piss-house walls. Drawing makes you happy, healthy, and a believer. I'm always alone. No girl loves me. No woman wants to sleep with me. No friend wants to be with me. I have no home, no country, am poor, outlawed and much hated . . . but I can draw, freely swing here and there . . . and I rejoice with the pencil, sing, pray and praise the Great Almighty.'

LUDWIG MEIDNER
Self-Portrait, 1926

CONRAD FELIXMÜLLER

Self-Portrait, 1919

IN 1971 FELIXMÜLLER wrote down some of his memories for the director of the Lindenau museum, where several of his best paintings are preserved (see, for example, the portrait of Raoul Hausmann, p. 137).

'In 1916 *Die Aktion* began to print contributions from me, and with lectures and guided tours of the first Expressionist exhibitions at the Galerie Arnold in Dresden, as well as exhibitions of my own work, I was the most active artist in Dresden. My *Postulat* [demand] about the inner motives behind the new painting was circulated in countless cyclostyled copies in 1917. . . . When the revolution began in November 1918 I thought . . . that an organized group of artists actively involved in public artistic life was necessary. I therefore invited to a "founding meeting" several young painters who, to me, seemed "progressive". Shortly before I had seen some hard-edged watercolours in the foyer of the E. Richter Gallery which had been taken there by an unknown called Otto Dix, just released from the army. . . . I went directly to him; in his unheated room I looked at a few pictures he was working on. . . . In view of my radically pacifist outlook we had a conversation about the final ending of that insane blood-bath.'

The group that Felixmüller founded in 1919 was the 'Dresden New Secession', and he made it clear to the artists he invited to join that it was 'necessary to be organized in the politically most determined party, the C.P.' Most of them refused for a variety of reasons, among them Otto Dix who, according to Felixmüller, told him: 'Stop bothering me with your stupid politics – I'd rather go to the whorehouse.' Only Konstantin Mitschke-Collande joined the Communist Party, and Felixmüller failed not only to make his group politically influential but also to make it artistically vital, largely because it consisted of artists for whom Expressionism, especially of the radically political variety, seemed increasingly irrelevant.

What Felixmüller achieved before 1925 – and this dramatic woodcut is a fine example of it – justifies a place in the highest rank of Expressionist artists. His lack of reputation outside East Germany is curious, only partly explained by his decision to remain in the Soviet Zone after the Second World War. Not until 1967, several years after his retirement as Professor at the University of Halle, did he move for family reasons to West Berlin, where he died in 1977.

ERICH HECKEL

Self-Portrait (Cover of 'Der Anbruch'), 1919

'AND SO ONE DAY a young man without collar or hat and loudly reciting from Zarathustra came up my stairs and introduced himself as Erich Heckel.'

Thus Kirchner remembered his first meeting in 1904 with one of the three fellow students with whom he would found *Die Brücke*. Heckel (1883–1970) was three years younger than Kirchner, began his studies later and was made aware of Kirchner and his similar interest in art by his older brother. At school in Chemnitz (now Karl-Marx-Stadt), Heckel had become the close friend of Karl Schmidt(-Rottluff), who joined him in the architecture department of the Dresden Polytechnic at the beginning of 1905. Fritz Bleyl, another student of architecture, had been Kirchner's friend since 1901 and was the fourth of those who in 1905 founded *Die Brücke*.

Since Kirchner was the only one of the four to have had any formal training in art (other than the freehand drawing classes they all had to take as part of their training as architects), and that only for a few months at an experimental, private art school in Munich, the aim of the *Brücke* – to renew German art – was somewhat optimistic. Perhaps the lack of conventional training proved of advantage to artists determined to be unconventional. Certainly they were able to respond without prejudice to the relatively new art from France that was just beginning to impinge on the general consciousness. They were almost the first German artists to do so, and within the space of four years they fashioned their own style out of what they had learned from Seurat, Gauguin and, especially, Van Gogh.

Heckel's self-portrait is in the woodcut technique that all the *Brücke* artists quickly mastered, with its appropriate echoes of primitiveness (Gauguin) and German-ness (Dürer). The work was executed long after the heroic days of the group, six years after it finally disintegrated in Berlin. Like Kirchner, Heckel was profoundly affected by life in the capital, where his paintings and prints became more sober in both style and subject-matter. Unlike Kirchner, however, who managed to sustain the power of his early work well beyond the end of the First World War, Heckel was unable to prevent an early decline.

Der Anbruch, a word which carries thoroughly Expressionist overtones of a new beginning, a new dawn, was one of a bewildering number of little magazines which made their first appearance in Germany between 1917 and 1923. It looked like a broadsheet and combined Expressionist poetry, prose and graphics made especially for it. The second and third volumes (of which this is the first issue) were published by I. B. Neumann's Berlin gallery, which specialized in prints. Heckel was one of the many artists on his books.

KARL SCHMIDT-ROTTLUFF
Erich Heckel

DERANBRUCH

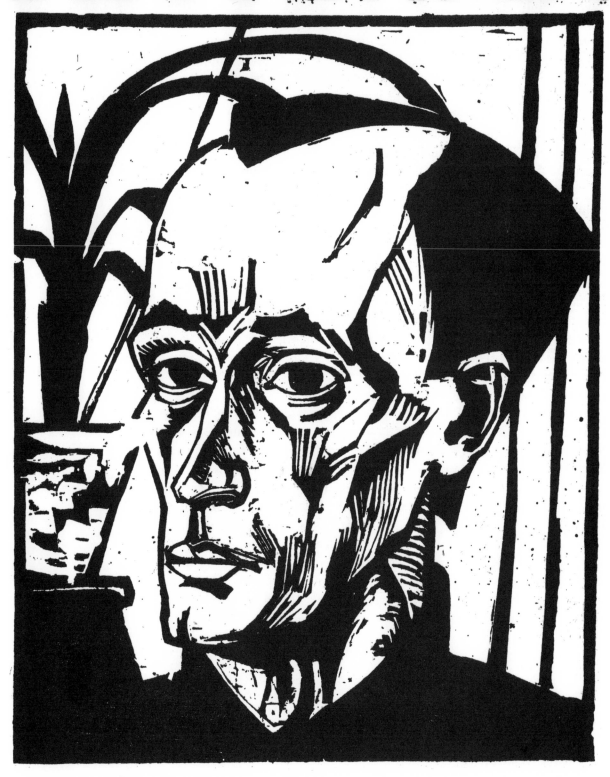

MAX BECKMANN

The Family, 1919
The Barker (Self-Portrait), 1921
Self-Portrait, 1922

THROUGHOUT HIS LIFE, Beckmann portrayed himself in every medium. He appears alone and with each of his two wives, by turns confident and troubled by doubt. He plays both leading and subsidiary roles in mythologies of his own invention which present human life as a drama, a sideshow, and an insoluble riddle.

Beckmann put himself into as many prints as paintings. *The Family* shows him together with Frau Minna Tube, his first wife's mother, and his son Peter. The gestures of all three are theatrical. Beckmann points prophetically outwards; his mother-in-law adopts a defensive pose; the boy, in a soldier's helmet, gleefully holds up a brace of hand-grenades.

This print belongs to a portfolio of lithographs entitled *Hell*. The subjects – which include disfigured war veterans, riots and a version of the powerful painting *Night* (Kunstsammlung Rheinland-Westfalen, Düsseldorf) – are a response to the aftermath of the First World War in Berlin, where Beckmann was recovering from a wartime breakdown. There, the abortive but bloody revolution of 1918–19 and the visible effects of the defeat (the racketeering, the crippled beggars on the street, the desperately predatory whores) assumed, for the sensitive observer, the aspect of the Apocalypse.

Beckmann moves here, as so often, from the specific and personal to the general and allegorical. One day the boy Peter, playing in the street, found what he thought were two tins of food, truly a treasure in those days of acute deprivation. He proudly bore them home, only to find that they were grenades. His father exploits the symbolic potential of the event by eliminating the consequent panic and alarm. As Peter Beckmann himself wrote: 'The scene is transformed into a demonstration of resistance against the principle of war, battle and weapons.'

The Barker is the first of the series of ten etchings which make up *The Fair*. Beckmann portrays himself as the seedy huckster outside the tent, ringing his bell to attract the crowds. But this barker is also the proprietor of the circus: the animals and the human performers exist in a world which is his creation.

Beckmann produced few woodcuts, and among them only one self-portrait. Because the technique of cutting directly into a block of wood allows for no errors or changes of mind, the artist needs to summon up all his confidence before beginning work. That confidence is mirrored here by the face itself, its mouth set firm, its gaze determined; yet the solid black of the eyes suggests a mask, or an enigmatic personality. Constantly, Beckmann presents himself with an apparent self-assurance which close inspection reveals to be a façade. Behind it are pain and puzzlement.

MAX BECKMANN
Self-Portrait in Bowler Hat, 1921

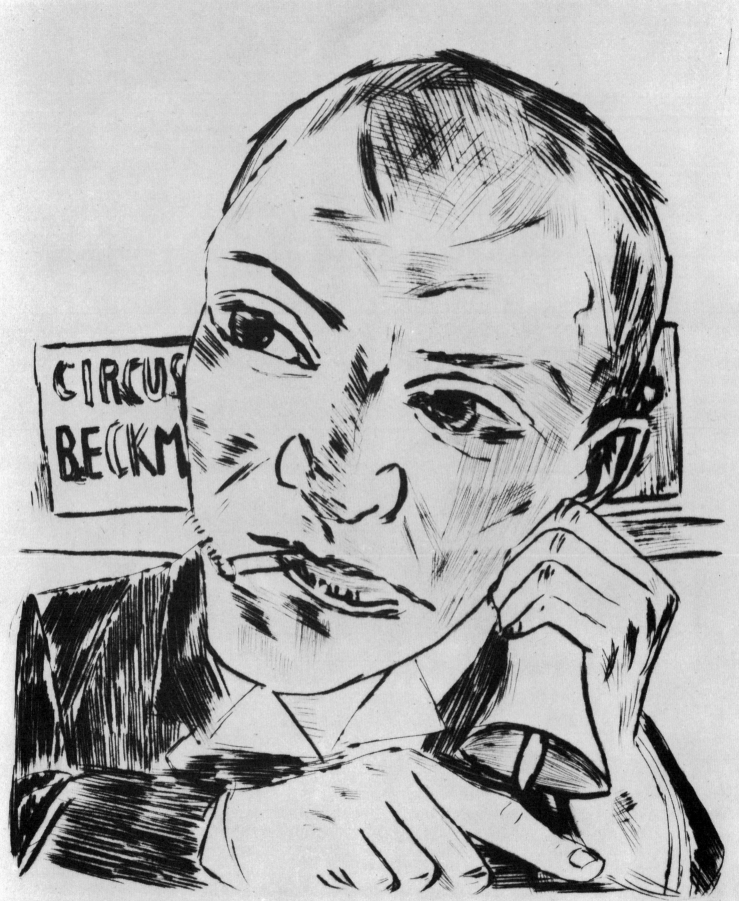

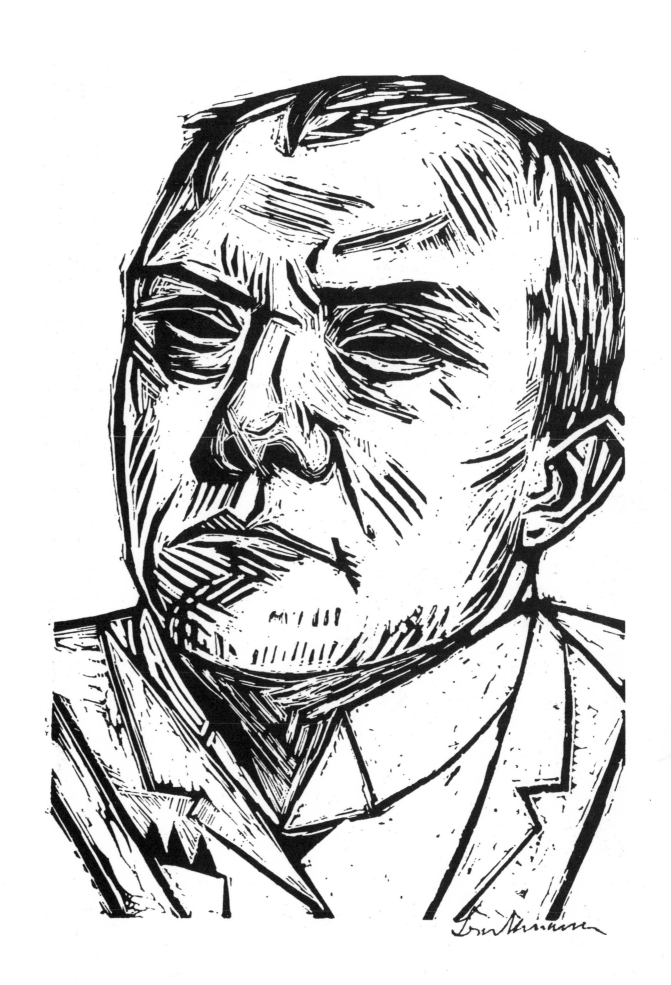

MAX PECHSTEIN

Self-Portrait (The Artist in his Studio), 1922

KIRCHNER AND HIS FRIENDS first became aware of Pechstein (1881–1955) in 1906, when he was regarded as one of the most able students at the Art Academy in Dresden. He had been commissioned to paint murals in a public building in the city. One of these decorative schemes employed colours that were too bright for the authorities. 'When I went there before the opening,' Pechstein remembered, 'I noticed to my fury that someone had toned down the fiery red with grey splashes, had made it sober, brought it into line with normal tastes . . .' He protested loudly and suddenly realized that 'someone was standing beside me, supporting me in my complaints'. It was Erich Heckel. Shortly after that, Pechstein was invited to join *Die Brücke*.

Thanks no doubt to his academic training, Pechstein was the first of the *Brücke* artists to achieve an individual voice. His early pastiches of Van Gogh are assured and controlled. He was the first, moreover, to visit Paris and see what artists there were doing under the influence of the same Post-Impressionist masters on whom the *Brücke* based its early style. He remained in Paris until the summer of 1908, met several artists from the circle around Matisse – among them the German Hans Purrmann and the Dutchman Kees van Dongen – and softened his style. When he returned to Germany it was not to Dresden and the provinces but to Berlin.

The success which Pechstein almost instantly enjoyed in the capital made Kirchner jealous. He suspected Pechstein of trimming his style to the wind of popular taste; but while it is true that Pechstein's style was never as intentionally coarse and brutal as that of the other *Brücke* painters (or, indeed, as original), it was certainly never bland, either. Kirchner was anxious lest it be thought that *Brücke* painting was merely an inept imitation of Fauvism: he always strenuously, if unconvincingly, denied that Pechstein had brought back from Paris detailed information about the most recent developments in France. While Pechstein flourished (by 1909 he was regarded as the leading young artist in Berlin), Kirchner's jealousy grew, and in 1912 he took it upon himself to expel him from the *Brücke*.

Like all the other artists of the *Brücke*, Pechstein was fascinated and influenced by primitive art, especially that of Oceania where Germany had colonies. In 1913, he realized his dreams of emulating Gauguin and went to live on the island of Palau in the Bismarck Archipelago. There he enjoyed a brief idyll, rudely interrupted by the Japanese who invaded the German territory in 1914 and forced Pechstein to return home via the United States. This woodcut, executed after Pechstein's return, service in the army and a period during the revolution as a political artist, speaks clearly of his interest in exotic cultures.

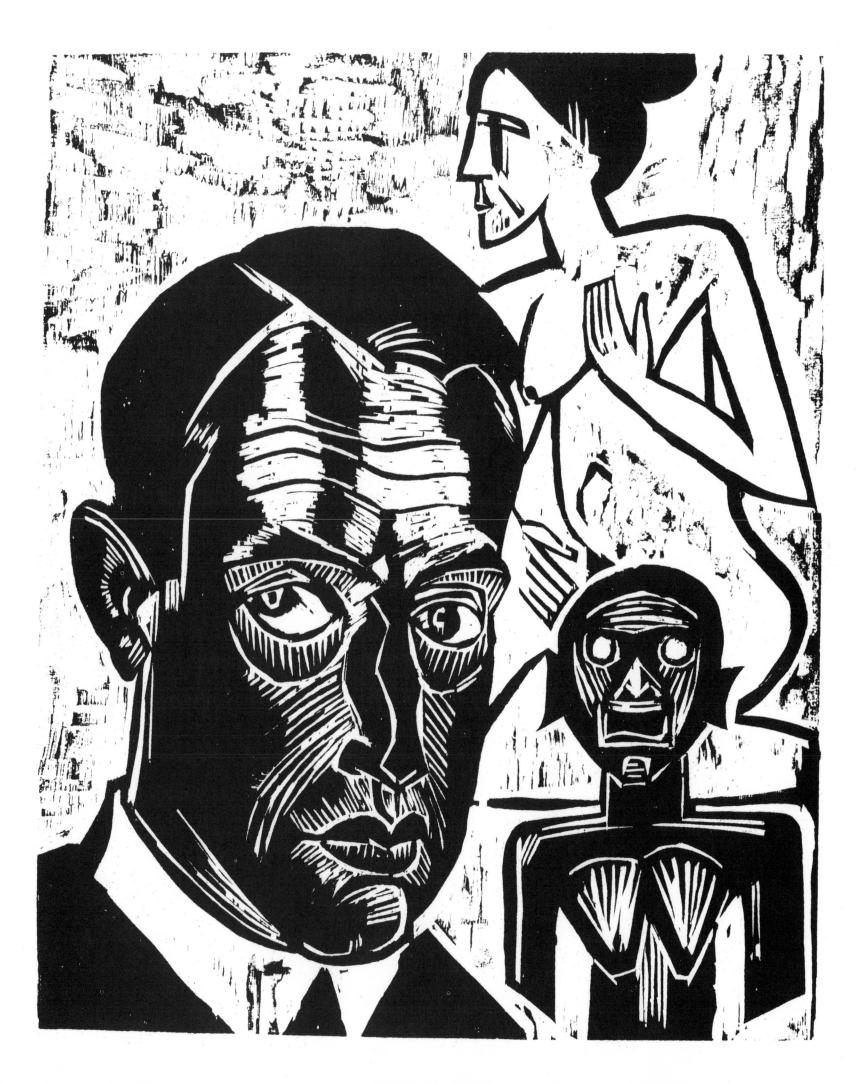

PAULA MODERSOHN-BECKER

Rainer Maria Rilke, 1906

RILKE (1875–1926) was one of the most important early modernist poets and prose writers in German, a polished stylist whose best-known works are probably the *Duino Elegies* and *The Notebooks of Malte Laurids Brigge*. He was also deeply interested in the visual arts, an interest which took him in 1900 to the artists' colony in the village of Worpswede near Bremen.

Rilke, who published a short memoir of life among the artists in retreat from city life and academic attitudes (*Worpswede*) in 1903, wanted to participate in the communal style of living and enjoy the solitude. The painters and sculptors in the colony were pleased to have writers among them: the great Naturalist playwright Gerhart Hauptmann was a frequent visitor. They were as pleased to have young women as their students in their midst, and two of these were to play important rôles in Rilke's life. The first was Clara Westhoff, whom he married soon after his arrival at Worpswede. The second was her best friend Paula Becker, who in 1901 married Otto Modersohn, one of the three founders of the colony.

Clara Westhoff had been a pupil of Rodin in Paris, and it was through her that Rilke met Rodin and became his secretary. By the time Rilke moved to Paris, however, he was no longer living with Clara: they parted amicably after less than a year together. Paula maintained contact with Rilke and learned much from him about art in Paris. She visited him there in 1903, 1905 and 1906, torn between her admiration for the metropolitan poet and her love for Otto Modersohn, the worthy but dull provincial painter.

This enigmatic portrait, more like a picture of a doll than a human being, may have been painted during one of those visits to Paris. It betrays the influence of several of the French painters she (and Rilke) admired: Gauguin, the Nabis and, not least, Cézanne. Such an understanding of contemporary developments in France, combined with the ability to assimilate them into a personal style, was unique in Germany at the time.

In 1907 Modersohn-Becker longed to go to Paris to see the great posthumous Cézanne exhibition at the Salon d'Automne. Pregnancy prevented the visit, so she wrote to Rilke asking for the catalogue. Three weeks after giving birth to her only child, a daughter, she died of a heart attack.

In 1909 Rilke published a long poem, a 'requiem' for a friend whose gifts he was the first fully to appreciate. The poem includes the following passage:

. . . the full fruits.
You laid them on dishes before you
and calculated their weight with colours.
And as you perceived fruit so, too, did you see women
and also children, from within
grown into the forms of their existence.
And finally you saw yourself as like a fruit,
naked, before the mirror . . .
saying nothing: that is I; No: this is.

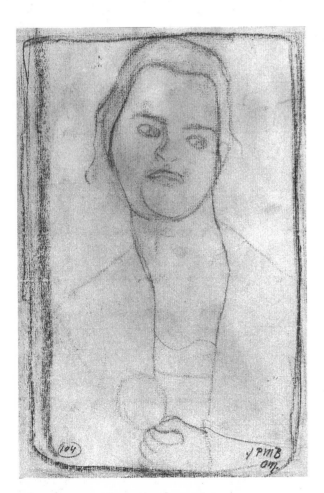

2
THE ARTIST'S WORLD

PAULA MODERSOHN-BECKER
Sketch for Portrait of Clara Rilke-Westhoff, 1905

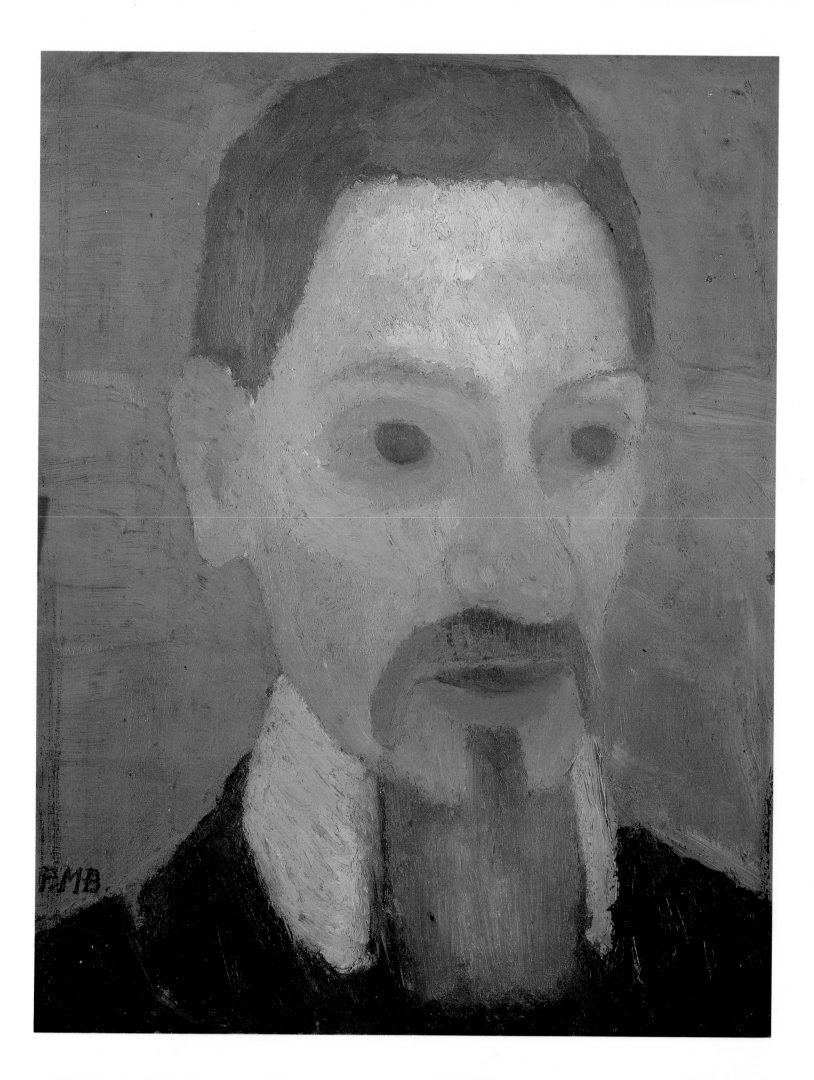

RICHARD GERSTL

Portrait of Arnold Schoenberg, 1905?

By COMPARISON with Gerstl's group portrait of Schoenberg with his family, in which the features of the sitters disappear in a blizzard of high-key paint, this likeness is restrained in execution and conventional in conception. Since Gerstl never signed anything or kept any records we cannot trace his brief and spectacular development with any precision, but this portrait is plainly earlier than the self-portrait of 1908 (page 35), and must have been executed soon after the painter met the composer in 1905. Gerstl was still a student then, rebelling against the reactionary attitudes of that same Professor Griepenkerl, at the Vienna Academy, who was later to persecute another gifted student, Egon Schiele.

Although Gerstl adopts a relatively conservative approach in this portrait, Schoenberg's claim, put down in his journal, that when he first saw Gerstl's pictures 'his ideal was Liebermann', is surely misleading. Far from looking back to Max Liebermann (1847–1935), the leading German follower of the Impressionists, the urgent brushwork and assertive pose in this portrait look forward to the moment when, lacking all models and precedents, Gerstl became not merely one of the earliest, but also one of the most extreme and convincing Expressionists.

Gerstl, who was passionately interested in music, first tried to make the acquaintance of Mahler, and when Mahler refused to sit for his portrait Gerstl contrived to meet Schoenberg at a concert of Mahler's music in Vienna. By 1907 he had become an intimate of the family, according to some living in the same house, to others in the same street.

RICHARD GERSTL
The Schoenberg Family, *c.* 1907

Irascible and difficult though he was, Gerstl shared a great deal with Schoenberg, not least the conviction that they were both revolutionary artists swimming against the tide of public hostility and ignorance. But Gerstl could have done something to stem the tide. He was asked to participate in an exhibition at the Miethke, the only private gallery in Vienna specializing in contemporary art; he refused this opportunity to present his work to the public simply because it would have meant exhibiting with Gustav Klimt of whom he disapproved.

Since 1905 the Schoenbergs had spent the summer months at Traunstein near Gmunden, and in 1907 and 1908 Gerstl stayed with them. Unknown to the composer, Gerstl was having an affair with Mathilde, his wife. In 1908 at Traunstein Schoenberg discovered them *in flagrante*, after which they hurried back to Vienna intending to live together. This took Schoenberg to the brink of suicide. But it was Gerstl who killed himself, after Schoenberg's friend and pupil Anton von Webern persuaded Mathilde to return to her husband and children.

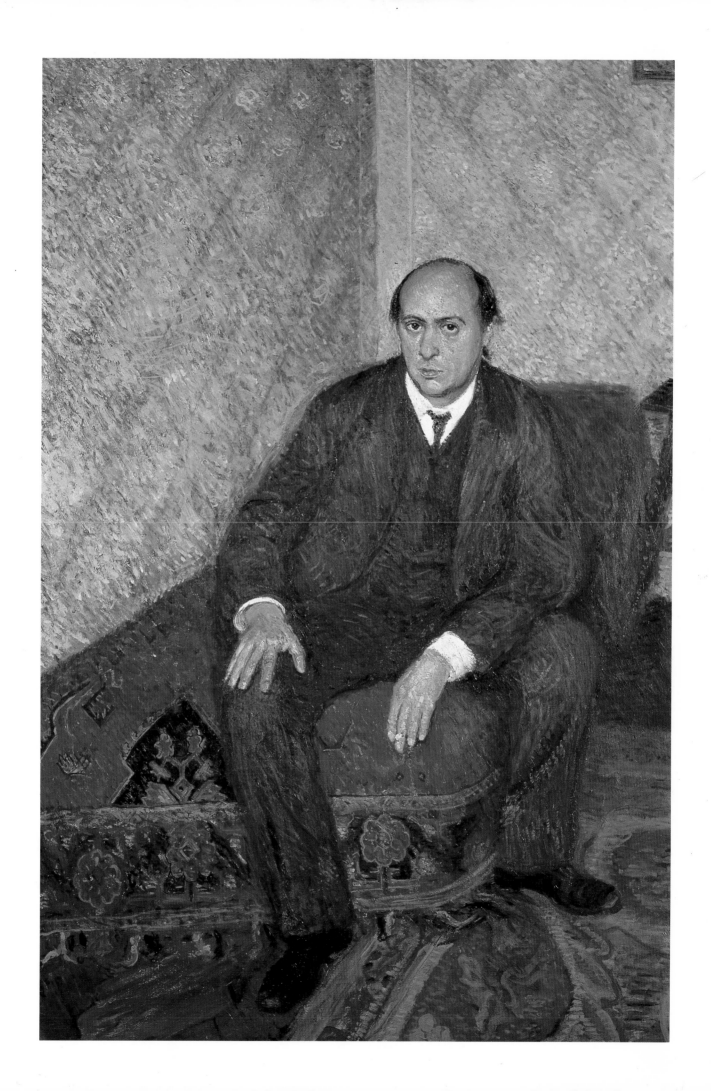

ERNST LUDWIG KIRCHNER

Erich Heckel at the Easel, 1907

THE ARTISTS OF THE *Brücke* drew and painted each other so often, not because they were the most patient and understanding models available, but because such portraits were an expression of the group's identity. Unlike the *Blaue Reiter* (Blue Rider) of Munich (which was nothing more than the name given to a book, two exhibitions and the artists associated with them), the *Brücke* was truly a group – to the point almost of suffocation.

To begin with, their intention was to live and work together in emulation of a medieval guild. They were determined that members should only ever exhibit with the group and that the group should never participate in mixed exhibitions. They also resolved to strive for a group style so coherent that the hand of individual members could not longer be discerned. They did acquire a communal studio, which they decorated with hand-painted drapes and crudely carved furniture, and where they worked together, most often painting or drawing the same model; but in spite of great similarities between their early works (and the occasional piece of collaborative painting) they never quite managed to produce, or even honestly to want, a communal style.

This portrait clearly betrays the influence of Van Gogh, whose bright colours and bold, rhythmic brushwork made an enormous impression on all the *Brücke* artists when they first saw fifty of his paintings at an exhibition at the Galerie Arnold in Dresden in November 1905. With varying degrees of success, all of them imitated and attempted to go beyond Van Gogh's late and most expressive style, and traces of the Dutchman's tenacious influence can be seen in *Brücke* work five years later.

This portrait, which makes Heckel look much older than the twenty-four he was at the time, may have been executed during a visit Heckel made to the village of Goppeln south of Dresden where Kirchner and Pechstein spent the summer of 1907. Every year they were accustomed to move to the country, although they did not all go to the same place. In 1907 Heckel was at Dangast near Oldenburg with Schmidt-Rottluff.

Once Bleyl had formally resigned from the *Brücke* in 1907 to work as a teacher of architecture, Heckel became Kirchner's closest friend, and they remained relatively close even after the recrimination and rancour surrounding the dissolution of the *Brücke* in 1913 had soured Kirchner's relationship with everyone else.

MAX PECHSTEIN
Erich Heckel, 1908

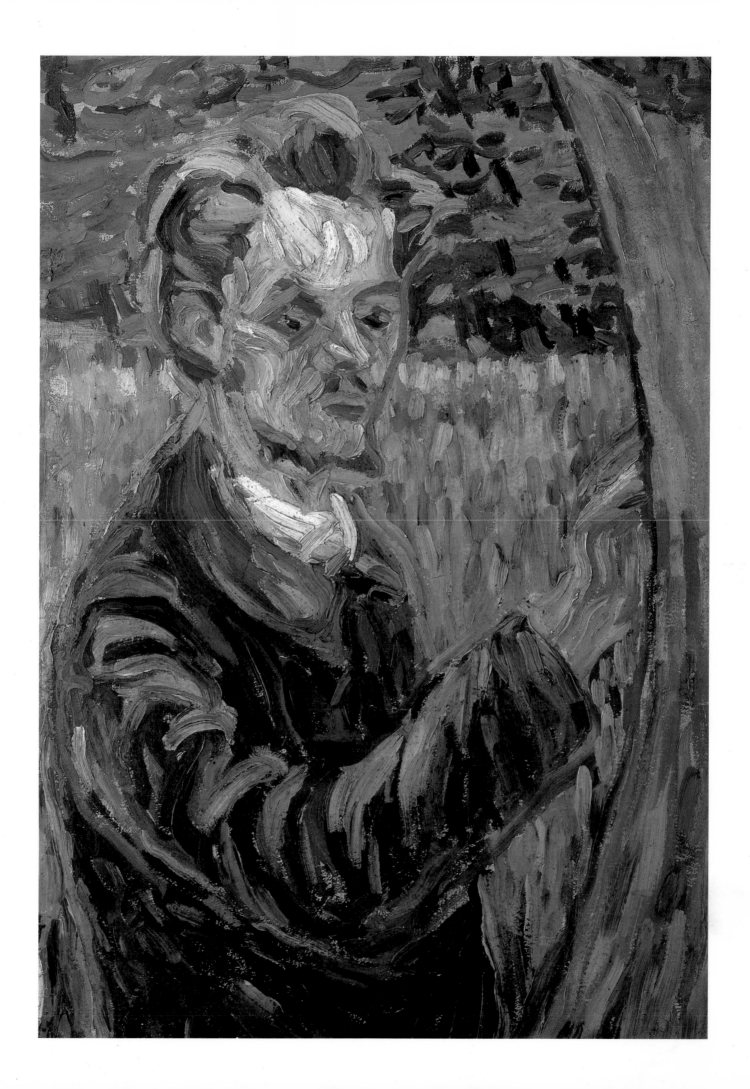

ERNST LUDWIG KIRCHNER

A Group of Artists: Otto Mueller, Kirchner, Heckel, Schmidt-Rottluff, 1926–27

CONVINCED of the historical importance of his art, jealous of the success of his contemporaries and anxious to be judged a radical innovator by future generations, Kirchner spared no effort in his attempt to have the world share his own estimate of himself.

He was justified in regarding himself as the major talent among the artists of the *Brücke*, the group he helped found in 1905, but he was loath to concede the merit of any of his fellow members, and became increasingly vehement in his entirely unjustified denunciations of their plagiarism.

In spite of Kirchner's growing paranoia (it is not too strong a word), the group held together as long as most of its members remained in Dresden and in daily touch with each other. But by 1911 when all of them had moved to Berlin there was little left of the original spirit and identity of aims. When Kirchner wrote, cut in wood and wanted to publish a brief 'History of the *Brücke*' (*Chronik der Brücke*) in 1913, the others rebelled. They had already endured enough, and now they saw themselves presented to posterity as minor planets revolving around a blindingly brilliant sun. The group was dissolved, and Kirchner found himself virtually friendless.

This monumental composition, begun in the year when Kirchner returned to Germany from Switzerland and visited his former haunts, must be seen as part of his uninterrupted propaganda campaign waged in order to establish his version of history. It shows from left to right Otto Mueller (1874–1930), the last painter to join the group, Kirchner himself (who emerges from behind a curtain emphatically to present the *Chronik* to his fellow members), Heckel and Schmidt-Rottluff. This was the membership at the time of the *Brücke*' dissolution. It is perhaps understandable that Kirchner chose to omit the founder-member Fritz Bleyl because he had resigned almost at once in order to make a living. The absence of Nolde (a member for only eighteen months), of the Swiss painter Cuno Amiet and of the Finn Akseli Gallén-Kallela may also be justified, since none of them fully participated in group activities. But the omission of Pechstein is another matter. He went early to Paris and was the first *Brücke* painter to see Fauve painting in the original and be influenced by it. Unlike Kirchner, he never sought to cover up the obvious affinities between the French style and the work of the *Brücke*. Worse still, Pechstein was both critically and financially successful earlier than Kirchner.

In spite of the complex and fraught psychological background to this painting, its composition is handsome. Kirchner himself regarded it as an important work of its period. When the picture was bought by the Nationalgalerie in Berlin, he noted the fact in his diary.

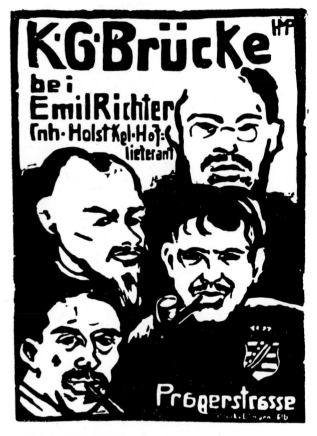

MAX PECHSTEIN
Poster for *Die Brücke* Exhibition at Galerie Emil Richter, Dresden 1909

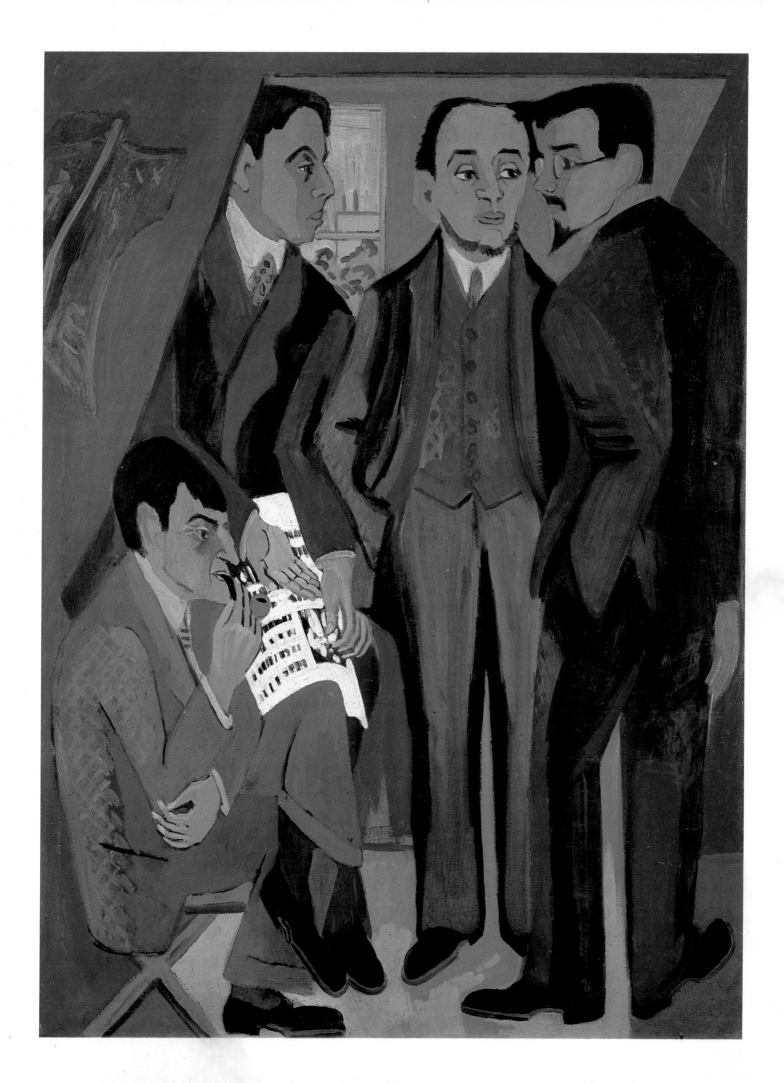

OSKAR KOKOSCHKA

Adolf Loos, 1909
Hans Tietze and Frau Erica Tietze-Conrat, 1909
Peter Altenberg, 1909

IN 1931 THE ARCHITECT Adolf Loos recalled his first meeting with Kokoschka:
'He had made the poster for the Vienna *Kunstschau*. I was told that he was employed by the *Wiener Werkstätte* and was occupied with the painting of fans, drawing picture postcards and similar things in the German fashion – art in the service of the businessman. It was immediately clear to me that one of the greatest crimes against the Holy Spirit was being committed here. . . . I promised Kokoschka that he would have the same income if he left the *Wiener Werkstätte* and I sought commissions for him.'

That was in 1908, and Loos's promise of an income equal to that provided by the more-or-less commercial work for the *Wiener Werkstätte* proved to be extremely rash. He believed that if he could persuade his friends and clients to sit for Kokoschka they would then purchase the results, but none of them did so, and Loos was obliged to buy them himself. He managed to use several of them to settle accounts with the tailor Kniže for whom he designed a shop.

Until then Kokoschka had produced very few portraits, and it is a tribute to Loos that he recognized a potential talent that was as great as it was unconventional. As a result of the architect's encouragement Kokoschka painted between 1909 and 1914 some of the most remarkable portraits in the history of modern art.

Here are three of them executed in the year when Loos first began to help the artist. Loos (1870–1933), the tireless champion of honesty in architecture, the implacable foe of the hypocrisy he saw everywhere around him (he gave the paper he founded, *Das Andere*, 'The Other', the ironic subtitle 'Journal for the Introduction of Western Civilization into Austria'), is shown as a lonely, embattled figure, turned inward upon himself. 'My meeting with him', Kokoschka later recalled, 'was decisive not only for my career but also for my life.'

Hans Tietze (1880–1954) was one of the leading art historians in Vienna; in 1911 he published an article about Kokoschka. His wife Erica was also an art-historian. The highly dramatic, even ritualistic gestures, the heads and faces strangely illuminated against a vague, atmospheric background, are all characteristic of Kokoschka's early portraits. They evoke a supernatural, nervous atmosphere and here suggest a creative tension between husband and wife.

Peter Altenberg (1859–1919) – poet, aphorist, wit, and, like Loos himself, a man dangerously susceptible to the charms of pubescent girls – has a ridiculous look about him, like a performing seal, a creature somehow out of its element. His real name was Richard Engländer. A close friend of the satirist Karl Kraus, he shared his table in the Café Central with Loos, Kokoschka and the few others whom Kraus was prepared to tolerate.

OSKAR KOKOSCHKA
Adolf Loos, 1909

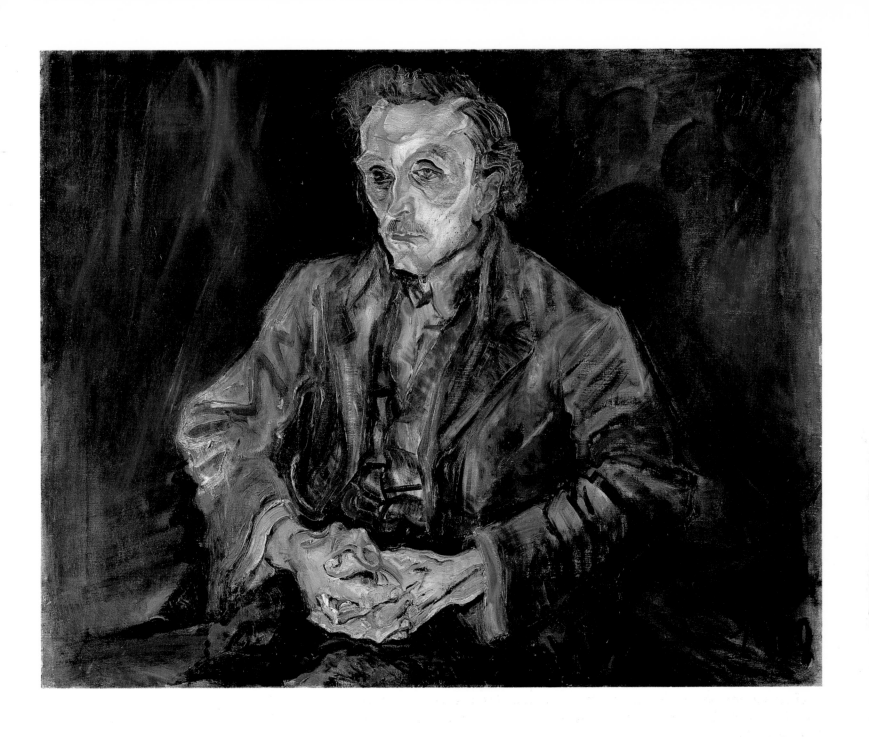

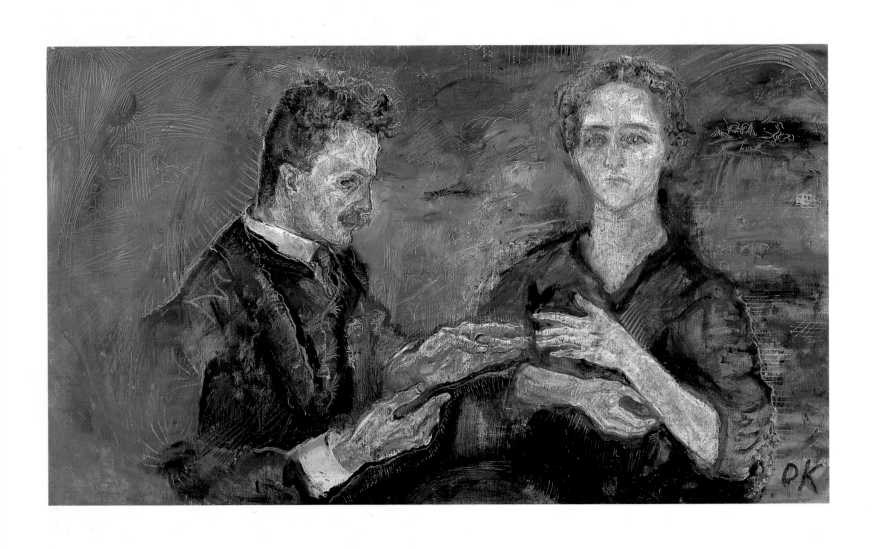

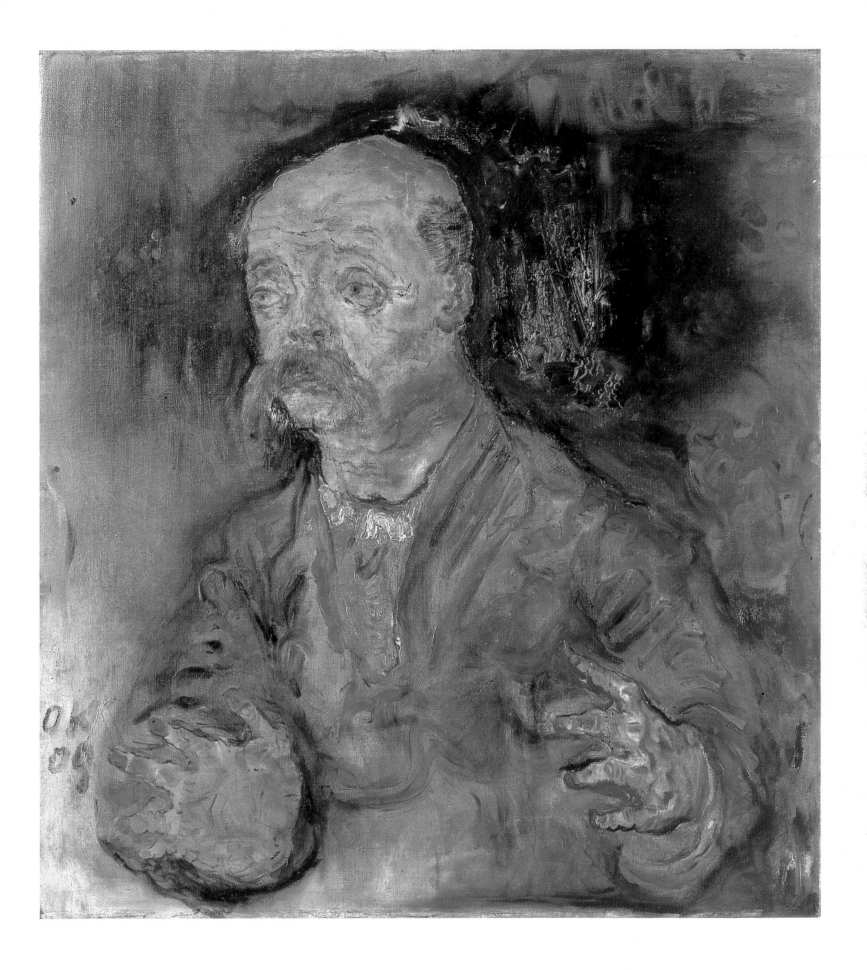

OSKAR KOKOSCHKA

Herwarth Walden, 1910

HERWARTH WALDEN (1878–1944) was a strange mixture of bohemian and businessman, artist and impresario. His real name was Georg Levin, and *Der Sturm*, the literary and artistic weekly which he founded in 1910 and edited until 1932, was his first successful venture after a string of short-lived journals mostly devoted to music, a subject he had studied and taught.

He was plumper and considerably less ascetic than this portrait makes him seem, although his high forehead, the mane of blond hair parted in the centre, and spectacles with thick pebble lenses to correct an acute astigmatism, did give him the misleading air of a withdrawn and absent-minded academic which he retains in Wauer's bust. He habitually wore heavy gold jewelry, was maladroit, clumsy and physically weak. He also chain-smoked.

In 1901 he married the Expressionist poet Else Lasker-Schüler who, addicted to morphine and dressed in a way that was as colourful as it was masculine, was even more bohemian than Walden. When in 1912 he divorced her and married the Swedish journalist Nell Roslund, he quickly grew to enjoy the benefits of money and to understand how to make it. *Der Sturm* became the centre of a business and artistic empire which comprised a gallery, a publishing house and a theatre. There were also *Sturm* soirées and lucrative public readings, always of Walden's authors, of course.

Until the First World War the *Sturm* was the most important and influential avant-garde publication in Germany, and the gallery was the most adventurous of its kind in Europe. In the 'First German Autumn Salon' of 1913 Walden brought together an astonishing collection of experimental and unorthodox painting and sculpture from every country in the world.

The history of Expressionism is unthinkable without Walden who, by applying the word to every artist he represented, virtually invented the movement. There is scarcely a major figure in Expressionism who was not connected with *Der Sturm* at one time or another.

Kokoschka owed much to Walden. Exploited whilst working for the magazine and in no small part responsible for its success, Kokoschka later greatly benefited from publicity in the weekly and exhibitions in the gallery. Walden also gave him a generous contract which Kokoschka broke in favour of an even more generous one with Paul Cassirer.

Walden emigrated to Moscow in 1932. Later he contributed to the German émigré journal *Das Wort* in whose pages a celebrated debate about the ideological roots of Expressionism was conducted by, among others, Georg Lukács, who argued that the Expressionist emphasis on the self, on feeling at the expense of intellect, and on the national (or racial) characteristics of culture, helped pave the way for Nazism. Walden, needless to say, disagreed.

For reasons that are still not clear, Walden fell victim to one of the Stalinist purges. In 1941 he was arrested and taken to a concentration camp on the Volga, and it was there that he died.

OSKAR KOKOSCHKA
Herwarth Walden, 1910

WILHELM WAUER
Herwarth Walden, 1917

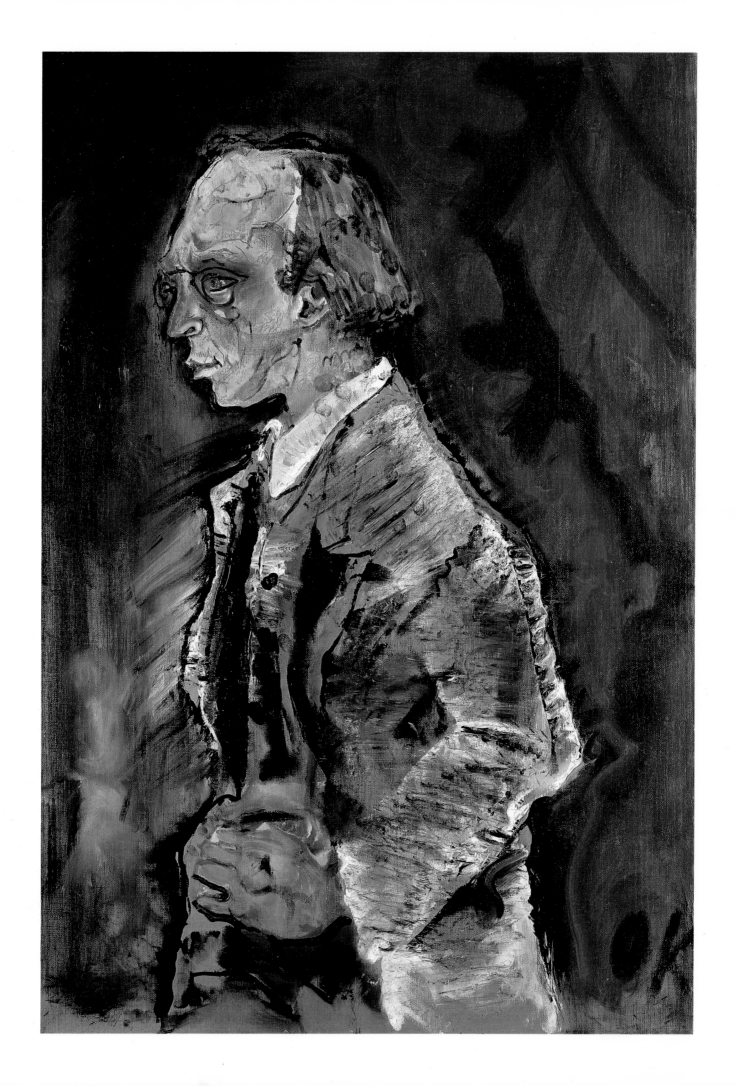

OSKAR KOKOSCHKA

Tilla Durieux, 1910

GIVEN KOKOSCHKA'S STYLE in 1910, it is difficult to see to what extent this portrait of the most celebrated German actress of her day is unfinished. However, it is clear that to some extent, at least, the seemingly perfunctory passages of paint, the areas of raw canvas and the various thumbings and smearings of colour, were the results not of design but of disaffection.

Tilla Durieux (the stage name of Ottilie Godefroy, 1880–1971) lived from 1909 to 1925 with the Berlin art dealer Paul Cassirer, for most of that time as his wife. In 1910 Cassirer showed Kokoschka's work at his gallery (together with that of the young Hans Hofmann), without either marked enthusiasm or success and only in response to the blandishments of Loos. His only other sign of interest in Kokoschka was to commission this portrait. In 1917, however, the dealer contracted to pay Kokoschka 2,500 marks a month in return for no precise obligations, and by 1925 Cassirer had represented the artist for long enough to have been responsible for a dramatic improvement in his fortunes.

A woman of legendary beauty, whose sexual magnetism seemed to predestine her for such roles as Strindberg's Miss Julie and Wedekind's Lulu, Durieux had already been painted by a great many artists, Renoir among them. She certainly did not consider it an honour in 1910 to sit for a young and unknown portraitist from Vienna, then living in reduced circumstances in Berlin. She kept him waiting for sittings, made him the victim of her mercurial moods (from which theatrical directors had also suffered ever since she first made her name with Max Reinhardt's company in 1893), and did her best to make him feel inferior. Neither for the first time nor the last, Kokoschka ignored the opportunity to wage psychological warfare with a sitter and abandoned the picture. He simply left it together with his equipment at the Cassirer house and, without announcing his intention, never returned.

The sitter thought little of the work. In her autobiography she mentions Kokoschka only once and in passing, while devoting an entire chapter to Renoir. But the Kokoschka, unfinished though it may be, is much the better portrait.

In 1925 Durieux left Cassirer for a banker named Katzenellenbogen, and divorce proceedings began. In January 1926 the dealer shot himself in his lawyer's office while Durieux was in an adjoining room. He clearly wished to do no more than make her feel guilty, but his aim was unfortunate and he killed himself by accident.

In 1933 Durieux left Nazi Germany for exile in Yugoslavia, where she distinguished herself fighting with the partisans in the Second World War. Kokoschka never quite came to terms with Cassirer's death, although the partners who took over the business were even more successful in promoting Kokoschka's career than Cassirer had been.

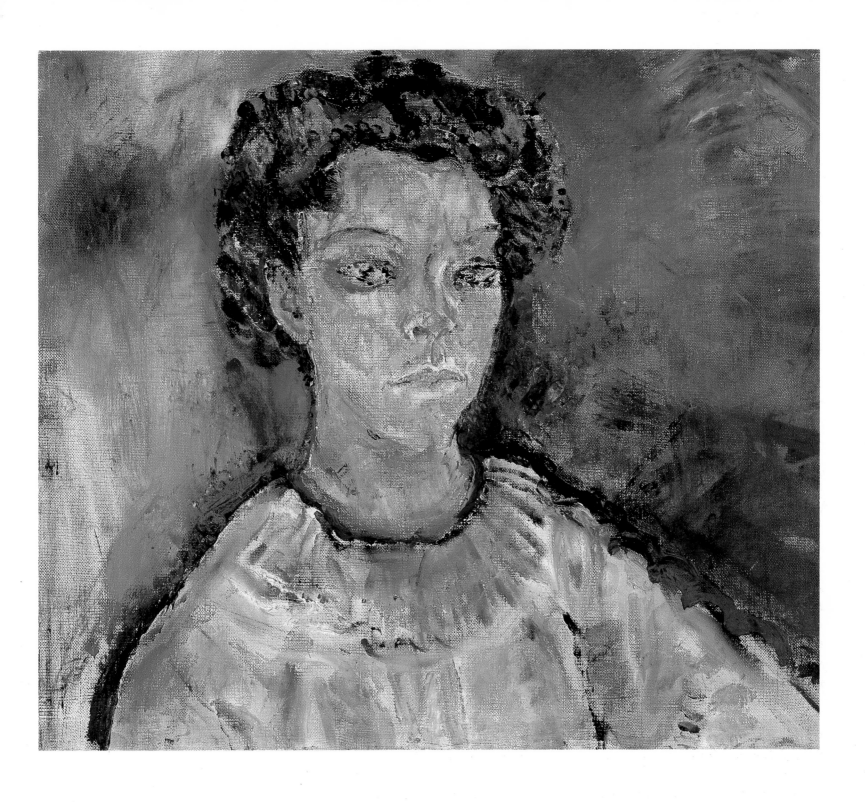

ERICH HECKEL

Sleeping Pechstein, 1910

THIS BOLD, BRIGHT and energetically painted oil is a splendid example of the first mature *Brücke* style, in which the broken and violent brushwork of the earlier paintings has given way to a more considered, decorative arrangement of flat areas of a single colour. It is very similar to Fauve painting of four and five years before; but, although the *Brücke* artists were aware of and influenced by developments in Paris, their art is less harmonious and balanced. For all their reputation as 'wild beasts', Matisse, Derain and their friends wanted to delight and seduce, to express the sensuous pleasure they derived from the light and warmth of the sun, while the *Brücke* was determined to shock and jolt the public out of its complacency.

Pechstein had been living in Berlin since 1908 and was therefore unable to contribute to the communal life which expressed such an important part of the group philosophy. But he remained in close touch with the artists in Dresden, not least during the summer months when he would join one or more of them in painting expeditions to the countryside. In 1910 he went with Kirchner, Heckel and a new group member, Otto Mueller, to the area of lakes and forests around Moritzburg not far from Dresden. There they painted each other, their girlfriends and models, as they bathed, played games or relaxed. Their pictures show them acting out some modern dream of Arcadia in which naked man communes with nature. Such art reflects the *Brücke*'s attempt to revive the kind of multi-figure composition which had long since become ossified at the hands of the academicians.

This portrait must have been painted either at Moritzburg or in Dresden. Soon after completing the oil Heckel produced a woodcut of it as an illustration for the catalogue of the group's third exhibition, at the Galerie Arnold in Dresden in September 1910. It was no doubt cheaper to illustrate the catalogue with woodcuts than with photographs, but economy was not the purpose of the exercise. The *Brücke* artists, for whom the woodcut in any case exerted an almost mystical fascination, were aiming at something close to a communal style, and as an expression of their interdependence occasionally made woodcut versions both of their own and each other's work.

Both for Pechstein and the *Brücke*, 1910 was an important year. In May the group participated in the first exhibition of the 'New Secession' in Berlin. This body was founded and led by Pechstein in protest against the conservative policy of the Secession, an organization which had until recently been the focus of unorthodox and experimental art in the capital. The *Brücke* exhibition at the Galerie Arnold was as much of a critical failure as the previous two had been; this fact and the growing success of Pechstein in Berlin persuaded all the members to move there. By 1911 they were all permanently lodged in the capital and the first phase of the *Brücke* had come to an end. So, too, had the emphasis on communal living and a communal style.

ERICH HECKEL
Sleeping Pechstein, 1910

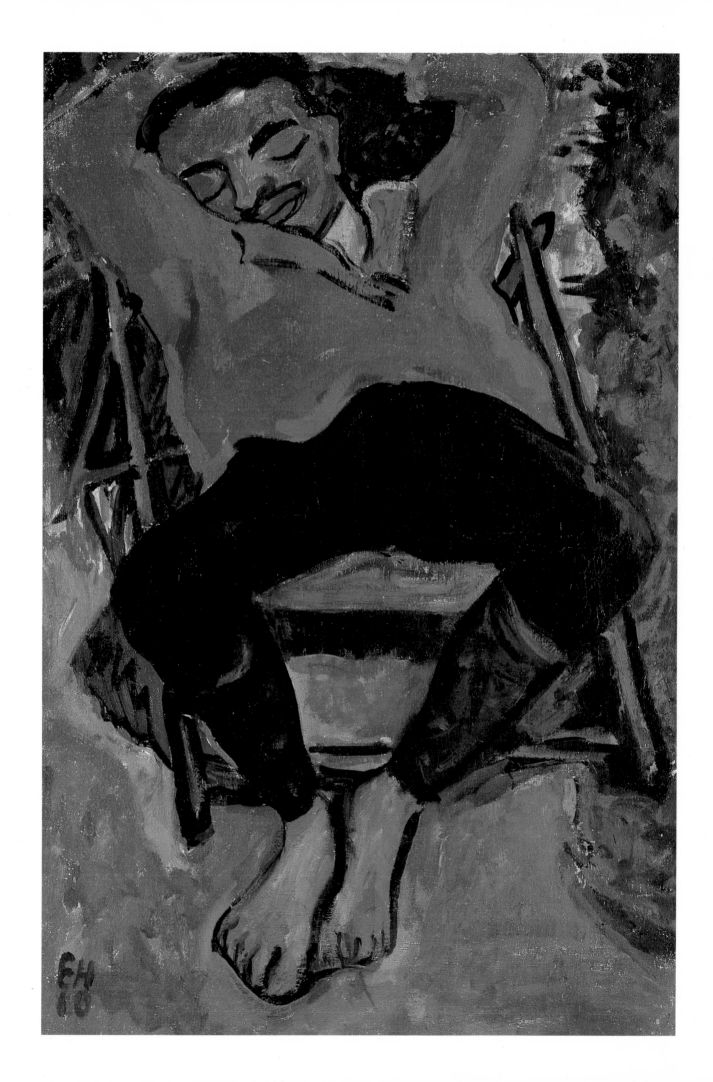

EGON SCHIELE

Max Oppenheimer, 1910

THERE IS SOMETHING SATANIC about this portrait of the painter Max Oppenheimer (1889–1954). The impression of evil is created by the black coat, the sickly green and yellow skin, and the illusion, conjured up by the pose and the billowing edges of the clothes, that the figure is floating. This watercolour is one of several portraits of painters which Schiele executed in this most productive year, although most of the other paintings are in oils and in the square format which Schiele borrowed from Klimt (and continued to use until every trace of Klimt's influence had been expunged from his style).

Oppenheimer (who signed himself MOPP rather than the OPP with which Schiele has credited him here) was one of several young Viennese artists, among them Anton Faistauer and Albert Paris von Gütersloh, who brought a psychological tension to the portrait which at Klimt's hands had become over-refined and vacuously glamorous. None of these portraitists could hold a candle to Gerstl, Kokoschka or Schiele, although their work was by no means entirely without merit. Indeed, the fact that Oppenheimer became moderately successful earlier than any of his more gifted contemporaries can be explained by his attractive and judicious mixture of the novel and the expected. Oppenheimer's portraits negotiate the dangerous frontier between true Expressionism and fashionable modernity.

Kokoschka was alarmed by Oppenheimer's early success. He considered that Oppenheimer's style was derived from his own, and that his rival was enjoying the fruits of another's originality. The poster for Oppenheimer's first Munich exhibition, on which the artist depicts himself naked and pointing at a wound in his side, is indeed a shameless piece of plagiarism, obviously based on Kokoschka's advertisement for *Der Sturm*. Although Oppenheimer's style of portrait painting is also close to Kokoschka's, it is not close enough to justify Kokoschka's anger, however. In 1911 he launched a campaign against Oppenheimer and brought on some very big guns indeed, including Kraus, Walden and Else Lasker-Schüler. She published a 'Letter to an Imitator' in *Der Sturm* which includes the following observations: 'Your ostentatious clothes have always given me great pleasure . . . They demonstrated not only courage but also taste. I was doubly pleased to accompany you to your exhibition of pictures in Munich, but the paintings which hung on the walls were not yours – all of them were by Oskar Kokoschka.'

This bitter campaign, quite characteristic of many waged in Vienna by artists of every type and at every period, appears to have had little effect on Oppenheimer's career. It continued to flourish. Today he is virtually forgotten.

MAX OPPENHEIMER
Poster for One-Man Show at Moderne Galerie, Munich 1911

EGON SCHIELE

Heinrich and Otto Benesch, 1913

THIS PAINTING of one of Schiele's earliest patrons and his son is one of the most remarkable of modern portraits because of the way in which it combines physical likeness and dramatic tension. It also suggests a complicated emotional relationship between father and son. Otto, about to gain his independence, seems vulnerable, sensitive, ill prepared for the rigours of adult life; between him and the hostile world stands the huge bulk of his father, arm outstretched to protect him, his stern gaze issuing a warning to anyone daring to come near.

Years later, Otto's wife Eva Benesch wrote: 'Had Schiele – consciously or unconsciously – understood a deep psychological situation? Heinrich Benesch liked to dominate. The intellectual burgeoning of his son began to make him feel uneasy. Schiele recognized *the gaze into the world of the mind* beyond all external barriers already in the boy who was then seventeen and he expressed it in the portrait. It was a mental world in which Otto Benesch quite naturally dominated.'

Perhaps, then, the gesture of the father's arm represents a doomed attempt to delay the arrival of maturity, a final unavailing proclamation of authority. The father-son conflict was acutely present and topical in early twentieth-century culture, from Freud and Kafka to Walter Hasenclever's Expressionist drama *Der Sohn* (1914). Heinrich Benesch's gesture is certainly powerful, and its energy comes not only from the straightness of the arm but also from the movement which Schiele suggests by painting it a second time, straight down, the hand in the father's coat pocket.

Heinrich Benesch, a railway official, began to collect Schiele's work in 1909. He supported Schiele through thick and thin, buying whenever he could afford to, providing loans wherever possible and giving advice and encouragement. It was Benesch who did much to ensure that Schiele was as little distressed as possible when the artist was committed to prison for an alleged sexual offence. Enormously impressed by Schiele's work but not wealthy enough to purchase very much of it (the artist's prices were high even in 1909), Benesch sent him a letter: 'I want to ask you one thing more. Don't put any of your sketches, no matter what they are, even the most trivial things, on the fire. Please write on your stove in chalk the following equation: "Stove equals Benesch."'

Otto inherited his father's love of art and became an outstanding art historian – and, most appropriately, the director of the Albertina in Vienna where many of Schiele's best drawings are preserved.

Curiously, this portrait was neither commissioned nor purchased by Benesch. Its first owner was Carl Reininghaus, one of the most important collectors of modern art in Vienna, who bought it from Schiele for the not inconsiderable sum of 600 crowns.

EGON SCHIELE
Sketch for Double Portrait (Heinrich and Otto Benesch), 1918

EGON SCHIELE
Portrait Sketch of Heinrich Benesch, 1913

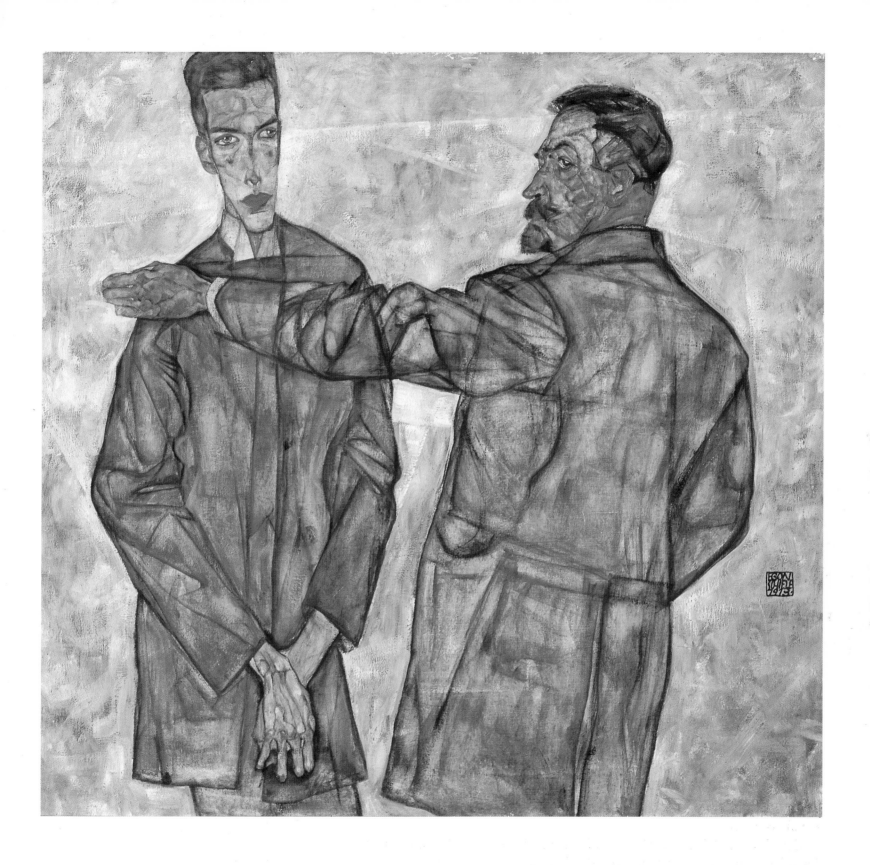

ARNOLD SCHOENBERG

Portrait of Alban Berg, 1910?

Photograph of Alban Berg with the portrait of him painted by Schoenberg

THROUGHOUT HIS LIFE the composer Schoenberg (1874–1951) painted, but never with the seriousness of the years between 1908 and 1912 when, as he himself said, painting allowed him to express what he was unable to in music. The music he was composing at the same time is commonly termed 'expressionistic'; his paintings, clearly the result of some irresistible emotional compulsion (that same *innerer Zwang* which, he said, drove him to create), are manifestly Expressionist in their exaggerated colours and forms.

Schoenberg was deeply involved with the avant-garde in Vienna. He knew Kraus, Altenberg and Loos; he knew Kokoschka and taught for a time at the same progressive school; he was painted by Oppenheimer and Schiele; to his cost he also knew Richard Gerstl who also painted him (page 106). He was equally close to the circle around Kandinsky in Munich, however. The Russian was deeply impressed by his *Harmonielehre* (theory of harmony) and struck by the emotional authenticity and genuine fervour of his paintings. In the *Blue Rider Almanac* which he edited with Franz Marc, Kandinsky reproduced several of them, together with a major essay by Schoenberg and the score of one of his *Lieder*.

In 1910 Schoenberg exhibited forty-seven oils and watercolours in a private Viennese gallery. In the catalogue they are divided into two groups: 'Portraits and Studies' and 'Impressions and Fantasies'. The second group consisted of the faces of strange, imaginary creatures which Schoenberg called 'Visions' and 'Gazes', while the former included slightly more conventional portraits of real people, among them this likeness of his friend and pupil Alban Berg.

Technically one of the most accomplished of Schoenberg's portraits, it is also one of the largest and best, profiting from the confidence with which it was made, a quality absent from most of Schoenberg's work which, in spite of Kandinsky's admiration, is too obviously from the hand of an amateur.

While the critics were very hostile to Schoenberg's 1910 exhibition ('Now he is painting, too. At first sight it is ghastly.' *Wiener Illustrirtes Extrablatt*, 9 October 1910), other artists were complementary. In an essay, *Schönberg der Maler*, published in 1912, Albert Paris von Gütersloh referred to his 'psychic primitiveness', while much later Kokoschka described him as a 'realist who wanted exactly to reproduce his own visions'.

Berg (1885–1935) was Schoenberg's pupil between 1904 and 1910, and his admiration for his master never dimmed. Three of his major works – the *Three Orchestral Pieces*, the *Chamber Concerto* and *Lulu* – are dedicated to him. His opera *Wozzeck* (1921) which employs Schoenberg's 'method of composing with twelve notes' is probably the most often performed of Berg's works. It is certainly thought by many to be a masterpiece of musical Expressionism, because of the tormented atmosphere it evokes by means of dissonance and fragmented utterance.

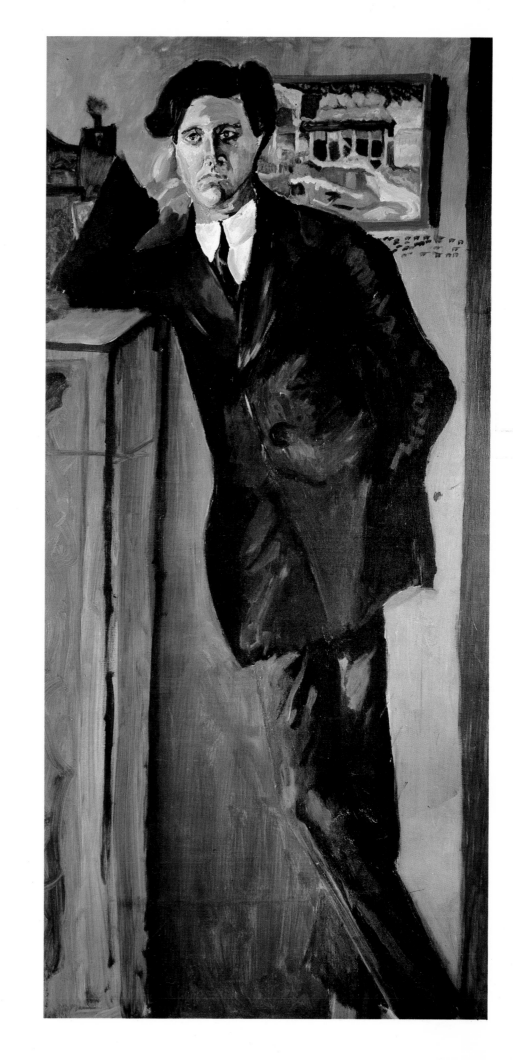

LUDWIG MEIDNER

Max Hermann-Neisse, 1913

MAX HERMANN, born in the little Silesian town of Neisse in 1886, was a poet and critic, a well-known literary figure in Berlin in the 1920s. He knew many contemporary painters and wrote about them (he reviewed the work of both Dix and Grosz), and they in turn painted him. Grosz's portraits are perhaps the most familiar (page 151), and Meidner painted him twice and drew him scores of times. The most curious of the portraits of the poet is in the top left-hand corner of Christian Schad's painting *Sonja* of 1928 (Hamburg, private collection) where his left ear and part of his head unmistakably establish his identity.

Meidner's portrait, made while Hermann was on a brief visit to Berlin from Neisse, is the earliest evidence of a friendship which sprang up because both worked for *Die Aktion*, and which lasted until the poet's death. 'I sat, even at that time unshakeable, like a statue, but he, possessed by the demon of his art, raged around me, apparently fighting a life-and-death struggle with all the devils who wished his art ill. Afterwards we celebrated the painter's final victory (or at least the fact that the previous position in the war had been held) with cognac either in the studio or in a bar in the Passauer Strasse, where at that time those appealing girls used to congregate whom Claude Farrère delightfully and appositely named '*les petites alliées*'. With other painters things were unfortunately much more sober in every respect.'

Hermann-Neisse ascribed his popularity among painters, perhaps ironically, to his ability to sit still – 'I'm simply phlegmatic and am happy to be allowed to sit there dozing without being disturbed' – but there were plainly other reasons. He was a hunchback and very small; he had a disproportionally large, almost bald head, prominent teeth which distorted a full, sensuous mouth, and large, bony hands. Photographs of him are reminiscent of Max von Schreck playing Dracula in Murnau's Expressionist film *Nosferatu*. He was, in short and in nature, a caricature who, to judge from photographs of his wife, was attractive to highly attractive women as well as to painters.

Permanently in Berlin after 1917, Hermann-Neisse (as he styled his name from then on) performed in political cabaret with such stars as Bert Brecht and Walter Mehring and wrote theatre criticism as well as establishing a considerable reputation as a poet. Soon after the Reichstag fire of 1933 he left Germany for London via Zurich, Holland and Paris. Until his death in 1941 he lived in an attic in Camden Town, unknown save to other German refugees such as the painter Martin Bloch (who was also born in Neisse) and Ludwig Meidner who remembered that he 'was embittered by what had happened and deeply unhappy, but on his daily walks through . . . Regent's Park he would always compose his German verses'.

Few knew better the misery of exile.

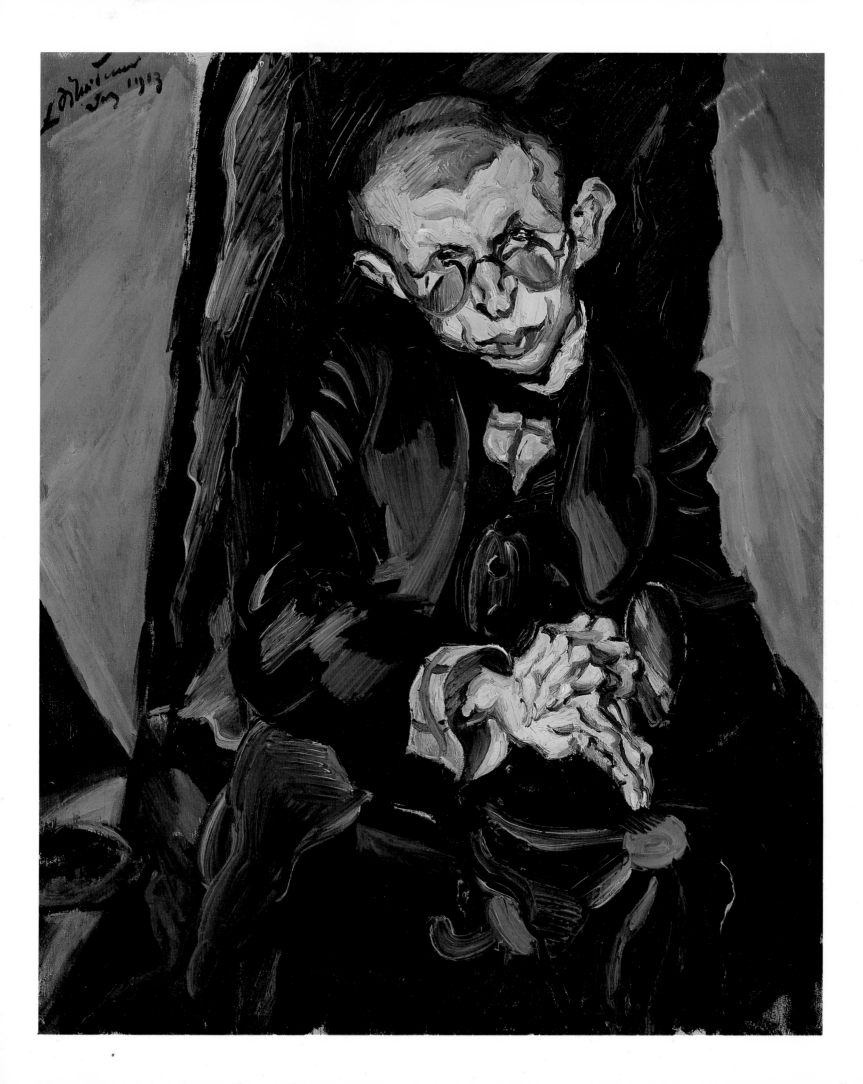

MAX BECKMANN

Max Reger, 1917

APART FROM THE REPEATED inclusion of musical instruments as symbols, there is little sign in Beckmann's work of his enthusiasm for music. This is the only portrait of a musician that he is known ever to have painted. Reger (1873–1916), unlike his almost exact contemporary Schoenberg – with whom he shared a love of Bach and Brahms – was a contrapuntalist, an essentially backward-looking composer. Beckmann almost certainly never met him; and, unusually, the portrait was a commission from a third party, a Hamburg collector and an important patron of Beckmann, Henry B. Simms. The artist must have painted it from photographs.

Whatever the reason for the commission, the portrait is characteristic of the few likenesses Beckmann made in the new, hard and harshly illuminated style which he developed after he returned home from the war. The colours are jaundiced, acidic, the forms clear cut. Most characteristic of all is the claustrophobic atmosphere. Reger's imposing bulk has been squeezed into the confines of the painting. The hands, usually such vital parts of a portrait because of their expressive potential, have been half cut off by the bottom edge. The composer's nose looks as if his face is pressed hard up against a pane of glass. The air above his shoulders is painted almost as if it were solid.

On 8 February 1918 Beckmann wrote to the publisher Reinhard Piper: 'Expressionism is something more decorative and anecdotal that has nothing to do with a vital feeling for art. With my paintings I can now prove that one can be new without making Expressionism or Impressionism. New according to the old law of art: roundness on a flat surface.'

If Expressionism had degenerated at the hands of a few imitators to the level of the decorative and anecdotal, that did not mean it was dead. Beckmann is too great an artist to be confined by a single label, but in this portrait as in all the works of this period, he has adopted several markedly Expressionist traits.

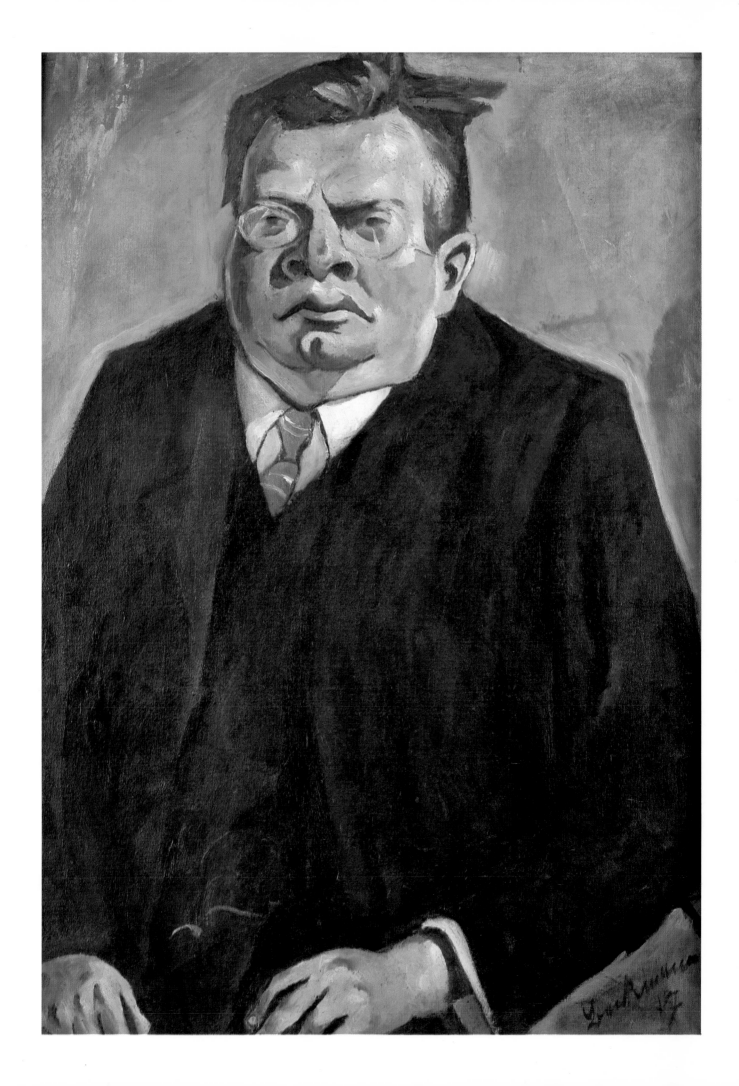

LOVIS CORINTH

Julius Meier-Graefe, 1917

WRITING IN 1914 about the general awareness of art in Germany around 1890, the great critic and historian of modern painting Julius Meier-Graefe (1867–1935) said that 'the inside of our heads looked like an emergency railway station in wartime. It is impossible to conceive how riddled with holes our mental communication system was. Touloue-Lautrec, Vallotton, Odilon Redon, Axel Gallén[-Kallela], Vigeland, Beardsley, Gauguin and Munch, Puvis de Chavannes and Whistler were our main sources of awareness apart from the German Romantics . . . I knew Bonnard before I knew Manet, Manet before I knew Delacroix. This confused state of mind explains many of our generation's subsequent mistakes.'

Meier-Graefe did more than anyone else to clear away the confusion, to educate his own and a later generation in the history of recent French art, and thus to prepare the ground for Expressionism. Trained as a mining engineer in Belgium, he was in Berlin during the early 1890s where he met Strindberg, wrote about Munch and, with Otto Julius Bierbaum, co-edited the influential literary and artistic journal *Pan*. In 1896 he went to Paris and worked for Samuel Bing, advising him to employ Henry van de Velde to design the interiors of his new emporium *L'Art Nouveau*. Back in Germany, he began to write the long series of monographs on such artists as Van Gogh, Gauguin and Cézanne which made his name, and to work on his most famous book, the *Entwicklungsgeschichte der modernen Kunst* (*Modern Art*) which was published in 1904 and translated in 1908.

Kirchner described Corinth (1858–1925) as 'At first a mediocrity. At the end truly great.' This was an opinion shared by most of the Expressionists, who had earlier disliked the man as much as they did his work. That was because Corinth, together with Max Liebermann and Max Slevogt one of the best of the so-called German Impressionists, hated Expressionism and, as President of the Berlin Secession, long did his best to keep out of the organization what he described as 'Franco-Slavic international art'. But then, in 1911, Corinth suffered a stroke which resulted in partial paralysis and a changed style of painting which was admired by the younger generation as soon as it came to their attention.

Corinth's style was always vigorous and dramatic, but his later work, of which this portrait is an example, is even wilder, even more vehement. Corinth's aim in his late work remained as it always had been: to be true to what his eye saw rather than to transform it in terms of what he felt; but the admiration of the Expressionists provides enough evidence of its affinities with Expressionism.

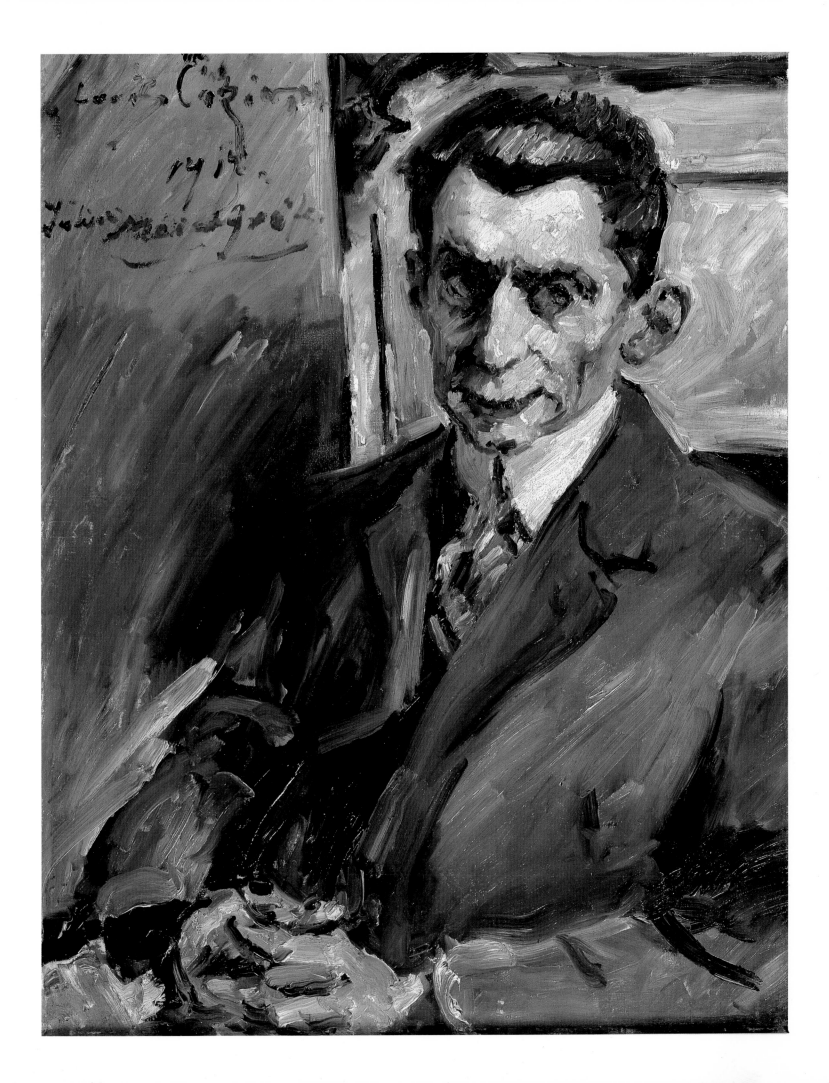

CONRAD FELIXMÜLLER

Otto Dix Paints, 1920

AT THE END OF 1918, when Otto Dix was released from the army (he had spent the last few months of service training to be a fighter pilot), he returned to Dresden to resume his art studies. Soon after he arrived he was visited by Felixmüller, one of the best-known of the young local artists, who had seen some of his work at a local gallery and was impressed by his dynamic and colourful style. Felixmüller immediately invited him to join a group of young, politically committed Expressionist artists which was about to be founded. Dix, although not nearly as interested in politics as Felixmüller, accepted and took part in the first exhibition of the 'Dresden New Secession Group 1919' in April of that year.

The members of the New Secession drew and painted each other. Dix painted the *Felixmüller Family*, while Felixmüller made an etching of Otto Dix chiefly to demonstrate the technique. Dix knew nothing about print-making and Felixmüller suggested that he might make some prints in order to earn some money. Felixmüller left a corner of the plate free so that Dix could try his hand at etching. Dix inscribed into the plate the easel and the painting of a woman undressing on which Felixmüller had depicted him working. Felixmüller – who taught Dix the elements of lithography, too – then used the etched portrait as the basis for this painting.

Dix owed Felixmüller more than this his introduction to print-making. Felixmüller gave a start to his career and provided him with the introduction to the 'Young Rhineland' group in Düsseldorf which proved so important in both his personal and artistic life. Nevertheless their friendship was brief. Felixmüller, the faithful husband and doting father, disapproved of Dix's regular visits to the brothel, which provided him with such a rich source of subjects, while Dix found Felixmüller far too committed politically, not to say naive. Although broadly sympathetic to the left, Dix had by no means been transformed into a pacifist, let alone a Bolshevik pacifist, by the horrifying experiences he had in the war.

In 1975 Felixmüller conceded that he had 'always admired and valued Otto Dix as a great artist, but after Dix once shocked us with the remark "You can't imagine the feeling when you're screwing someone in the belly with a bayonet", our relations became very cool'.

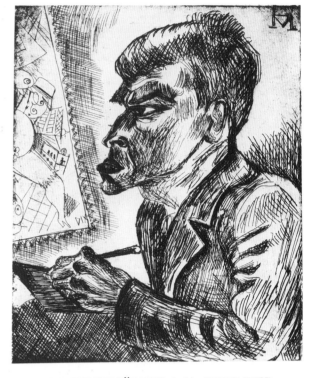

CONRAD FELIXMÜLLER (with OTTO DIX)
Otto Dix Draws 1920

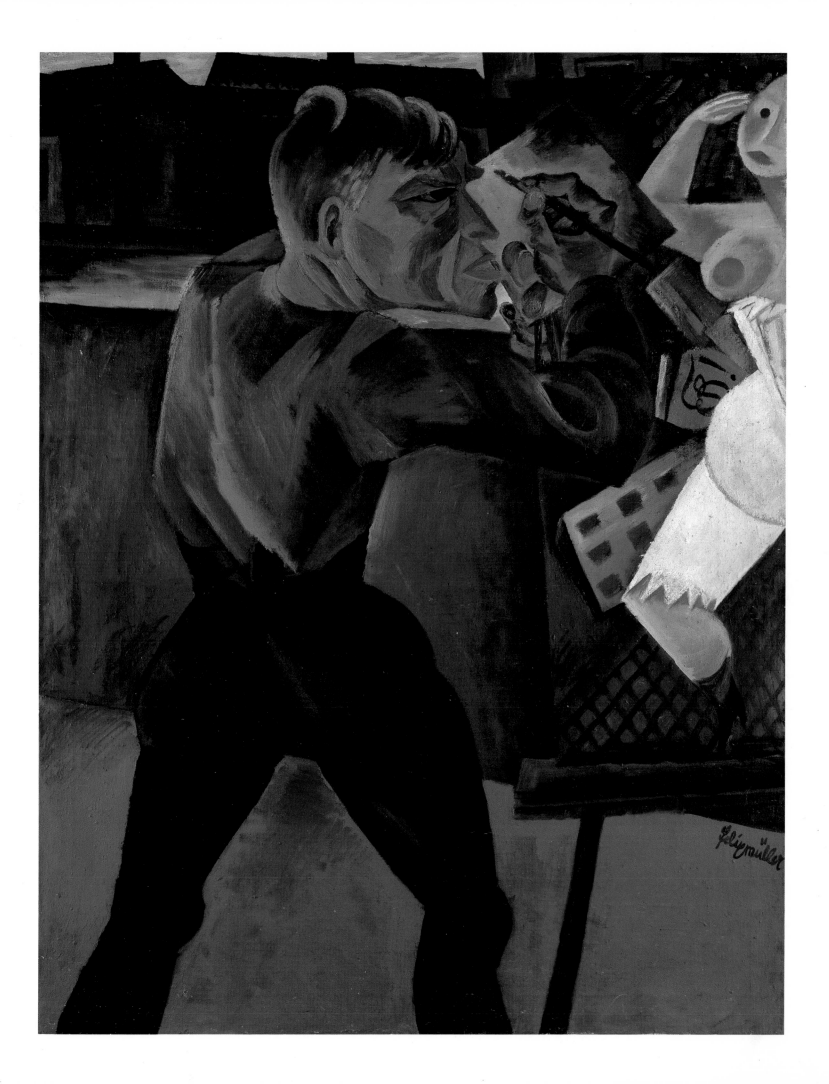

CONRAD FELIXMÜLLER

Raoul Hausmann, 1920

IN 1915 FELIXMÜLLER LEFT the Dresden Academy and took a trip to Berlin 'with a bundle of woodcuts, drawings and etchings in order to show them to a dealer in modern art who was already well known – Herwarth Walden. That same day I visited Ludwig Meidner who had me to stay straight away. . . . Life in Meidner's studio appealed to me. . . . Here Raoul Hausmann, Anselm Ruest, Joh[annes] R. Becher, Wieland Herzfeld[e], Salomon Friedländer, Alfred Wolfenstein, Willy Zierrath and others whose names I have forgotten would meet. Through this circle, and above all through Raoul Hausmann, I came to Franz Pfemfert – it was an antimilitarist group, revolutionary not for the sake of aesthetic questions but in a social and political sense.'

Hausmann, Meidner and the writers Felixmüller met in Meidner's studio contributed to Pfemfert's Expressionist weekly *Die Aktion* because they all shared its pacifist and republican views. Hausmann had begun his association with the paper in 1916. Before that he worked occasionally for *Der Sturm*, a weekly equally committed to Expressionism but to no particular political opinions. Earlier still, Hausmann (who had lived in Berlin since leaving his native Vienna in 1900 at the age of fourteen) had exhibited his painting and sculpture at Walden's gallery.

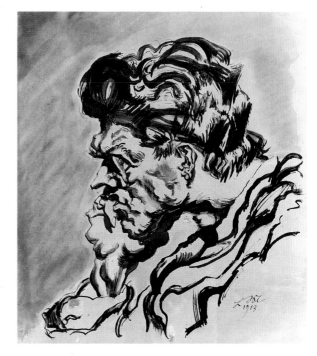

LUDWIG MEIDNER
Raoul Hausmann 1913

Hausmann's early work is now forgotten, and he is remembered only as a leading Dadaist: as a contributor to Franz Jung's proto-Dadaist journal *Die Freie Strasse* ('The Open Road'), as the *Dadasoph* and co-founder of Berlin Dada in 1918, and as one of the inventors and most inventive users of photomontage, together with his mistress Hannah Höch. He is less convincingly credited with the invention of the sound (or phonetic) poem. His best-known work in this medium, 'f m s b w t', inspired Kurt Schwitters to write his *Ursonate*. Hausmann edited the first two issues of the periodical *Der Dada* and coedited the third with George Grosz and John Heartfield.

Although Dada disclaimed all connections with the art of the past, especially the immediate past, and was especially hostile to Expressionism because of its obsession with the self, most Dadaists, whether in Zürich, Cologne or Berlin, had been enthusiastic Expressionists before their conversion to anarchy. Hausmann was no exception. Felixmüller painted his friend, a splendidly intimidating figure who habitually wore a monocle and cultivated a brusque, irritable manner, in 1920, the year in which Berlin Dada had its greatest publicity success. It was in 1920 that Hausmann, Grosz, Heartfield and others organized the 'First International Dada Fair' at a private gallery in Berlin. It was closed down by the authorities soon after it opened because of its most prominent exhibit, a dummy suspended from the ceiling with a real pig's head and wearing army officer's uniform.

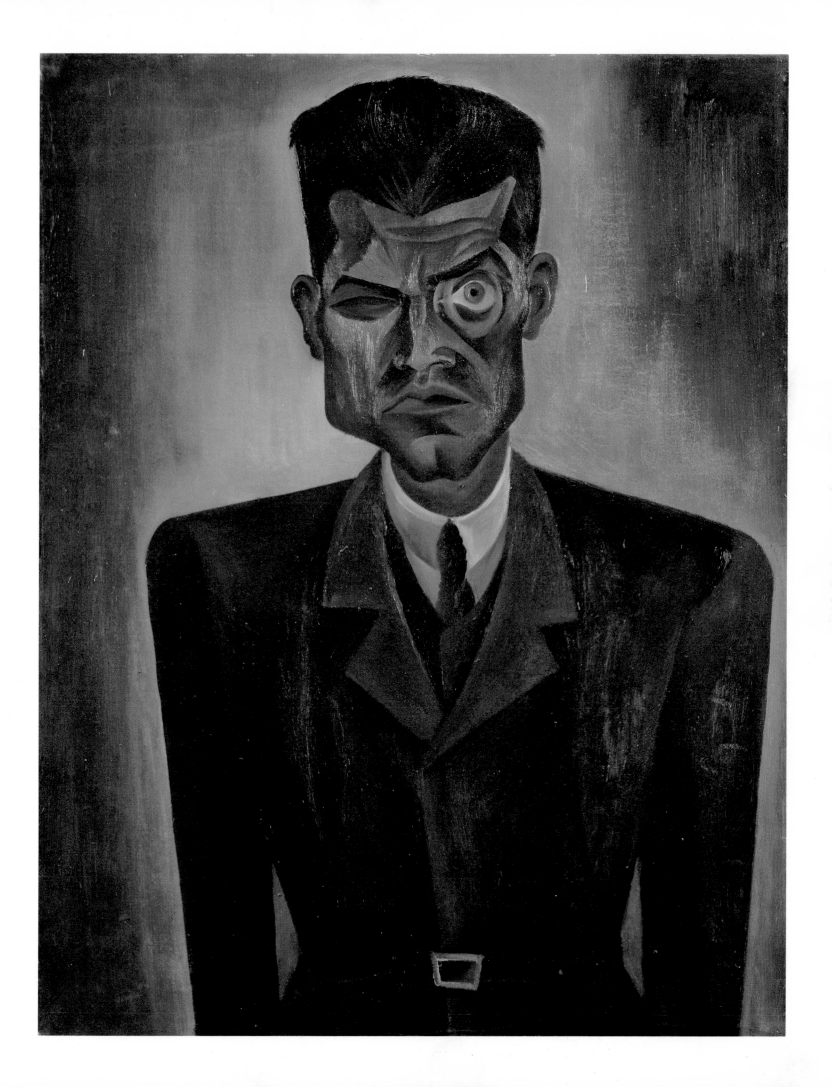

CONRAD FELIXMÜLLER

Death of the Poet Walter Rheiner, 1925

'I MET [RHEINER] in a small Dresden bookshop in 1916,' wrote Felixmüller, 'at a time when he was still working in business in Leipzig. The bookseller – Felix Stiemer – handed him the special 'Felixmüller' issue of *Die Aktion* which had just appeared.

'That was the start of the friendship between the three of us. It caused connections to be made over the years between Dresden, Leipzig and Berlin – with the circle around Franz Pfemfert, Raoul Hausmann, Joh[annes] R. Becher, Ludwig Meidner, Herzfelde and Franz Jung.

'Walter Rheiner soon moved to Dresden. There he was a writer. What he wrote I illustrated. *Menschen* ['People', the Expressionist journal coedited by Felixmüller] and Felix Stiemer's publishing house brought out his first books. In the middle of the war in hardship, cold, hunger . . . what we lived on, how we kept ourselves warm – I can no longer remember. The studio – unheated – was the meeting place of an increasing number of like-minded people. . . . Dresden was too quiet, too narrow for us. We went to Berlin . . . in 1917 – January – the most terrible winter of the war.'

In the moving memoir of his friend Rheiner which he wrote in 1975, Felixmüller goes on to describe their bohemian life and work together in Berlin, Rheiner's poetry readings at the 'Expressionist soirées' which Felixmüller organized in his Dresden studio, and how, after the war, they lost touch.

'We were living as a young family in a remote suburb of Dresden – Walter Rheiner had been driven by unemployment and inflation to the outskirts of Berlin. No publisher was prepared to print his universal paeans. Despairing at his lack of success and in great financial difficulties, he had distanced himself from all his friends. Cocaine became his consolation. In a Berlin doss-house, abandoned by God and the world, weighed down by loneliness, bottle and syringe falling from his cramped hands, he succumbed to the most abject destitution – alone in his beloved city, Berlin – on 12 June 1925.'

Rheiner had committed suicide at the age of 30. He had first taken cocaine, as had several others, Johannes R. Becher among them, to avoid conscription. In 1918 he published one of his best stories, *Kokain*, in which he describes the life and death, by his own hand, of an addict in Berlin.

Greatly distressed by the news of his friend's death, Felixmüller immediately set about painting this picture, using as an aid a portrait lithograph which he had executed in 1918. This, one of the greatest late Expressionist portraits, shows Rheiner, apparently in ecstasy, floating out from a window over the city at night, his right hand tugging at a curtain, his left holding a syringe. The painting exploits a style which Felixmüller had virtually abandoned by 1925. It is as though he returned to an earlier, more thoroughly Expressionist manner in order to sharpen his memory of a friend, an Expressionist poet, whom he knew best while he was perfecting it.

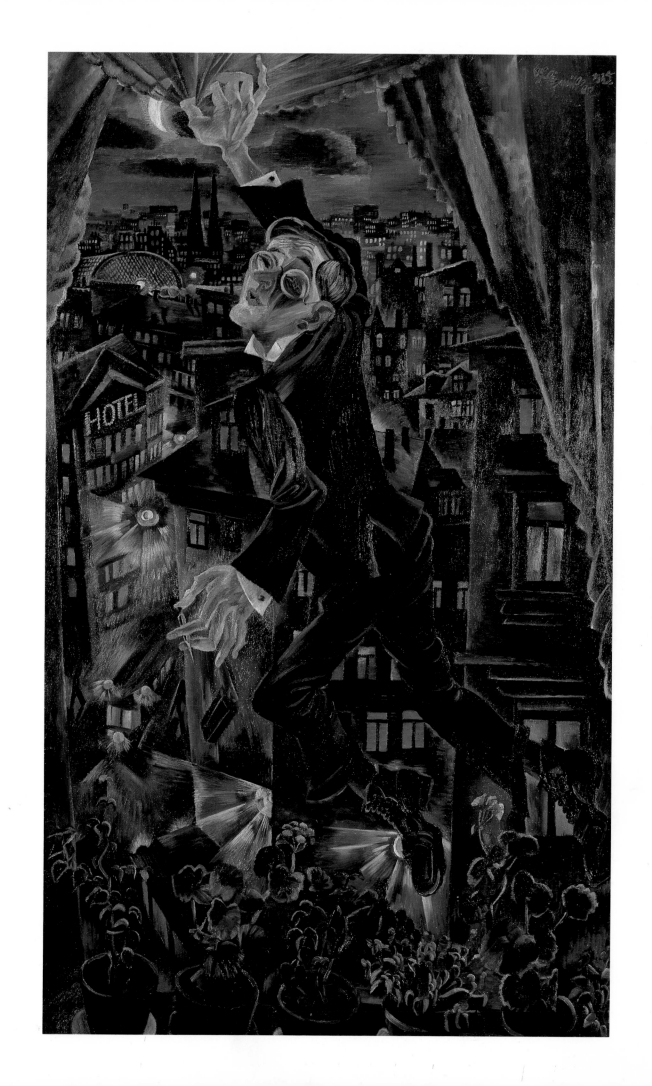

OTTO DIX

The Dermatologist and Urologist Dr Hans Koch, 1921

IN THE EARLY 1920S Dix seemed incapable of producing a sympathetic portrait of anyone, even of his friends. This horrific likeness transforms the specialist's consulting room into a torture chamber, the chair at the right with its straps and stirrups the rack on which unspeakable acts will be committed with the aid of clyster, clamp, syringe and tweezer. In isolation the doctor's smile may be pleasant enough, but together with the slight squint in the eyes, the thick-lensed spectacles and the double duelling scar, it hints at something more sinister than pleasure in a job well done.

This – surprisingly – was a work commissioned by the sitter, a fact which demonstrates that patrons did exist for the new art, even when it was at its most difficult, especially among the professional classes. Koch (1881–1952) had begun to collect before the war, especially French art bought mostly from Alfred Flechtheim's Düsseldorf branch. When that closed in 1917 for the duration, Koch and his wife opened their own print gallery and became its best customers. Still working as a doctor, Koch searched the country for new talent and discovered Dix in Dresden. When Dix went in October 1921, on Felixmüller's recommendation, to Düsseldorf and Cologne he quickly visited Koch and showed him the work he had brought with him. Koch bought two of Dix's greatest works, the two pictures of whores waiting for clients in a brothel, both called *The Salon*. He also commissioned this portrait.

While working on it Dix paid as much attention to the doctor's wife, Martha, as he did to Koch himself. The marriage was in difficulties: Koch had already begun an affair with his sister-in-law by the time Dix arrived. 'I imagined that a young man would turn up with lots of spots and blond hair', Martha remembered. 'He really did have blond hair, and above all he was very cheerful. It came out that he was a fantastically good dancer. Hans thought that daft and was even more silly than usual. Awful. I was terrifically fond of dancing and we decided to get a gramophone. So we danced and Hans drank. We drank, too. From baccara goblets, a quarter-litre of wine at a time.'

Dix got drunk and felt very ill. 'He was living at Frau Ey's [see page 142]. She was unhappy about the whole thing, how it was developing. It kept developing. And at the end it went wrong. I always told him: there's no point. I'd be satisfied if he just came to visit once in a while, but Hans Koch was determined to get a divorce.'

Martha Koch returned with Dix to Dresden, leaving her children behind. In the autumn of 1922 they returned to Düsseldorf together and were married there early in 1923.

We would be wrong to discern any animosity towards the subject in this portrait, other, perhaps, than an animosity towards humanity in general. Dix liked Hans Koch and kept in touch with him. In 1933, persecuted by the Nazis, Dix sought refuge near Lake Constance in a castle owned by the doctor, who had married Martha's sister and thus become his brother-in-law.

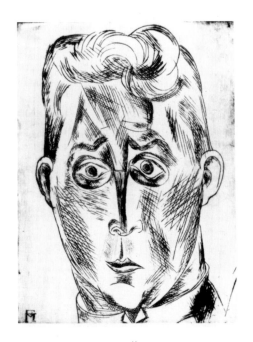

CONRAD FELIXMÜLLER
Dr Hans Koch, Düsseldorf 1919

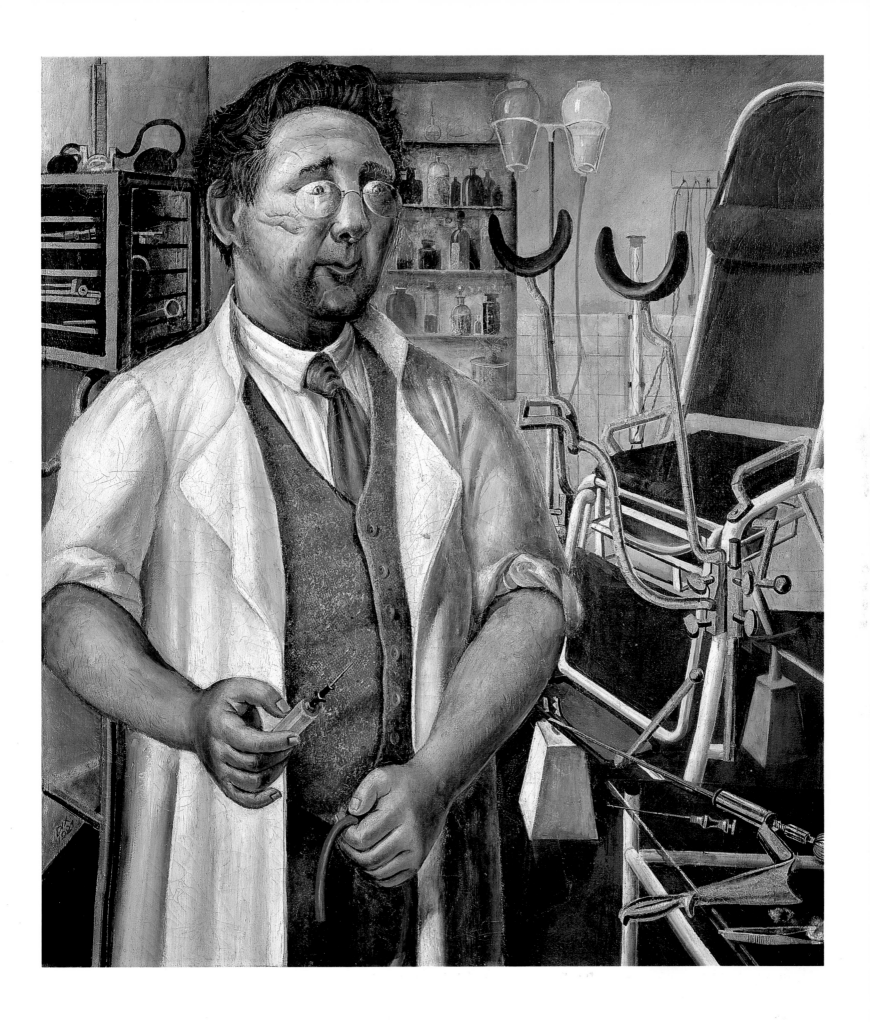

OTTO DIX

The Poet and Painter Adolf Uzarski, 1923

ON THE RECOMMENDATION of Conrad Felixmüller, Dix moved from Dresden to Düsseldorf in 1922 to continue his studies at the Academy (under the Expressionist Heinrich Nauen). During the inflation there were more wealthy people in the Rhineland than elsewhere, and they ensured the presence in Cologne and Düsseldorf of a lively art market. Both dealers and artists were attracted there. One of those dealers, by far the most extraordinary, was Johanna 'Mutter' Ey, who ran a bohemian pub, liked art, and liked even more to mother artists.

Mutter Ey's pub (from which she sold pictures) was the meeting place for the young painters who called themselves *Junges Rheinland* (Young Rhineland). They included left-wing realists such as Otto Pankok as well as the less orthodox Max Ernst. Another member was Adolf Uzarski.

This strange likeness of an artist best-known at the time as an Expressionist illustrator, and now known only for his connection with Dix, is one of several executed at about the same time in Düsseldorf in which characteristics of physiognomy, bearing and physique are pushed to the point of caricature. Distortion is used to reveal a highly personal view not so much of actual appearances but of character and personality.

His spider-like hands raised in a rhetorical gesture, his shoulders distorted like those of a hunchback, Uzarski stands against an imagined pseudo-Baroque background like a stage-set. The colours are equally unreal, livid, suggestive of disease.

Unlike the two portraits of Dix's parents, *Adolf Uzarski* is mocking and, like others of the same period, even cruel. In 1924 Willi Wolfradt published a short monograph on Dix in which he describes such portraits as 'resembling in their annoying objectivity those "wanted" posters which indiscriminately record all "distinguishing marks". They are hair-raisingly accurate yet at the same time the result of a single-minded heightening of reality'.

It is, of course, the introduction of such devices as caricature and unexpected combinations of lurid colour which heighten reality and which, in spite of the lack of emotive handling, make such a portrait Expressionist.

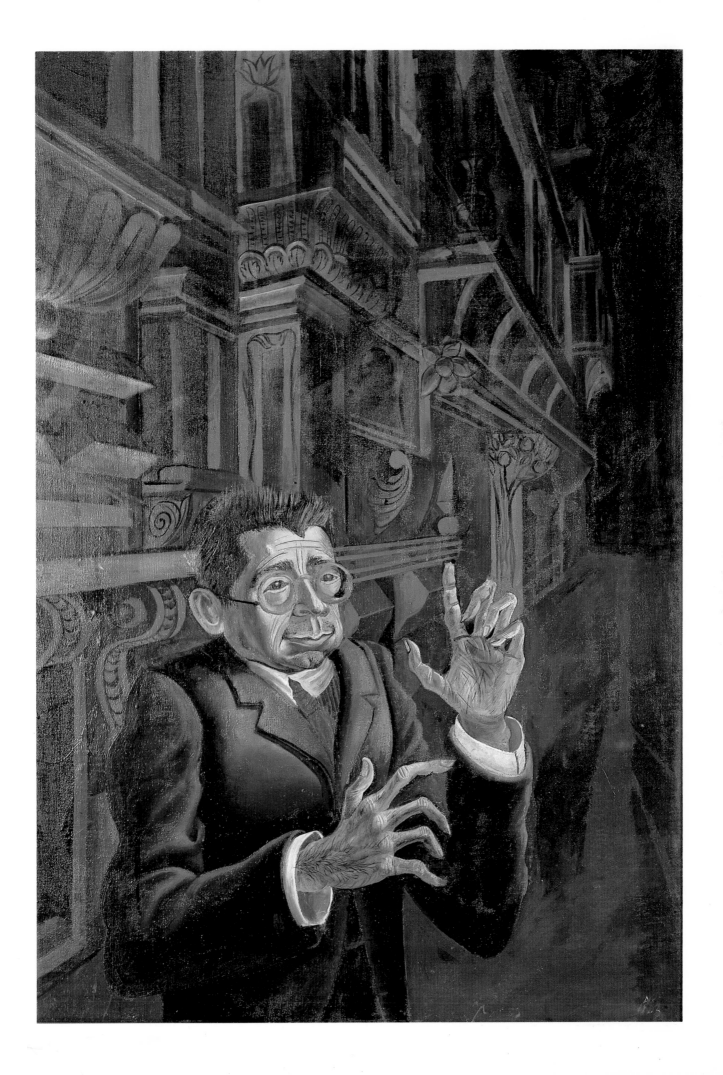

OTTO DIX

Portrait of my Parents II, 1924

DIX'S FATHER FRANZ (1862–1942) worked in an iron foundry for most of his life. His mother Louise (1863–1953) seems to have been more artistically inclined. Certainly, to judge from the number of drawings and paintings Dix made of her throughout her life (the last on her death bed), he felt closer to her than he did his father. An artist who sympathized with the underprivileged and unacknowledged members of society, Dix saw the marks of a lifetime's toil whenever he looked at his parents.

Dix painted them together twice, the first time in 1921 during visits to their home (and his birthplace) in Gera. This later version, which differs in some important respects from the earlier, was done from studies in his Düsseldorf studio. (Dix worked in the Rhineland city from 1922 to 1925.) While both portraits stress the physical effects of ageing, and portray the couple as almost broken by their labours, the second version is more colourful, places as much emphasis on details of wallpaper and sofa as it does on the lines of the faces and hands and shows the couple directly from the front and side by side.

This 1924 portrait reveals the extent of Dix's stylistic development since the self-portrait *To Beauty* (page 53). The magnified size and compositional importance of the hands betray a subjectivity which is entirely Expressionist. The sober observation and discipline are rigorous enough to put one in mind of the German Old Masters. Indeed, such artists as Cranach, Dürer and Holbein seemed to Dix especially admirable models, not only of technical skill and detailed representation but also of psychological penetration in portraiture. The high finish of Dix's portrait is the result of the patient application of transparent glazes. Equally traditional is the presence of a text on a piece of paper pinned to the wall. In a hand which wavers between German and Latin script Dix has written: 'My father 62 years old. My mother 61 years old. Painted in June 1924.' The monogram signature is a further device borrowed from Old Master painting; and yet in spite of so many references to tradition the picture is in no sense academic or anachronistic. Dix knew that even a style which celebrates the tiniest detail and sets out to achieve a convincing representation of an external object must be the result of elaborate artistic conventions, which here serve to intensify the expression of his feelings for the subject.

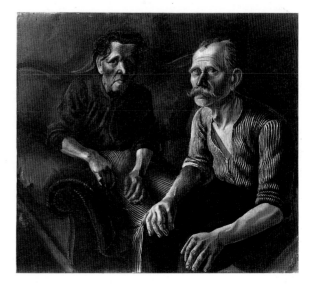

OTTO DIX
The Artist's Parents, 1921

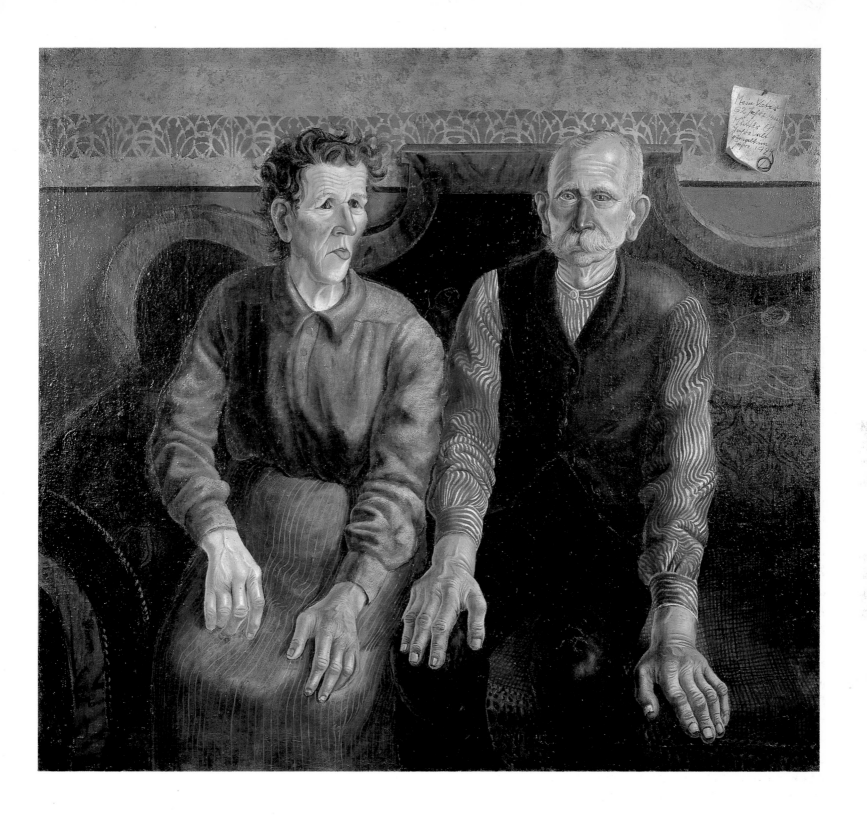

OTTO DIX

The Art Dealer Alfred Flechtheim, 1926

FLECHTHEIM (1878–1937) was one of the most successful dealers in Germany. He specialized in modern French painting and owned galleries in Berlin and in Düsseldorf, where Dix came to know him. He was also the publisher and editor of the influential literary and artistic journal *Der Querschnitt*, which he founded in 1921 and ran for the next three years.

Dix moved from Düsseldorf to Berlin in 1925, largely at the instigation of the Galerie Nierendorf which represented him and was anxious to establish his reputation in the capital. When the Nierendorf family realized that Dix was becoming increasingly friendly with Flechtheim, one of their rivals, they became alarmed that one of their potential stars was about to be poached. In fact Flechtheim did more to increase Dix's reputation than his fortune, and the Nierendorfs continued, very successfully, to represent the painter for several years.

This great portrait is, alas, the only remaining document of Dix's friendship with Flechtheim. When the Nazis came to power Dix burned all the correspondence that he believed to be compromising, including that with Flechtheim, a Jew. Flechtheim himself managed to escape to England where misfortune pursued him. First his wife committed suicide. Then he had an accident following which he had to have a leg amputated. He died from the effects of the operation.

Even given Flechtheim's notorious ugliness in life – which was an inspiration to several other artists, among them the sculptor Rudolf Belling – Dix's likeness is scarcely complimentary. With his left hand firmly on the frame of a painting by Braque (a Gris, ironically signed by Dix, hangs on the wall), and his right supporting his weight on an erotic drawing by Picasso, the dealer has been made to personify the acquisitiveness and even the greed on which his trade depends.

Almost thirty years after painting this picture, Dix admitted that it made Flechtheim look avaricious and grasping. He also said that it took him about three weeks to paint such a portrait. 'Most often I would make a precise drawing in front of the model and then, after transferring it to the canvas, I would undertake the underpainting, also in front of the model. I have learned that in front of the model you see something here and then there . . . gradually everything gets worse and worse and much too complicated . . . Consequently I reached the point where I gave it up, finished the work without the model.'

The underpainting was in tempera, which dried quickly. In the manner of the Old Masters Dix then proceeded with layer after layer of transparent glazes, each more colourful than the last.

RUDOLF BELLING
Alfred Flechtheim, 1927

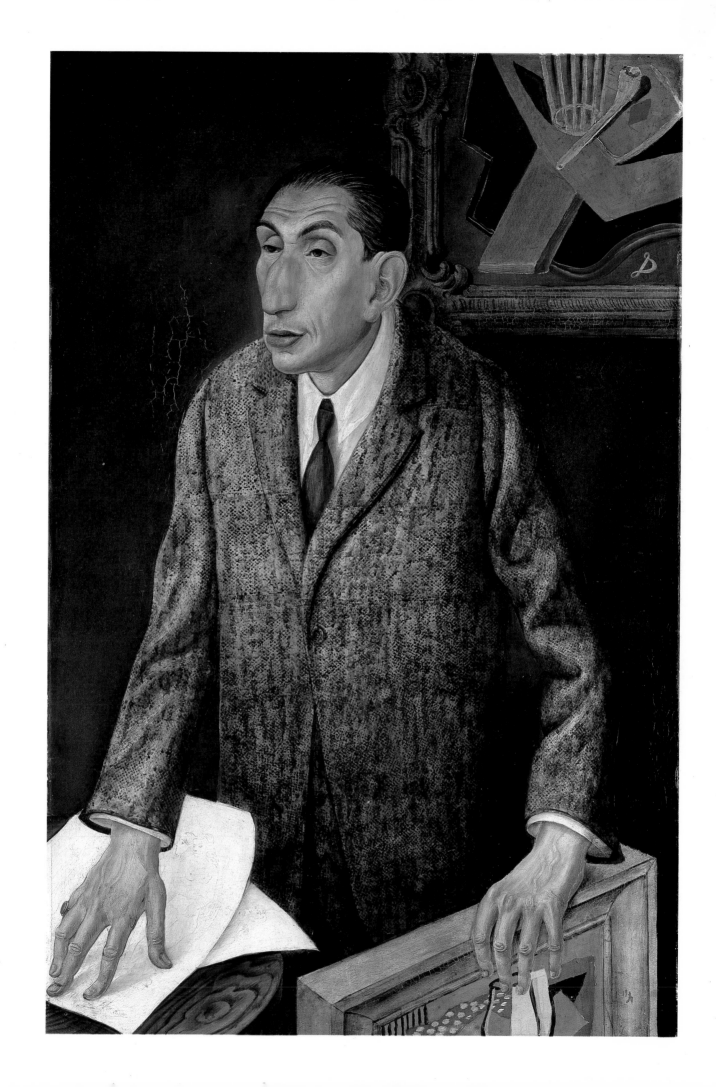

OTTO DIX

The Journalist Sylvia von Harden, 1926

THIS PORTRAIT is not merely one of the most important ever painted by Dix, it is one of the most important (because most evocative) to have come out of Weimar Germany. The designer of the film *Cabaret* knew what he was doing when he placed an actress dressed and made-up to look like the figure in this portrait in the opening scene.

The predominant, feverishly hot red, the awkward pose, huge supple hands, the tired, hooded eyes, prominent teeth and dark mouth suggest talent and a coruscating wit as well as decadence and even deviance. The red-tipped cigarettes in the personalized box and the hint of stocking rolled below the hem of the skirt simultaneously suggest nonchalance and affectation.

Not everything we know about the sitter confirms these intimations. Sylvia Lehr was affected enough to call herself (more aristocratically and glamorously) von Harden, but she had little talent and less wit. A journalist of no great reputation, she earned most of what little money came her way from writing cheap romantic fiction. Nor was she markedly bohemian. She lived in a stable relationship with the left-wing writer Ferdinand Hardekopf, a regular contributor to the Expressionist paper *Die Aktion* and the translator of André Gide. She was also the mother of his child.

Sylvia von Harden spent many hours drinking in the Romanisches Café, presumably because that was where all the best writers and artists congregated and she liked to be seen in their company. The Romanisches Café was near the Gedächtniskirche in the West of Berlin and within walking distance of Dix's house on the corner of Kurfürstendamm and Fasanenstrasse. It was the centre of artistic life in Berlin after the First World War, as important as the Café des Westens had been before it. There Dix could be seen almost nightly with such painters as Max Oppenheimer and Max Slevogt and such poets as Ivar von Lücken, whom he also portrayed. It was there, too, that he met Sylvia von Harden.

Sensing that fame depended exclusively on the fact that Dix had painted her, Sylvia von Harden never allowed anyone to forget it, least of all Dix himself, with whom she remained in contact for the rest of her life. She sought exile in London during the Nazi period and remained there in reduced circumstances until her death in 1962.

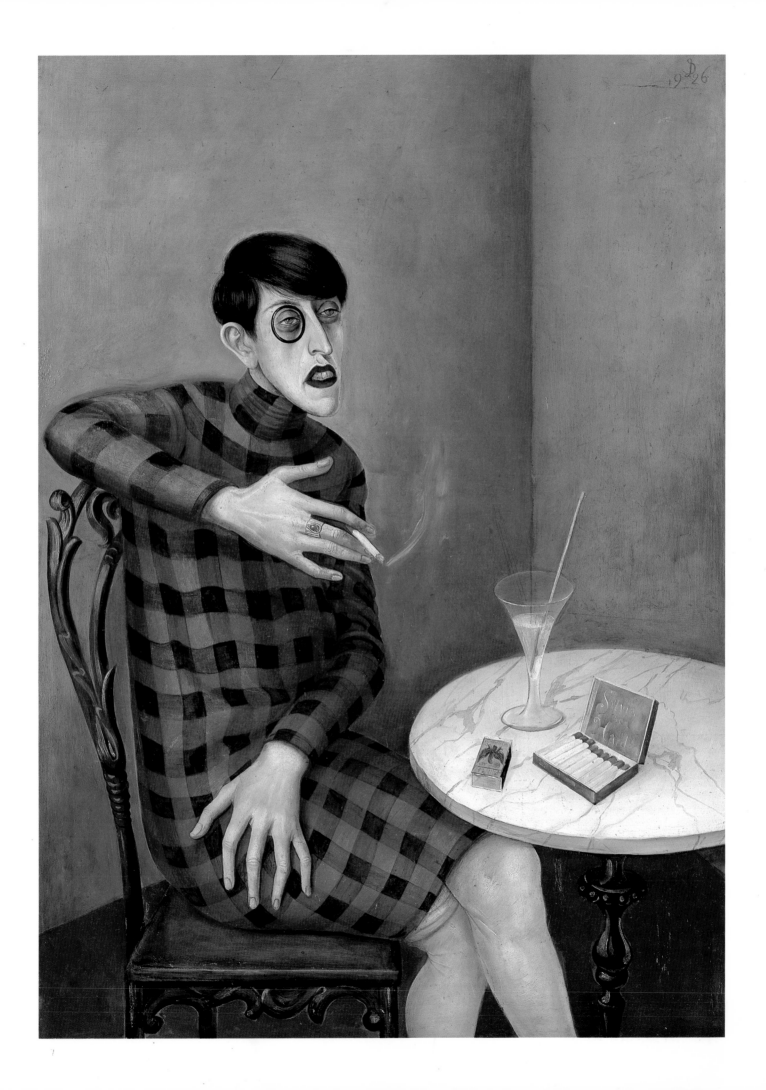

GEORGE GROSZ

Max Hermann-Neisse, 1927

GROSZ (1893–1959), self-taught as a painter and during the early 1920s best-known as a satirist and political cartoonist of the radical left, was a close friend of the writer Max Hermann-Neisse (see page 120). He drew him on countless occasions and painted him twice. This is the later and less familiar of the two portraits. The earlier hangs in the Kunsthalle in Mannheim, where it was first publicly shown in the *Neue Sachlichkeit* exhibition of 1925 soon after it was completed. In our portrait the sitter dominates the foreground, and the background is filled with details suggesting a studio atmosphere, while in the earlier painting the tiny deformed figure sits isolated in a chair on a dais against a more or less bare background. The earlier picture quickly became famous: perhaps Grosz made this second version in an attempt to repeat his success.

Between 1922 and 1925 Grosz had done little or no painting, preferring to concentrate on cartoons, book illustration and other graphic work. The Mannheim version of the portrait was the first painting he attempted after the break, and he admitted to having had difficulties with it. The second version is looser and more confident. The preparations for it were also very elaborate, involving the making of several highly worked and painstaking pencil studies.

'I always felt at home with George Grosz', wrote Hermann-Neisse in an article about the artists he had known. 'We had roughly the same opinions and moods, the same inclinations as collectors and the same (aggressive) feeling for the trivia of life, we came from a very similar background, we both liked to drink kirsch and we talked the same language if not in the same dialect, we were both lyric poets as well as cynics, correct and anarchic! I sat for him countless times with great pleasure and was delighted to be in his studio, where there reigned among the tools an exemplary order of the kind I liked, and against the walls stood the pictures which for normal, respectable citizens were truly a chamber of horrors. He worked on my portrait with a care which made creation a serious business . . . in between we made excursions to all sorts of strange pockets of life: to a dance hall for servants in the Chausseestrasse, a music hall with an all-girl band or to a *bock*-beer festival on the Hasenheide.'

The *Neue Sachlichkeit* exhibition of 1925 is frequently cited as marking the end of Expressionism by revealing for the first time the extent of the interest in Realism shown by artists throughout Germany. Yet *Sachlichkeit* (best translated as 'Sobriety', 'Objectivity') is as loaded a word as 'Realism', and few of the artists represented at the Mannheim exhibition were primarily concerned with the faithful transcription of visible facts. No doubt Grosz liked Hermann-Neisse to sit for him so much because – with his hump, diminutive stature and goatish features – he was a living caricature, offering Grosz the opportunity to paint a portrait that was at the same time 'objective' and intensely expressive.

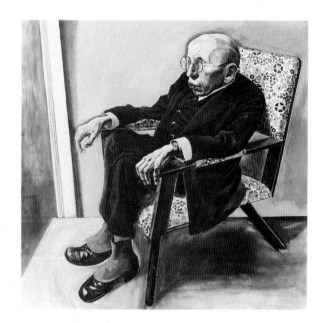

GEORGE GROSZ
Max Hermann-Neisse, 1925

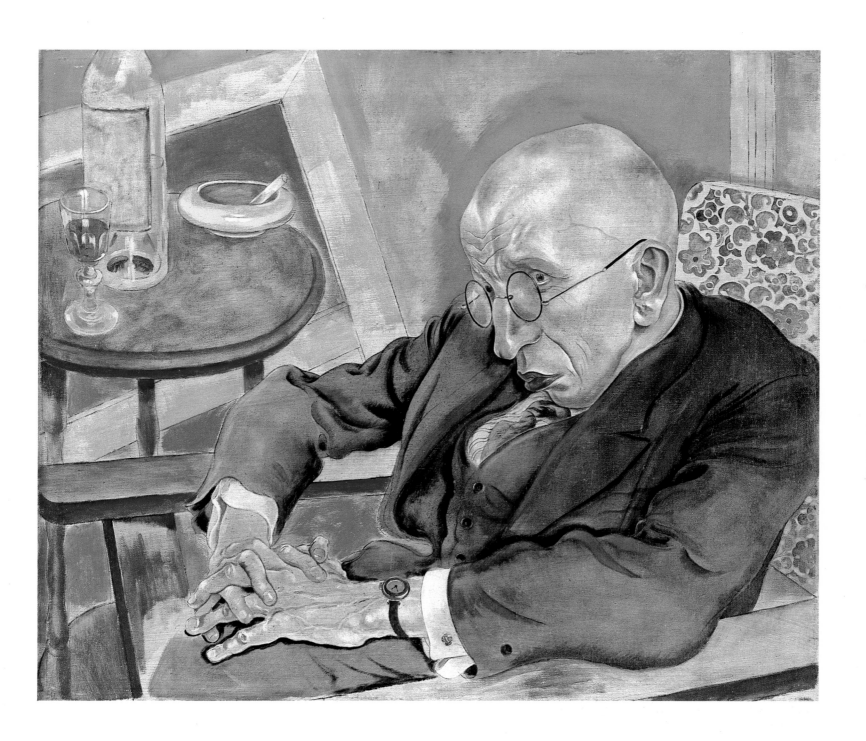

OSKAR KOKOSCHKA

Karl Kraus I, 1910

KOKOSCHKA PAINTED Karl Kraus twice – in 1909 and 1925 (the earlier version is lost) – and he also drew him twice. This ink drawing was made for publication not only as an illustration in *Der Sturm* but also as one of a series of *Sturm* postcards of portraits of literary and artistic celebrities. It is less like photographs of Kraus than is the later pencil sketch. The wide variety of marks, those on the face like eruptions caused by some serious disease of the skin, are very similar to those equally imaginative scratches, smearings and blotches which appear in the paintings of the same year, the results of what were virtually attacks by the artist on his canvas.

Kokoschka owed a great deal to Kraus, the most brilliant German-speaking writer and journalist of his day who, in the pages of his magazine *Die Fackel* ('The Torch'), anatomized society to disclose only corruption and the stench of decay. Kraus permitted the young artist to join his very select circle at his regular table in the Café Central in Vienna, mostly, it seems, on the strength of Kokoschka's connection with Adolf Loos (one of the few people Kraus admired). Kraus supported Kokoschka when few others would. As early as 1910 *Die Fackel* published an appreciative article about his work. It was Kraus, too, who was initially responsible for the contact with Herwarth Walden. Walden admired *Die Fackel* and wanted to found a paper as like it as possible in Berlin. Kraus was enthusiastic enough to lend Walden money to begin his enterprise, and for a time the editorial offices of *Der Sturm* in the Halensee area of Berlin acted as the German branch of *Die Fackel*.

Convinced that the moral condition of a culture is reflected clearly in the state of its language, Kraus inveighed against the contemporary, unthinking and grandiloquent use of German, especially by journalists and politicians. He himself wrote in the most exceptionally precise, never dry and always vivid way. His style was especially appropriate to the creation of barbed and polished aphorisms, at least two of which concern portraiture. Of the 1909 Kokoschka portrait he wrote: 'Those who know me will not recognize me in this picture. But those who do not know me will.' With equally clear insight into the nature of the art he also asserted that 'In a true portrait one must recognize which painter it represents.'

OSKAR KOKOSCHKA
Karl Kraus II, 1912

OSKAR KOKOSCHKA

Alma Mahler, 1912
Alma Mahler, 1913
Paul Scheerbart, 1910

THE EARLIER OF THE two black crayon drawings of Alma Mahler is dated quite precisely: 12 April 1912. There is a mystery here. Kokoschka's first letter to his future mistress, apparently written on the day after he met her, is dated 15 April. Even if the artist had dated his drawing long after it was done, it is unlikely that he would have forgotten when the first meeting had occurred. Alma Mahler dominated his thoughts for years, and the date must have been etched on his mind.

The later, more elaborate drawing seems better to represent the actual appearance of the woman who was considerably older than Kokoschka (she was thirty-three, he was twenty-six), and whose attraction (to judge from photographs and eye-witness accounts) depended more on a mesmeric personality and an intoxicating aura of sensuality than on any outstanding natural, physical beauty.

The daughter and step-daughter of painters, Alma Schindler (1879–1964) was gifted musically and as a young woman cultivated the company of performers and composers. She married Gustav Mahler in 1902 and was still in mourning for him when she began the affair with Kokoschka, whom she first met when he came to her house to draw her portrait. Because of the recent death of her husband she tried to keep the liaison secret. Kokoschka, who wanted to shout about his feelings from every rooftop, found this frustrating. He was also excessively jealous and possessive. According to her, the affair was 'a single violent lovers' quarrel. Never before had I tasted so much tension, so much hell, so much paradise'. He wanted very much to marry her. She wanted no such commitment and, when she discovered that she was pregnant, aborted their child. It should have been clear to Kokoschka that she had lost interest even before he began his military training in January 1915. In fact she had revived an old affair with the architect Walter Gropius and, unknown to Kokoschka, married him in August 1915.

Soon after that she began to live with the Expressionist writer Franz Werfel (later famous for his popular novel *The Song of Bernadette*), whom she subsequently also married.

The portrait of Paul Scheerbart was made for *Der Sturm* and published in the series of postcards to which the drawing of Kraus also belongs. Scheerbart (1863–1915), of whom Kokoschka also made a portrait in oils, was a writer of weird, fantastic and dream-like novels, a kind of highly individual science-fiction. He also wrote *Glasarchitektur* (published under the *Sturm* imprint in 1913), a piece of speculative, Utopian theory couched in ecstatic Expressionist language which influenced several architects, among them Bruno Taut.

Nrn 12. April 1912 OK

17. VI. 13

OK

OK

LUDWIG MEIDNER

Jakob van Hoddis, 1914
Alfred Wolfenstein, 1921
Johannes R. Becher, 1922

MEIDNER'S PORTRAITS make up an almost complete gallery of literary Expressionism. *Die Aktion* published many of them; the first Expressionist verse anthology, *Menschheitsdämmerung* ('Twilight of Humanity', 1920) includes among its portraits of poets more by Meidner than anyone else.

The first poem in the book, 'Weltende' ('End of the World') by Jakob van Hoddis, expresses the apocalyptic hopes and fears of a whole generation. It provides the closest verbal equivalent to Meidner's own cityscapes.

> From off the fellow's pointed head his hat is flying.
> And, scream-like, echoes bounce around the skies.
> Roofers collapse, go down, divide,
> And, at the coast – we read – the flood tide's rising.
> The storm is there, the wild seas leap
> Upon the land to smash deep dykes untold.
> Most men suffer from a touch of cold.
> Express trains plummet from the bridges steep.

One of the most influential Expressionist poets, Van Hoddis (Hans Davidsohn, 1887–1942) did his best work before 1914, when he became mentally ill. He and Meidner shared long nocturnal walks: 'After midnight we would leave the Café des Westens to march straight-backed, straight ahead and rather briskly through the streets, always following our noses. While I, the painter, looked all around me enjoying the lively chiaroscuro, van Hoddis seemed unaware of his surroundings; but he was aware of them, and saw things that the painter ought to have seen.'

Die Aktion, which published the first edition of Van Hoddis's poems in 1918, also published those of Alfred Wolfenstein (1888–1945), whose 'Städter' ('Townsfolk') exemplifies not his Activist political commitment but the ambivalent Expressionist view of city life.

> Close together like the holes in the mesh of a sieve
> Stand the windows in rows, while house grasps hold
> Of house so fast that the cold
> Streets look swollen grey like strangled people. . . .
> Our walls are thin as skin,
> So everybody hears me when I cry and
> Whispering penetrates the air like moaning:
> And, as though silent in some hidden cave
> Untouched, unseen,
> Everybody stands apart and distant, feels: alone.

The career of Johannes R. Becher (1891–1958) illustrates the affinities between Activist Expressionism and left-wing politics. An ecstatic Utopian poet, a regular contributor to *Die Aktion* after 1912 and a Communist from 1918, Becher eventually became Minister of Culture in the German Democratic Republic and the author of its national anthem.

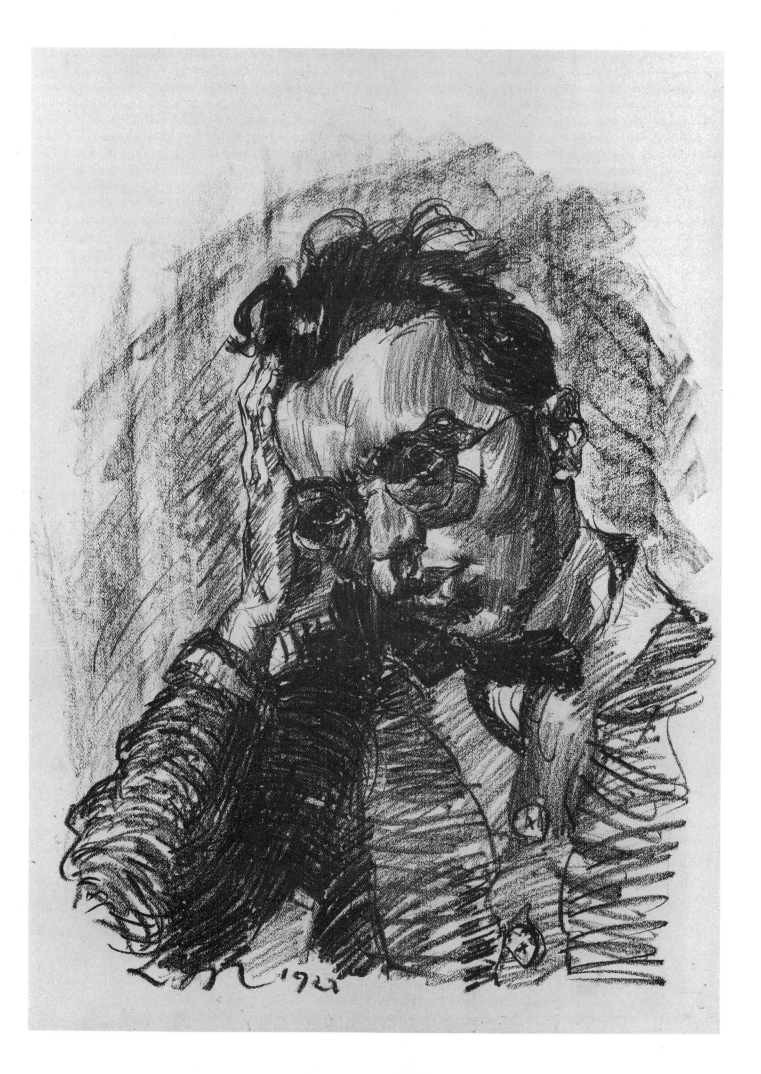

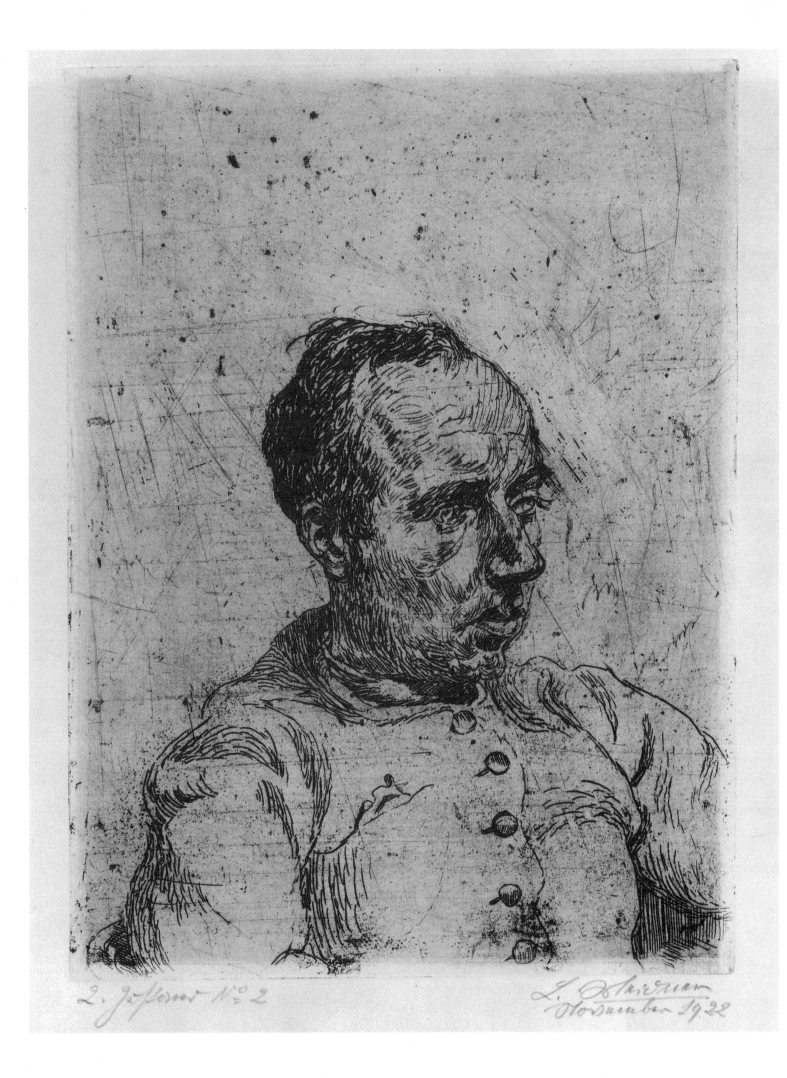

2. gestoren Nº 2 L. Steiner
 November 1922

EGON SCHIELE

Arthur Roessler, 1914

EXPRESSIONISM NO LESS THAN any other avant-garde movement depended for its survival in large part on critics. (Ernst Ludwig Kirchner knew this: aware that he was being neglected by the press and troubled by the consequences, he invented his own champion, a French critic, Louis de Marsalle, who was able to make the kind of statements about Kirchner that no one would have taken seriously had he uttered them himself.)

Arthur Roessler (1877–1955), the art critic of the Vienna *Arbeiter Zeitung*, began to write about Schiele in 1909 after he had seen his work in the exhibition of 'new artists', the *Neukünstlerausstellung*, which Schiele himself had helped organize. From then on and for long after Schiele's death, Roessler wrote about his work. Between 1921 and 1922 alone, he wrote or edited no fewer than five books on the subject. One of them was *Egon Schiele im Gefängnis* ('Egon Schiele in prison'), which purports to be the diary which the artist kept in 1911 while he was in Neulengbach jail on suspicion of sexually abusing children. No original manuscript exists and it seems that Roessler wrote it himself, no doubt basing it on conversations with Schiele, but dramatizing it enormously in the process.

Roessler, then, was largely responsible for the creation of the Schiele myth, the image of the misunderstood and tormented artist, the victim of an uncomprehending and philistine public. It is a measure of Roessler's gifts as a writer that the myth continues to be so tenacious. In fact, Schiele was neither so reviled nor so underrated as he liked to pretend; the 'suffering artist' was a vital part of the self-image he assiduously cultivated. He received very few portrait commissions, however, and was content to paint his friends. He lived mostly from the sale of erotic drawings of very young girls, and this of course was what led to his arrest at Neulengbach.

Roessler commissioned Schiele to paint a portrait of himself and another of his wife, and although the portrait of Roessler (Vienna, Historisches Museum der Stadt Wien) predates this drypoint by four years, it is very similar in the attitude of the head and the vital expressive rôle played by the hands.

Roessler in fact not only suggested to Schiele that he take up printmaking, but early in 1914 gave him money to buy tools and copper plates. Given the outstanding graphic qualities of Schiele's art it is surprising that he produced so few prints. The *oeuvre* catalogue lists only seventeen prints, and that includes a poster and such minor works as small rubber stamps. He made only six engravings (all of them drypoints), of which this is certainly the most accomplished.

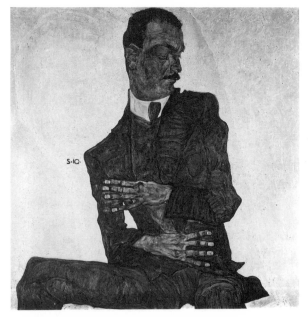

EGON SCHIELE
Arthur Roessler, 1910

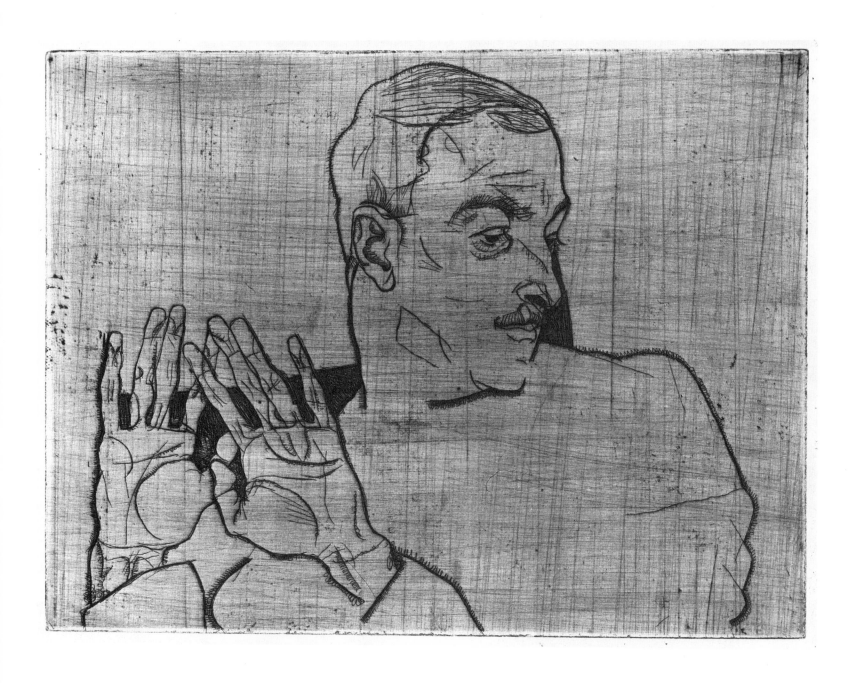

EGON SCHIELE

Albert Paris von Gütersloh, 1918

THE PAINTER GÜTERSLOH (1887–1973) exhibited many times with Schiele; the writer Gütersloh published one of the earliest and most sensitive appreciations of Schiele's art as early as 1911. The actor Gütersloh, born Albert Konrad Kiehtreiber, acquired his curious stage-name in the following manner. He was performing in the industrial city of Gütersloh when one day he was half-recognized in the street by a woman, who, struck by his good looks, asked a friend who he was. The friend, equally impressed, replied: '*Das ist der Paris von Gütersloh!*' He gratefully divested himself of Kiehtreiber.

It must have been difficult for Paris von Gütersloh to decide which of his talents to develop. He began his stage career in Berlin, where he joined Max Reinhardt's company in 1907, but seems to have given up acting by 1914, although he was later a theatre director in Munich in 1919–21. He had long since begun seriously to paint; his works exploit an outstanding colour sense but by comparison with those of Schiele or Kokoschka they are unadventurous, content (until 1914, at least) to remain in a distant orbit of Cézanne. His writing, on the other hand, especially the extraordinary, hallucinatory novel *Die tänzende Törin* ('The Dancing Fool'), written in 1910 when he was twenty-three, bears comparison with Robert Musil or any of his other great contemporaries. It was, however, as a painter that he made his career.

Schiele painted Paris von Gütersloh in 1918, not long before his own death, and the picture shows the sitter in a chair, holding both his hands up and with an intense expression on his face, as though he were in the act of hypnotizing someone. There are also at least two sketches for the portrait, and a further drawing was made to be transferred to a lithographic stone. All three drawings are extraordinarily assured. It seems that Schiele had no real need of exploratory studies to assist him in achieving a likeness. He simply transferred the image in his mind directly to the paper.

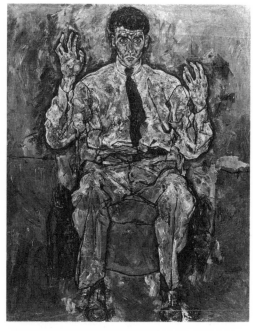

EGON SCHIELE
Albert Paris von Gütersloh, 1918

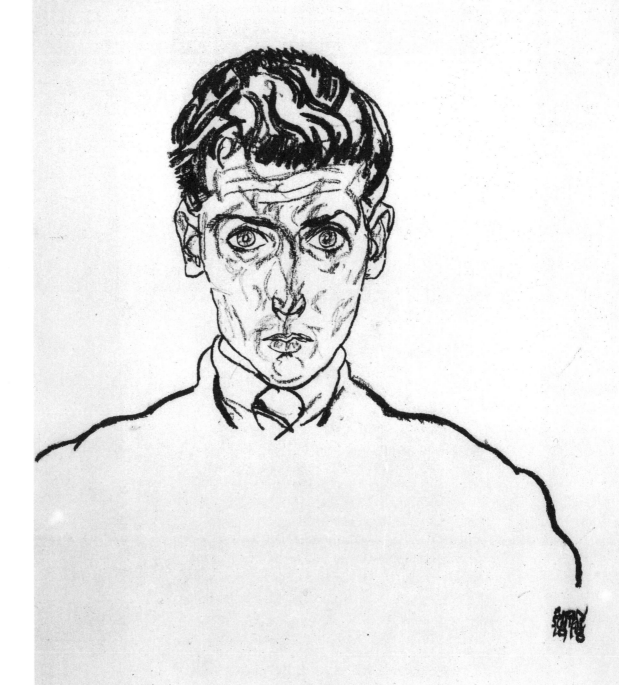

PARIS GÜTERSLOH

ERNST LUDWIG KIRCHNER

The Composer Klemperer, 1916

In January 1916 Kirchner wrote to Karl Ernst Osthaus, the wealthy industrialist, patron of contemporary art, and one of those who helped him survive the difficult months after his release from the army, that he was 'now in a sanatorium since I have scarcely been able to walk as a result of nervous debility. It is very difficult for me, but I have to endure things here for a time in order to be able to work again.'

The sanatorium was at Königstein, in the Taunus hills not far from Frankfurt am Main, and was directed by a Dr Kohnstamm, a psychiatrist as well as a general physician, interested above all in researching shell-shock and other mental problems caused by the war. Kirchner, who appeared at the time to live exclusively on cigarettes and the sedative Veronal, was greatly helped by Kohnstamm, but the artist's restless moods (and also, perhaps, the doctor's bills) took him away from Königstein for extended periods no less than three times during 1916. He left finally for Berlin in July 1916, and just before he did so he painted five murals in the sanatorium pump-room. (They were eventually destroyed by Nazi iconoclasts somewhen after 1933.)

Kirchner also made this woodcut during one of his stays at Dr Kohnstamm's sanatorium. It is based on a series of sketches of a fellow patient. At that time Otto Klemperer (1885–1973), a former protégé of Mahler's, had been making his way as a conductor, mainly in provincial opera houses, for some years; but his main ambition – as we can perhaps deduce from the title of the woodcut – was still as a composer. During the time of the Weimar Republic, Klemperer was to be director of the Krolloper in Berlin, the theatre that did more than any other between the wars to establish modern ideas of operatic design and production. The coming of the Nazis in 1933 put a stop to all that, and to Klemperer's career in Germany (he was a Jew). The rest of his long life was spent elsewhere. By the end he was probably the greatest living conductor, the last of a generation that included Furtwängler, Walter and Kleiber.

When Kirchner met him, Klemperer was recovering from one of his recurrent bouts of deep depression. Dr Kohnstamm imported a piano to aid his recovery, and Klemperer gave a number of recitals in the sanatorium. This fine woodcut (an etching and five drawings also exist) is the outcome of artistic therapy on the highest level, both for the sitter and for the artist.

ERNST LUDWIG KIRCHNER

Head of Van de Velde, Light, 1917

DURING THE LAST TWO YEARS of the war Kirchner's prodigious gifts as a graphic artist found expression in a series of large portrait woodcuts. Most of them employ a single colour; a very few are in three or four colours. Continuing the practice which he began during the early years of the *Brücke* in Dresden, Kirchner printed each sheet himself (often without a press).

Henry van de Velde (1863–1957) was one of the most versatile artists who ever lived. A Belgian-born painter, designer and architect, he was based for many years in Weimar where he built houses (one of them for Nietzsche), advised the local government on ways in which the quality of regional manufactures could be improved, and founded and directed the Kunstgewerbeschule, the school of arts and crafts. He resigned as director just before war broke out in 1914 and before he left he suggested the names of three possible successors. One of them was Walter Gropius, who in 1919 amalgamated Van de Velde's school with the Art Academy to form the Bauhaus. After Germany invaded Belgium, disregarding its neutrality, Van de Velde became increasingly aware of the danger of his continuing presence in Weimar. Having acquired a German passport (which somehow preserved his Belgian nationality), he contrived in 1917 to be sent as an official German envoy to Switzerland to look after the interests of German architects, artists and craftsmen interned there. He set up an office in Bern, and although he was responsible for the welfare of Germans in no fewer than three internment camps he seems not to have been too taxed by his responsibilities.

He had heard much about Kirchner both in Weimar and Berlin. Although the two may have met briefly at the *Werkbund* exhibition in Cologne in 1914, they did not know each other well. Soon after he arrived in Switzerland the architect resolved to visit the artist, who in 1917 was being treated at Davos by a Dr Luzius Spengler. The visit took place in July, after Van de Velde had sent a large sum of money to cover Kirchner's considerable debts. The artist was deeply impressed, less by the gift than by Van de Velde himself, who encouraged him in a fatherly way and promised to do whatever he could to improve his circumstances.

The architect, for his part, was disturbed by Kirchner's condition (his arms and legs seemed to be affected by irreversible creeping paralysis) and suggested that he move to a sanatorium at Kreuzlingen, run by a Dr Binswanger, whose uncle had successfully treated Van de Velde in 1914. At first Kirchner was reluctant to take this advice, wishing to be reassured that, among other things, Kreuzlingen was in Switzerland rather than Germany. For the summer of 1917 he preferred to go farther up the mountain to a place above Frauenkirch called the Stafelalp. There Kirchner was visited by Van de Velde for a second time on 25 or 26 August, when the sketches for this woodcut were made. A second version was made later, either from memory or from a drawing made directly on to the block in front of the subject.

ERNST LUDWIG KIRCHNER
Head of Van de Velde, Dark, 1917

ERNST LUDWIG KIRCHNER

Head of Dr Ludwig Binswanger and Little Girls, 1917–18
Head of Ludwig Schames, 1918
Head of David Müller, 1919

THE WOODCUTS which Kirchner made between 1917 and 1919 are not merely the most important prints he ever made, they are also among the greatest masterpieces of Expressionist graphic art. They overshadow the paintings of the same period, and although they employ a similarly wide range of subject-matter, their qualities are most apparent in portraits, of which Kirchner made no fewer than seventeen in the winter of 1917–18 alone. The heads of Binswanger and Schames belong to that important group of prints.

Binswanger, his image cut here on a piece of wood selected for its unconventional shape, was a physician, the director of the sanatorium at Kreuzlingen (on the Swiss shore of Lake Constance), to which Kirchner went on Henry van de Velde's recommendation in September 1917 and where he remained for an entire year (see page 168). Known both to Freud and Jung, Binswanger was essentially a psychiatrist himself. Although Kirchner did benefit somewhat from his treatment, Binswanger wrongly ascribed his illness, in particular the paralysis, to inadequate spinal marrow which, the doctor suggested, had developed before Kirchner's birth.

By the time Kirchner made his monumental and moving portrait of Schames, his Frankfurt dealer, he had left Kreuzlingen and was back at Frauenkirch in the mountains above Davos. The portrait was a commission from the Frankfurt Kunstverein, a private art association supported by members' subscriptions, in exchange for which they received an annual gift such as this print. Kirchner had not seen Schames since 1916, so, unless he had a photograph of him, he must have made the woodcut from memory. Since Kirchner did not have a press at home, each print was painstakingly made by rubbing over the reverse of a piece of paper with a hard tool. Once again, the block was chosen for its unconventional format. The female figure in the background is probably a large woodcarving executed in primitivistic fashion by Kirchner himself.

David Müller was one of the four sons of the Swiss farmer who in the autumn of 1918 offered Kirchner a home in one of the houses on his mountain farm (called 'In the Larches') at Frauenkirch. The print was published as part of one of the portfolios issued by the Bauhaus in Weimar as a means of raising money for the school. Kirchner, who probably agreed to contribute to the portfolio because of the connections between the Bauhaus and Van de Velde, must have sent to the school's printing workshop the main block together with another of his signature.

ERNST LUDWIG KIRCHNER
Professor Dr Ludwig Binswanger, 1917–18

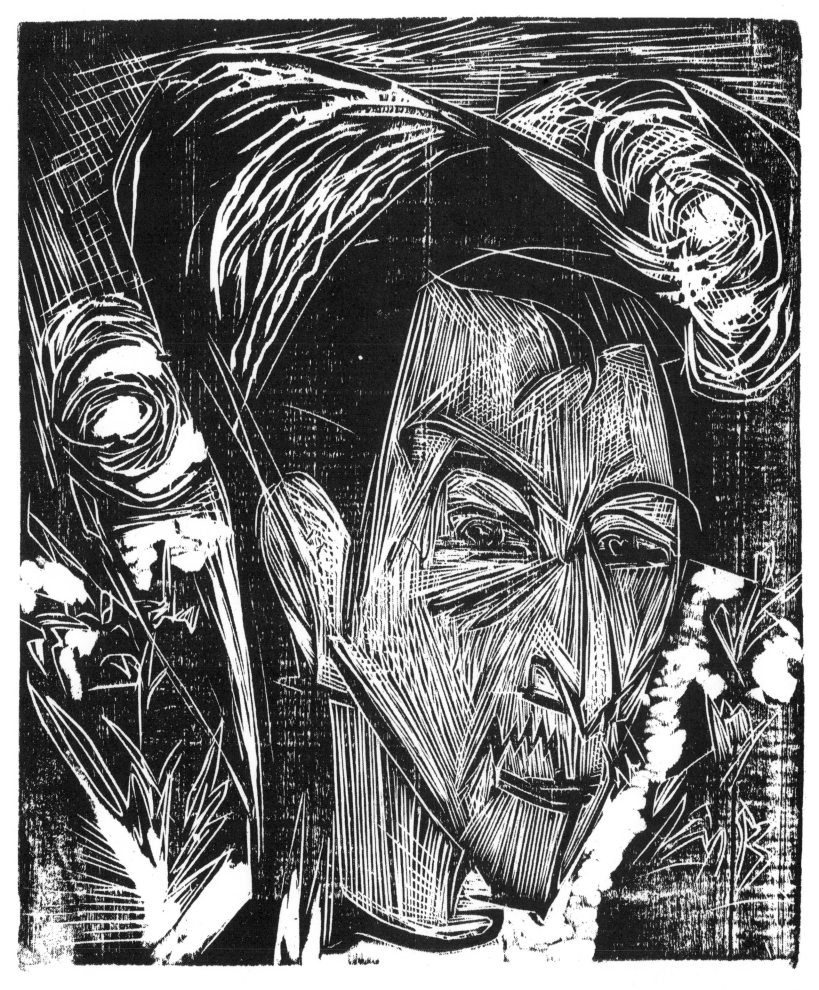

ERICH HECKEL

Roquairol, 1917

In 1912, soon after Heckel, Schmidt-Rottluff and Kirchner moved to Berlin in the footsteps of Pechstein, the *Brücke* celebrated its greatest success. It was given a prominent place in the *Sonderbund* exhibition in Cologne, the largest showing of modern art staged anywhere until then and the first sign visible to the general public that there was a school of Germans, conveniently if loosely described as Expressionists, and comparable in number and quality with anything foreign. In the same year, shows at private galleries, participation in the second *Blue Rider* exhibition and works by *Brücke* artists illustrated in the *Blue Rider Almanac*, provided further evidence of the increasing recognition of the group.

At the moment of success, however, strains that had been evident for some time threatened to destroy the group. Most of those strains were caused by Kirchner's view of himself as the natural leader of the *Brücke*. In 1912 he expelled Pechstein and ordered the withdrawal of the portfolio of prints by him intended as the annual gift to the 'passive' or lay members of the group who supported it with subscriptions. The immediate pretext for the expulsion was that Pechstein had exhibited on his own; but Kirchner had been unhappy for some time with the critical attention Pechstein's work had been receiving.

In 1913 Kirchner suggested that instead of the usual portfolio of prints which the *Brücke* published annually, it should send to members an illustrated history of its activities since 1905. The other members agreed and contributed graphics. But when they saw Kirchner's text, which made it seem as though he had dominated the *Brücke* from the beginning and that they were merely his disciples, they refused to agree to its publication and resigned from the group. Later Kirchner made a few copies of this text, the *Chronik der Brücke* ('Chronicle of the *Brücke*'), and published them in Switzerland.

Heckel and Kirchner did remain in touch, however, and in 1914 worked on murals together at the *Werkbund* exhibition in Cologne. Then the war came, and Kirchner went off to military training in Halle and then to sanatoria in Germany and Switzerland, while Heckel was a medical orderly in Flanders (where he met Beckmann and visited Ensor at Ostend) from 1915 until the armistice.

This woodcut and the painting of the same name were made, presumably, in Flanders where an understanding superior officer allowed Heckel time to work. The title is the name of a character in *Titan*, a novel of 1800–03 by the German Romantic writer Jean Paul. Roquairol is a typically Romantic character, hypersensitive, inwardly split and weighed down by the consciousness of his own guilt. Heckel, who read a great deal, especially the German classics, obviously recognized Kirchner in the fictitious character and made this image of a psychologically wounded man in the likeness of his former friend.

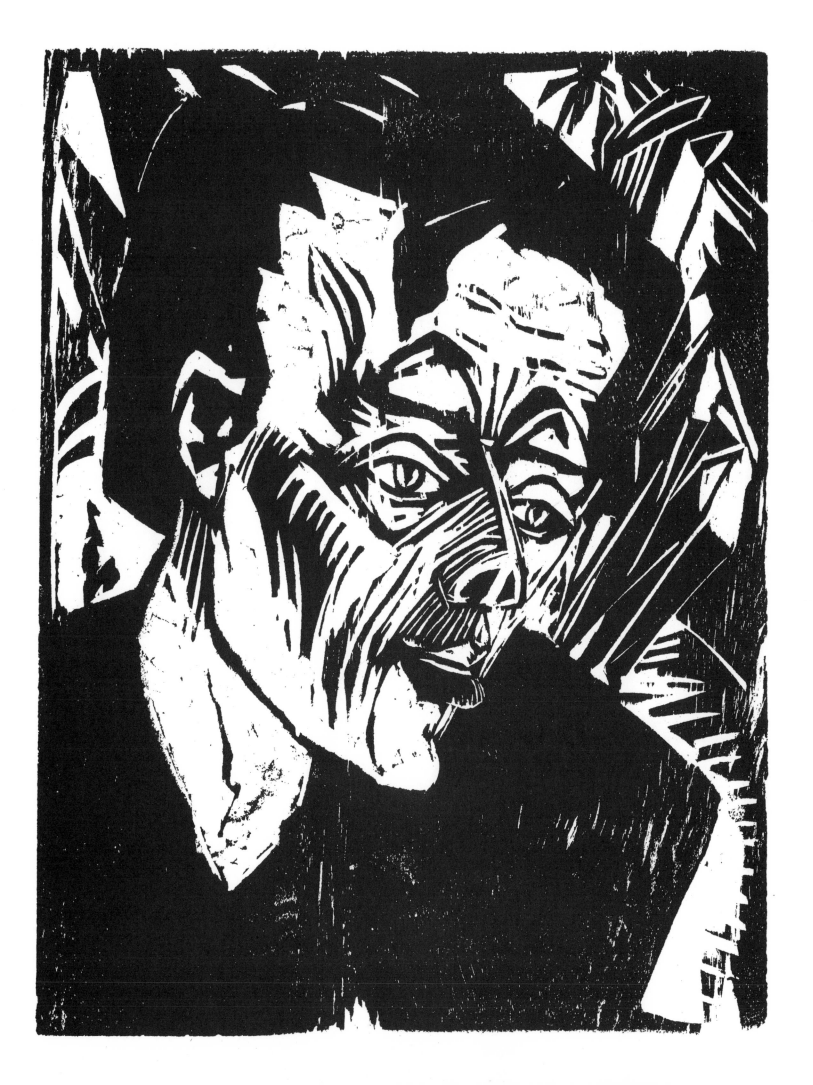

ERICH HECKEL

Asta Nielsen, 1919

THE RELATIONSHIP BETWEEN the Expressionist movement and the cinema was remarkably close and fruitful. Artists, writers and intellectuals took film very seriously and longed to help shape what they regarded as potentially the most vital art form of the twentieth century. Painters and architects with established reputations, such as César Klein and Hans Poelzig, designed movie sets; Schoenberg wrote a score for an imaginary silent film; writers as talented as Albert Ehrenstein, Max Brod and Walter Hasenclever contributed screenplays for *Das Kinobuch* ('The Cinema Book') which was published in 1914 by the most active Expressionist publisher, Kurt Wolff of Leipzig, and edited by Kurt Pinthus who was also to edit the most successful anthology of Expressionist poetry, *Menschheitsdämmerung* ('Twilight of Mankind', 1920).

This woodcut portrait, highly stylized and even more highly unflattering, of the 'Nordic Duse of the cinema art' and one of the most beautiful women to grace the silent screen, provides a further fragment of evidence of the love affair between the Expressionist generation and the cinema.

The Danish-born actress Asta Nielsen (1881–1972) was perhaps the most popular film star in Germany after the First World War. She made her first film in 1910 and is now best remembered for her starring rôles in Jessner's *Erdgeist* of 1923 ('Earth Spirit', after the play by Wedekind) and Pabst's *Freudlose Gasse* ('The Joyless Street', of 1925) in which the cinema registered the same shift from Expressionism to Realism that was occurring at the same time in the other arts.

Nielsen inspired several poems by gifted writers. One of the best-known of them is by the Expressionist poet Hans Schiebelhuth. It first appeared in *Wegstern*, the volume of lyric poems he published in 1921.

ERICH HECKEL
Asta Nielsen, 1920

> You are the murder that took place somewhere in me while I still wore
> knickerbockers.
> Since then you are the black angel with the sword of fate,
> who never leaves me, suckling my dreams with poison.
> . . .
> I can no longer think, you always turn me upside down.
> My songs have long since been given away to your many lips.
> It is so sweet to squander myself on you.
> Again and again I must sit about in cinemas,
> cow-eyed I tear you out of every film,
> Still perplexed only for that part of my life
> which cries darkly soft for you before the screen.

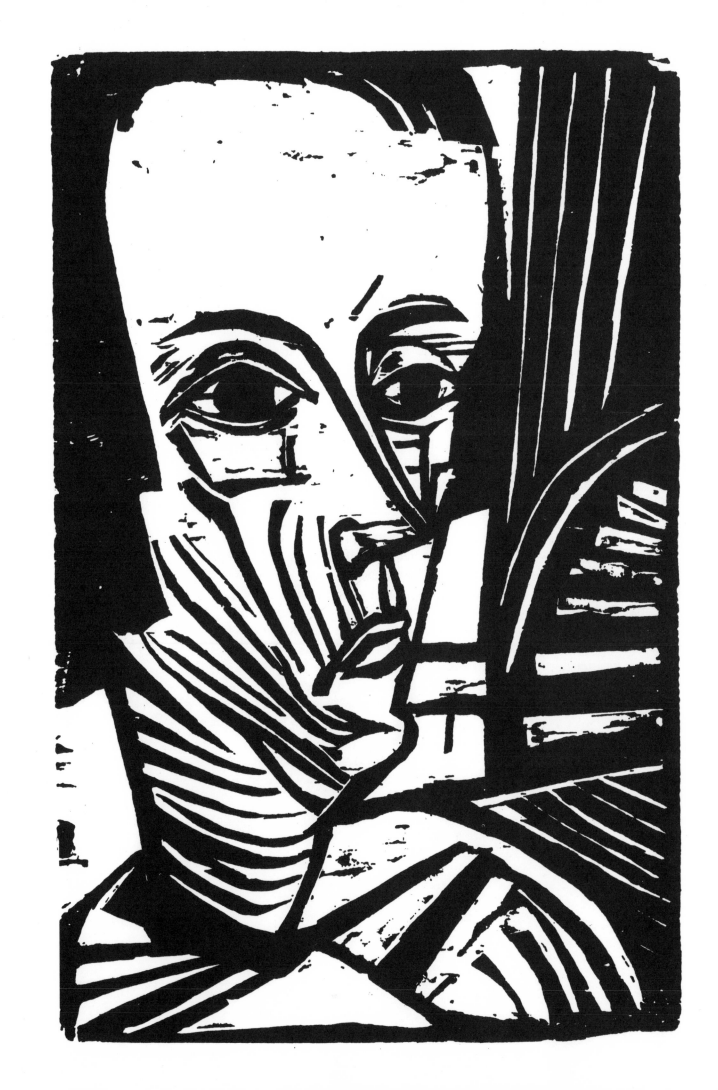

MAX BECKMANN

Woman with Candle, 1920

BEFORE THE WAR and the radical change in his style, Beckmann publicly expressed his hostility to Expressionism, most famously in an attack on the Munich artist Franz Marc in the pages of the periodical *Pan*. It was not least the claims of Expressionism to metaphysical truth which he rejected. It was ironic, then, that the new manner which Beckmann introduced in 1917 owed more than a little to Expressionism, not least in the marked attenuation of the figures and the preference for a crowded, narrow and otherwise claustrophobic space. These are, of course, also characteristics of Gothic painting, and in November 1917, in the foreword to a print catalogue published by his dealer I. B. Neumann, Beckmann wrote: 'I love the 4 great painters of virile mysticism: Mälesskircher, Grünewald, Breughel and Van Gogh.' It was an avowal that might have been made by any of the Expressionists whom he had earlier claimed to dislike so much.

The post-war Beckmann comes closest to the Expressionists in his prints, especially his woodcuts. This portrait of a woman can be directly compared with Kirchner's likeness of Schames (page 172); although it must be admitted that some of the similarities are the result of imperfect cutting in the Beckmann at this early stage of the print's making. In later states the lines and open areas of white are considerably more tidy and precise.

The woman is almost certainly Beckmann's first wife, Minna, *née* Tube, whom he married in 1906. After the birth of their son Peter she became increasingly interested in singing and in 1915 joined an opera company. That was while Beckmann was in Strasbourg recovering from his mental collapse. Both her burgeoning career and his state of mind, especially his desire to make an entirely new start in his art as well as life, caused them to drift apart, and their relationship had cooled considerably by the time this print was made. In 1914 Beckmann met Mathilde von Kaulbach in Vienna. Called 'Quappi' by the mutual friend who introduced them (presumably as an allusion to the word *Kaulquappe* – 'tadpole'), she, too, was a singer but, unlike Minna, was prepared to abandon her career for her husband.

Candles and mirrors play an important (if unclear) rôle in Beckmann's symbolism. Their meaning here is as impenetrable as elsewhere in his paintings and prints.

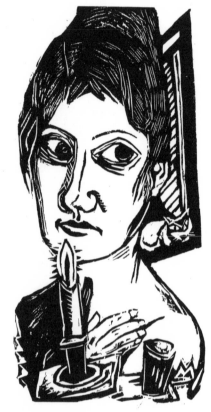

MAX BECKMANN
Woman with Candle, 1920 (later state)

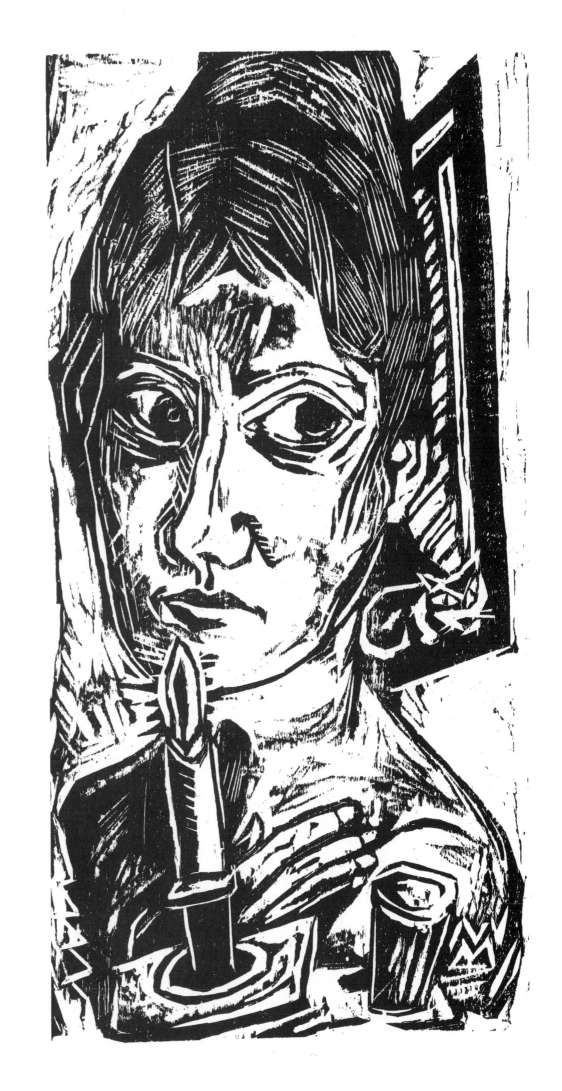

MAX BECKMANN

Group Portrait, Eden Bar, 1923

THIS IS ONE OF THE LARGEST and most complex of Beckmann's eighteen woodcuts (there are some three hundred prints in all media in his graphic *oeuvre*) and although the figures are not identified in the title we know them to be, from the left, Johanna Loeb, her husband Karl, and Elisa Lutz. All of them were friends of Beckmann. They sit around a table in the bar of the Eden Hotel in Berlin. Behind them three musicians can be seen from the neck down.

The woodcut was the quintessentially Expressionist graphic medium. It carried medieval overtones; it produced bold, sharp images, and it could create effects that were consciously primitivistic. It was frequently employed by Kirchner, Schmidt-Rottluff and Nolde who, together with Heckel, were largely responsible for continuing the revitalization of this, the oldest print-making technique, that was begun towards the end of the nineteenth century by Gauguin and Munch. Kirchner and Nolde also used subjects taken from Berlin's cabarets, bars and dance halls, and other Expressionists were equally fascinated by the tawdry glamour, the tired spectacle and forced levity of the capital's little theatres and clubs. They, however, concentrated on the acts on stage, the dancers, acrobats and comedians, while Beckmann here is only interested in the audience.

Not surprisingly, Beckmann is at his most Expressionist as a maker of woodcuts. Here, the atmosphere created by these three fashionably dressed, sophisticated people is in itself Expressionist: in spite of their physical closeness they seem spiritually isolated, alienated from their surroundings and each other.

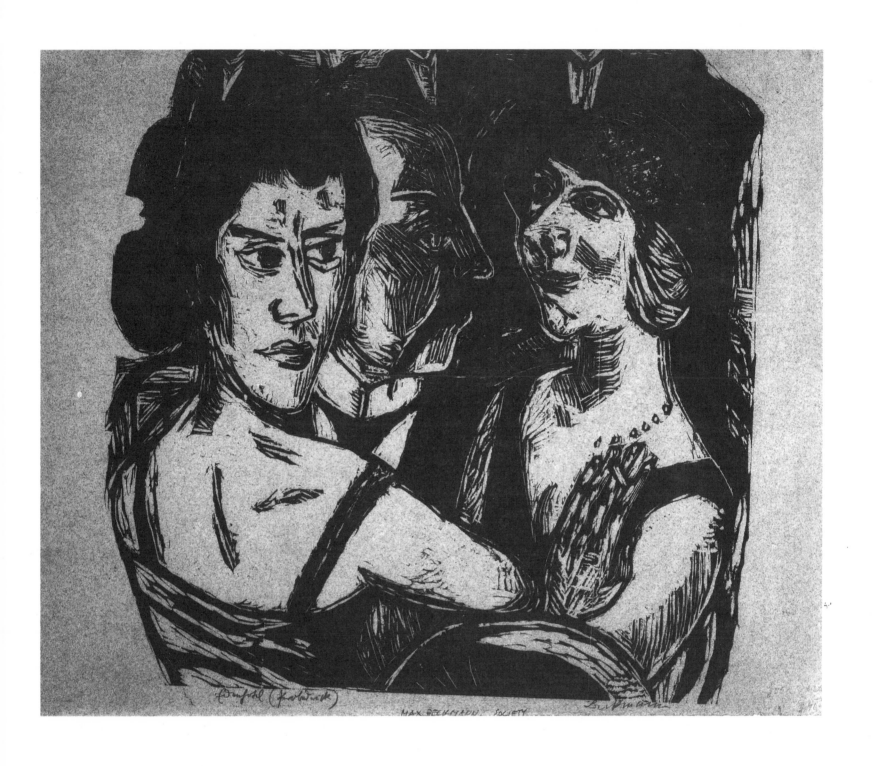

MAX BECKMANN, SOCIETY

OTTO DIX

Sweet Little Elly, 1921
I. B. Neumann, 1922
Paul Westheim, 1923

AFTER THE FIRST WORLD WAR, Dix drew and painted several pictures in which crippled veterans beg or sell matches on street corners and whores tout for custom or pleasure their clients with varying degrees of enthusiasm. Such work is among the most memorably shocking to have come out of the early years of Weimar Germany, a republic that to its critics perpetuated the worst of the monarchy's social injustices, a nation newly dedicated to freedom and equality in which pimps and war profiteers flourished while the rest were needy and miserable. The obsession with grotesque, revolting detail in Dix's work of this period is a product of his belief that beggars and whores were the types most representative of defeated, disillusioned and bankrupt Germany. The cripples, who shout nationalistic slogans as they propel their legless bodies along on wheeled carts, have learned nothing. The whores know that they can survive only by pretence. Their beauty is skin-deep, their promise of ecstasy all too hollow.

Most of Dix's whores are not even superficially pretty. He frequented brothels himself, and it was in one of these in Dresden in 1921 that he produced a series of portrait drawings in preparation for the two paintings he called *The Salon*. These unfortunate women are of varying age and varying charms. Elly and Mia are two of the more attractive; one of the most horrifying is an ageing crone dressed in a hat and low-cut, feather-trimmed dress. Dix identifies this nightmarish vision as 'Elsa, the Nun from the Café Casino'.

Most of the drawings are not devoid of humanity, however. On the contrary: by emphasizing their very inadequacies, Dix engages our sympathies. They are not the predators. Society itself is predatory and forces them to demean themselves.

Dix was involved with various dealers at different stages of his career, first Israel Ber Neumann, then Karl Nirendorf and finally Alfred Flechtheim. Neumann worked on Dix's behalf in Düsseldorf and emigrated to New York in 1925, at about the same time as the artist moved to Berlin. He also published books and an Expressionist journal, *Der Anbruch*. Dix remained in touch with Neumann for years and turned to him for help when he found himself in difficulties during the Nazi period.

Paul Westheim was a distinguished art historian and critic, the editor of the most important German journal concerned with contemporary art, *Das Kunstblatt*. No less a writer than Theodor Däubler wrote an article about Dix for it as early as 1920. Later Westheim took Dix's part in public controversies about his art, which was widely condemned as pornographic.

OTTO DIX
Mia, 1921

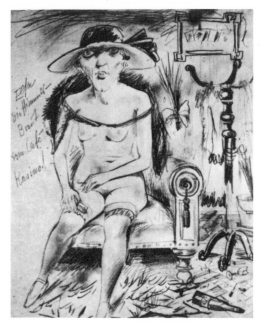

OTTO DIX
Elsa, the Nun from the Café Casino, 1921

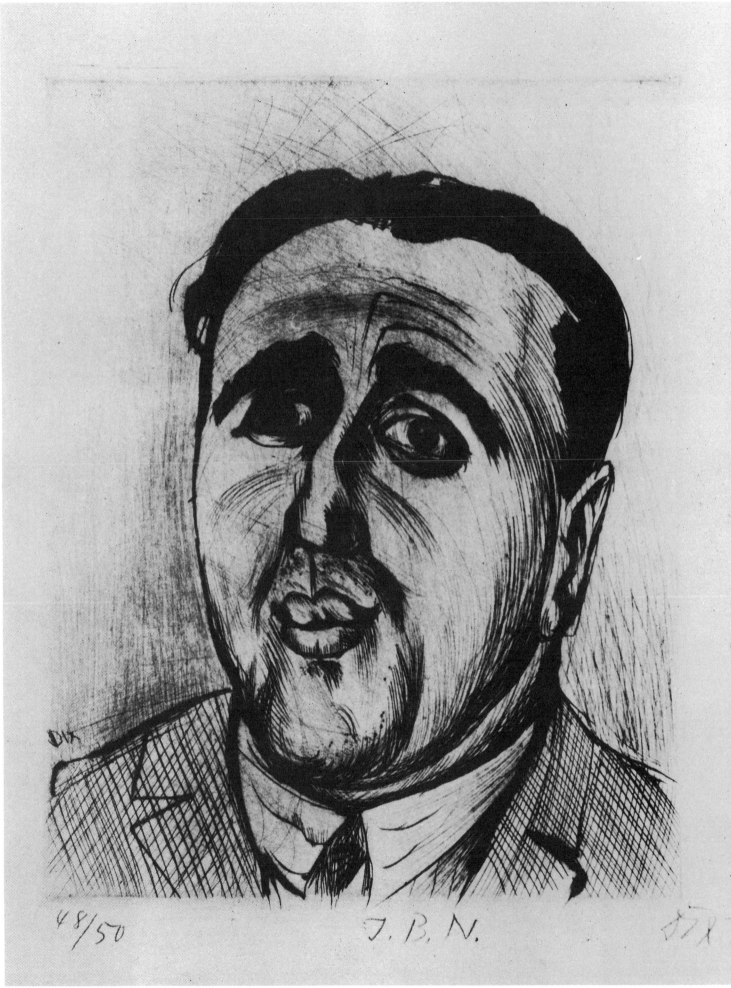

48/50 J. B. N.

GEORG TAPPERT

Franz Pfemfert, 1921

ALTHOUGH *Der Sturm* was the earliest Expressionist periodical, it did not remain free from competition for long. On 20 February 1911 its most serious rival emerged in the form of *Die Aktion* which, also a weekly, consisted of a similar mixture of literature, comment and graphics, most of them woodcuts. It was by no means an imitation of *Der Sturm*, however. It was much more political, espousing the view that art can and should influence opinion and that Expressionism was predestined to culminate in actual rather than simply aesthetic revolution. By the end of 1911 it boasted more of the first rank of Expressionist writers among its contributors than *Der Sturm*. During the First World War, when *Der Sturm* became almost anodyne in the face of censorship, *Die Aktion* managed subtly to air its pacifist and republican views. Painters were urged to build barricades, poets to take an active part in politics.

Die Aktion was founded by Franz Pfemfert (1879–1954), who edited it until 1932 when he deemed it wise to cease publication of what had in any case already become a tired and lacklustre journal. During its dynamic years many major Expressionist artists contributed to its pages, among them Meidner, Morgner, Oppenheimer, Schiele, Schmidt-Rottluff, Grosz, Kokoschka, Marc and Kirchner. Felixmüller was the most gifted graphic artist to collaborate with Pfemfert after 1918, when *Die Aktion* was at liberty to become more directly political. It supported Karl Liebknecht and Rosa Luxemburg and the Communist Party they founded, and it supported the Bolshevik government in the Soviet Union until disillusionment transformed Pfemfert into a Trotskyite.

In 1933 Pfemfert left Germany for Czechoslovakia, pursued by the Gestapo. He eventually found his way to Mexico, where he worked as a commercial photographer without ever writing another word for publication. He had long since abandoned the belief on which *Die Aktion* was founded, that art could – and would – change the world.

Georg Tappert (1880–1957) was one of the most regular contributors to *Die Aktion* during the years of the war and the early years of the Weimar Republic. Far more celebrated then than he is now, he played a central rôle in the development of German art from around 1906 when he joined the Worpswede colony and helped found an art school there. In Berlin after 1910 he was one of the earliest members of the New Secession and a close associate of Pechstein and the other members of the *Brücke*. In 1912 he exhibited not only at the *Blaue Reiter* exhibition in Munich but also at the *Sonderbund* show in Cologne. He had already worked for *Der Sturm* before joining Pfemfert in 1914. After the war he was a leading member of both revolutionary artists' organizations, the *Novembergruppe* (November Group) and *Arbeitsrat für Kunst* (Working Soviet for Art).

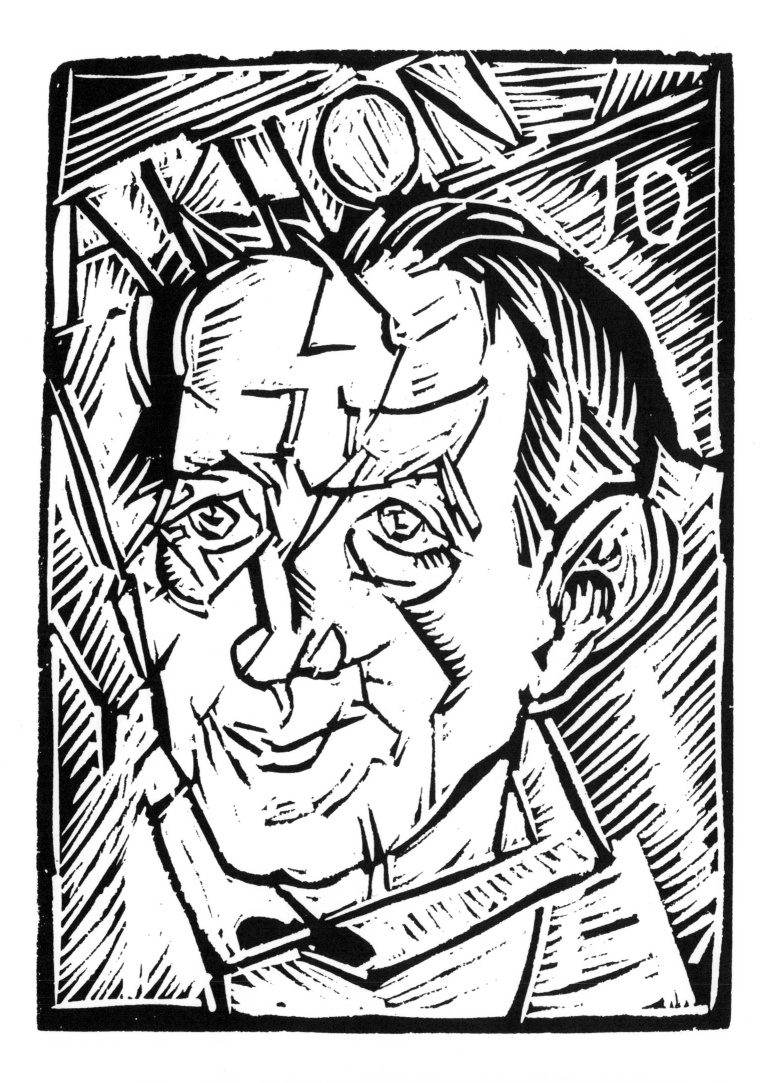

CONRAD FELIXMÜLLER

Carl Sternheim, 1925
Max Liebermann, 1926
Lovis Corinth, 1925
The Painter Christian Rohlfs, 1927

THESE EXTRAORDINARILY LARGE woodcuts show Felixmüller at the height of his powers as a graphic artist. Formally less fragmented than his earlier woodcuts, more calculated and disciplined, they nevertheless share much with all truly Expressionist work, not least their psychological intensity.

Sternheim (1878–1942), shown here against a background of his own books, was a playwright, novelist and essayist with a lively interest in the visual arts. His article about Felixmüller's early work (published in the journal *Der Cicerone* in 1923) helped establish the artist's reputation.

Liebermann (1847–1935) was Germany's most famous (and most wealthy) modern painter, whose style, although usually described as Impressionist, owed much to both Manet and French Naturalism. Daring by German standards in his early maturity, Liebermann became increasingly conservative and had little time for Expressionism, which he considered to be barbaric. He did approve of this portrait, however, admitting in a letter to Felixmüller that 'I do not fail to recognize certain qualities in works produced by your generation, especially in the woodcut. In the portrait of me, you have mastered the technique of simplification which links you to the graphic art of the sixteenth century. You have also succeeded in your disposition of black and white across the plane. I do not deny that the conception is very characteristic, even if it does lapse rather too far into caricature.'

Lovis Corinth was also known as an Impressionist, although there was almost as much South German Baroque in his art as anything more recent and French. In 1911 he suffered a stroke, after which his style changed dramatically. It was either the effects of the crisis or conscious intention which resulted in a looser, wilder manner very like Expressionism in many ways (see page 133). Corinth was amazed by the large size of Felixmüller's woodcut and liked 'the clouds in front of the studio windows very much, but I would like to ask you why you have made the windows acute-angled, since in reality they are horizontal; in any event you obviously intended to achieve a certain style in this way.'

Rohlfs (1849–1938) was a relatively conservative artist who in 1910, at an advanced age, fell under the influence of Van Gogh and Gauguin. He produced highly colourful, formally adventurous work of a clearly Expressionist kind. He knew and liked Nolde, but had little contact with other artists. He lived in relative seclusion in the town of Hagen in Westphalia and, left to his own devices, rapidly developed an extremely original style which, by 1913, had brought him to the edge of abstraction.

Felixmüller's Expressionism was moving towards Realism. As Sternheim put it: 'The only true and worthwhile goal of life is to live by one's own essential nature. . . . Never obscure this by harping on the stale old theme of a "higher humanity", despised by all those who truly know and deeply love, as I do, a humanity which is here and now.'

CONRAD FELIXMÜLLER
Carl Sternheim, 1921

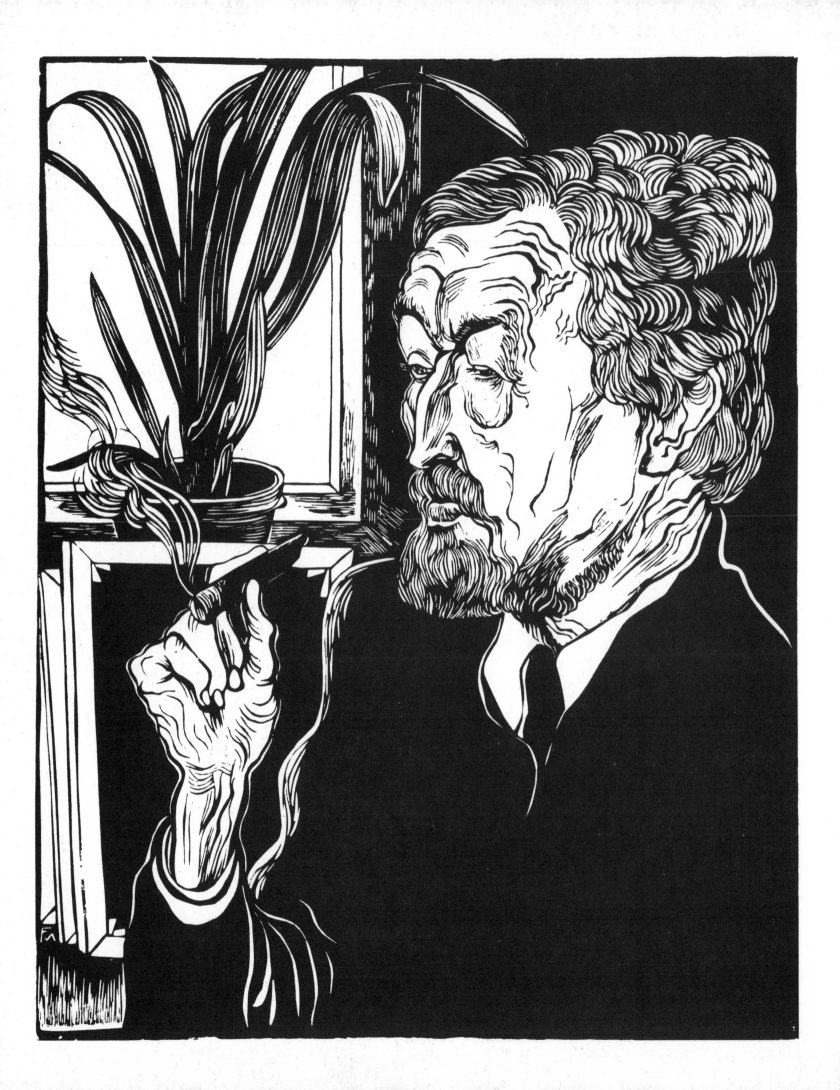

TEXT REFERENCES

INTRODUCTION

7 Auguste Forel: *Out of My Life and Work*, tr. Bernard Miall, London 1937, p. 273.

8 Arthur Roessler: *Kritische Fragmente*, Vienna 1918, p. 97.

8 Peter Scher: H. M. Wingler, ed., *Oskar Kokoschka, ein Lebensbild*, Berlin 1966, pp. 32–33.

9 Kasimir Edschmid: in *Die Neue Rundschau*, vol. 29, No. 1 (1918). Otto F. Best, ed., *Theorie des Expressionismus*, Stuttgart 1976, p. 57.

9 Theodor Däubler: 'Expressionismus', in *Dichtungen und Schriften*, Munich 1956, p. 883.

11 Gottfried Benn: 'Bekenntnis zum Expressionismus', in *Deutsche Zukunft*, V (November 1933). Victor H. Maisel, *Voices of German Expressionism*, Englewood Cliffs, N.J., 1970, p. 195.

11 Eckart von Sydow: in *Neue Blätter für Kunst und Dichtung*, vol. 1 (1918–19), pp. 193 ff.

12 Emil Nolde: *Jahre der Kämpfe*, 1902–1914, Berlin 1934, pp. 186 ff. Maisel (as 11), p. 37.

12 Ludwig Rubiner: 'Nachwort', in *Kameraden der Menschheit*, Potsdam 1919, p. 176.

13 Kurt Hiller: 'Ortsbestimmung des Aktivismus', in *Die Erhebung*, ed. Alfred Wolfenstein, Vol. 1 (1919), pp. 360 ff.

19 Vincent van Gogh: Letter (W22) to his sister Wil from Auvers-sur-Oise, first half of June 1890.

24 Edvard Munch: in H. B. Chipp (ed.), *Theories of Modern Art*, Berkeley 1968, p. 114.

28 *Dadaistisches Manifest*, Berlin 1918. Hans Richter, *Dada, Art and Anti-Art*, London and New York 1965, p. 105.

29 G. F. Hartlaub: circular to prospective exhibitors in the '*Neue Sachlichkeit*' show, 1925. Wieland Schmied, catalogue '*Neue Sachlichkeit and German Realism of the Twenties*', Hayward Gallery, London 1979, p. 9.

29 George Grosz: 'Zu meinen neuen Bildern', 1921. Uwe M. Schneede, ed., *George Grosz, Leben und Werk*, Stuttgart 1976, p. 66.

29 Max Beckmann, *Schöpferische Konfession*, Berlin 1920. Wieland Schmied, *Neue Sachlichkeit und Magischer Realismus in Deutschland 1918–1933*, Hanover 1969, p. 244.

1 THE SELF-PORTRAIT

32 *Paula Modersohn-Becker in Briefen und Tagebüchern*, ed. G. Busch and L. von Reinken, Frankfurt am Main 1970, p. 440.

36 Ernst Ludwig Kirchner: letter to Hannes Mayer, 11 July 1923. Catalogue 'E. L. Kirchner 1880–1938', Nationalgalerie, West Berlin 1979–80, p. 218.

42 Oskar Kokoschka: letter to Albert Ehrenstein, *Briefe I*, ed. Olda Kokoschka and Heinz Spielmann, Düsseldorf 1984, p. 276.

46 Anton Faistauer: *Neue Malerei in Österreich*, Zürich 1923, pp. 20–21.

48 Willi Wolfradt: 'Ludwig Meidner', in *Das junge Deutschland*, 1920. Quoted after 'Thomas Grochowiak über Ludwig Meidner', in catalogue 'Ludwig Meidner', Kunsthalle Recklinghausen, October–December 1963.

48 Ludwig Meidner: letter of 29 September 1957. Catalogue 'Ludwig Meidner', University of Michigan Museum of Art, 1978, p. 61.

50 Ludwig Meidner: 'Anleitung zum Malen von Grossstadtbildern', *Kunst und Künstler*, vol. 12 (1914). Thomas Grochowiak, *Ludwig Meidner*, Recklinghausen, Bongers, 1966, p. 78.
Ludwig Meidner: *Im Nacken das Sternemeer*, Leipzig and Munich 1918. Grochowiak, p. 73.

54 Otto Dix: conversation with Hans Kinkel. Lothar Fischer, *Otto Dix, ein Malerleben in Deutschland*, Berlin 1981, p. 28.

56 Max Beckmann: letters. Catalogue 'Max Beckmann Retrospective', Munich, Berlin, St Louis, Los Angeles 1984–85 (Munich, Prestel, 1984), p. 239, and Hans Günter Wachtmann, *Max Beckmann*, Wuppertal, Von der Heydt-Museum (Kommentare zur Sammlung 2), 1979.

64 Käthe Kollwitz: journal, 21 February 1916. Quoted after catalogue 'Käthe Kollwitz', Kettle's Yard, Cambridge, 1981, p. 14.

68 Emil Nolde: *Mein Leben*, Cologne 1976, pp. 146, 147.

74 Paul Klee: *Schöpferische Konfession*. Uwe M. Schneede, *Die Zwanziger Jahre*, Cologne 1979, p. 196.

76 Oskar Kokoschka: interview with Wolfgang Fischer. Catalogue 'Kokoschka Lithographs', Arts Council of Great Britain, London 1966, p. 13.

86 Otto Dix: interview, 1963. Dietrich Schubert, *Otto Dix in Selbstzeugnissen und Bilddokumenten*, Reinbek bei Hamburg 1980, pp. 25–26.

88 Ernst Ludwig Kirchner: letter to Gustav Schiefler, 27 July 1919. Catalogue (as 36), p. 70.
Eberhard Grisebach: ibid., p. 74.
Ernst Ludwig Kirchner: Catalogue 'E. L. Kirchner Zeichnungen', Museum der Stadt Aschaffenburg, 1980, p. 236.

92 Ludwig Meidner: *Im Nacken das Sternemeer*, Leipzig and Munich 1918. Quoted after catalogue 'Ludwig Meidner', Kunsthalle Recklinghausen, 1963.

94 Conrad Felixmüller: letter to Dieter Gleisberg. *Conrad Felixmüller, Werke und Dokumente*, ed. Archiv für bildende Kunst am Germanischen Nationalmuseum Nürnberg, Klagenfurt, Ritter, n.d., pp. 72–75.

98 Peter Beckmann: Catalogue (as 56).

102 Max Pechstein: 'Erinnerungen'. Quoted after Georg Reinhardt, *Die frühe Brücke*, Berlin, Brücke-Museum (Brücke-Archiv Heft 9/10), 1977, p. 43.

2 THE ARTIST'S WORLD

104 Rainer Maria Rilke: 'Requiem für eine Freundin'. *Sämtliche Werke*, Wiesbaden 1955, Vol. 1, p. 649.

108 Adolf Loos: *Sämtliche Schriften*, Vienna 1962, vol. 1, p. 443
Oskar Kokoschka: *My Life*, London 1974, p. 35.

122 Else Lasker-Schüler: 'Brief an einen Nachahmer'. Quoted after Wingler (as 8), p. 34.

124 Eva Benesch: foreword to Heinrich Benesch, *Mein Weg mit Egon Schiele*, New York 1965, pp. 6–7.

126 *Wiener Illustriertes Extrablatt*, 9 October 1910.
Albert Paris von Gütersloh: 'Schönberg der Maler', 1912. Eberhart Freitag, *Arnold Schönberg in Selbstzeugnissen und Bilddokumenten*, Reinbek bei Hamburg 1973, p. 62.
Oskar Kokoschka: interview with Hans Keller, BBC Third Programme, 6 November and 1 December 1965.

128 Max Hermann-Neisse: 'Meine Erlebnisse mit der bildenden Kunst', in *Das Kunstblatt* (1929), pp. 78–79.

128 Ludwig Meidner: *Dichter, Maler und Cafés*, Zürich 1973, p. 22.

130 Max Beckmann: letter to Reinhard Piper, 8 February 1918, in *Die Realität der Träume in den Bildern*, ed. Rudolf Piller, Leipzig 1984, p. 88.

132 Julius Meier-Graefe: in John Willett, *Expressionism*, London 1970, p. 12.

134 Conrad Felixmüller: Fischer (as 54), p. 30.
136 Conrad Felixmüller: *Conrad Felixmüller* (as 94), p. 57.
138 Conrad Felixmüller: *Conrad Felixmüller – von ihm – über ihn*, ed. Gerhart Söhn, Düsseldorf 1977, pp. 65–70.
142 Martha Dix: Fischer (as 54), p. 30.
144 Willi Wolfradt: Schubert (as 86), p. 63.
146 Otto Dix: interview with Maria Wetzel. Schubert (as 86), p. 89.
150 Max Hermann-Neisse: 'Meine Erlebnisse . . .' (as 128).
152 Karl Kraus: *Die Fackel*, 9 April 1910, p. 25, and 16 October 1911, p. 7.
154 Alma Mahler-Werfel: *Mein Leben*, Frankfurt am Main 1963, p. 49.
158 Jakob van Hoddis, *Weltende*, Berlin-Wilmersdorf 1918.
Ludwig Meidner: Catalogue 'Expressionismus: Literatur und Kunst 1910–1923', Schiller-Nationalmuseum, Marbach a.N., 1960, p. 27.

Alfred Wolfenstein: 'Städter' (1919). Wolfgang Rothe, ed., *Deutsche Grossstadtlyrik vom Naturalismus bis zur Gegenwart*, Stuttgart 1973, p. 194.
166 Ernst Ludwig Kirchner, letter to Karl Ernst Osthaus, 4 January 1916. Catalogue (as 36), p. 71.
176 Hans Schiebelhuth: 'Asta Nielsen' (1921). Catalogue 'Expressionismus: Literatur und Kunst' (as 158), p. 225.
178 Max Beckmann: foreword to 'Graphik-Katalog', I.B. Neumann, Berlin 1917. Beckmann (as 130), p. 88.
188 Max Liebermann: *Conrad Felixmüller* (as 94), p. 101.
Lovis Corinth: *Conrad Felixmüller* (as 94), pp. 94–95.
Carl Sternheim: quoted after Otto F. Best, ed., *Expressionismus und Dadaismus*, Stuttgart 1974/1986, p. 107.

FURTHER READING

Some idea of those publications helpful in the preparation of this book can be had from the list of Text References. The following, highly selective bibliography is intended as a guide to further reading. It deals with Expressionism in general before addressing itself to the artists whose work is reproduced here. It does not concern itself with portraiture in general, an art poorly served by scholars and critics alike. Books marked in the first section with an asterisk are wholly or largely concerned with the visual arts.

EXPRESSIONISM

*Dube, Wolf-Dieter. *The Expressionists*, London 1972
*Miesel, Victor H., ed. *Voices of German Expressionism*, Englewood Cliffs, New Jersey, 1970
*Myers, Bernard S. *The German Expressionists*, New York 1957
Raabe, Paul. (ed.) *Expressionismus, Aufzeichnungen und Erinnerungen der Zeitgenossen*, Olten 1965
——. *Expressionismus, der Kampf um eine literarische Bewegung*, Munich 1965
——. *Die Zeitschriften und Sammlungen des literarischen Expressionismus*, Stuttgart 1964
——. *Ich schneide die Zeit aus*, Munich, 1965
Raabe, Paul, and Ludwig Greve, eds. *Expressionismus: Literatur und Kunst, 1910–1923*, exhibition catalogue, Deutsches Literaturarchiv Marbach, Stuttgart 1960
Rothe, Wolfgang, ed. *Expressionismus als Literatur*, Bern and Munich 1969
Samuel, Richard H., and R. Hinton Thomas. *Expressionism in German Language, Literature and the Theatre*, Cambridge 1939
Schneider, Karl Ludwig. *Zerbrochene Formen*, Hamburg 1967
*Selz, Peter. *German Expressionist Painting*, Berkeley 1957
Sokel, Walter H. *The Writer in Extremis*, Stanford 1959
*Willett, John. *Expressionism*, London 1970

BECKMANN

Beckmann, Max. *Briefe im Krieg*, Munich 1955
Haus der Kunst München, Nationalgalerie Berlin, The Saint Louis Art Museum, Los Angeles County Museum of Art. Exhibition catalogue 'Max Beckmann Retrospective', 1984–85

BRÜCKE (Heckel, Kirchner, Pechstein, Schmidt-Rottluff)

Buchheim, Lothar-Günther. *Die Künstlergemeinschaft Brücke*, Feldafing 1956
Herbert, Barry. *German Expressionism: Die Brücke and der Blaue Reiter*, London 1983
Wentzel, Hans. *Bildnisse der Brücke-Künstler von einander*, Stuttgart 1961

CORINTH

Corinth, Lovis. *Selbstbiografie*, Leipzig 1926

DIX

Otto, Gunter (with Hans Dickel). *Otto Dix: Bildnis der Eltern*, Frankfurt 1984
Schmidt, Diether. *Otto Dix im Selbstbildnis*, Berlin/DDR 1981

FELIXMÜLLER

Kunstmuseum Düsseldorf. Exhibition catalogue 'Conrad Felixmüller – das druckgraphische Werk im Kunstmuseum Düsseldorf', 1986

GERSTL

Kallir, Otto. 'Richard Gerstl, Beiträge zur Dokumentation seines Lebens und Werkes' in *Mitteilungen der Oesterreichischen Galerie*, 1974, pp. 125–193

GROSZ

Grosz, George. *Briefe 1913–1959*, Reinbek bei Hamburg 1979
Schneede, Uwe M. *George Grosz, Leben und Werk*, Stuttgart 1975

KIRCHNER

Nationalgalerie Berlin, Haus der Kunst München, Museum Ludwig in der Kunsthalle Köln, Kunsthaus Zürich. Exhibition catalogue 'Ernst Ludwig Kirchner 1886–1938', 1979–80
Gordon, Donald E. *Ernst Ludwig Kirchner*, Munich 1968
Kornfeld, Eberhard W. *Ernst Ludwig Kirchner. Nachzeichnung seines Lebens*, Bern 1979

KOKOSCHKA

Kokoschka, Olda, and Heinz Spielmann, eds. *Oskar Kokoschka. Briefe*, Düsseldorf 1984–86

Schweiger, Werner J. *Der junge Kokoschka. Leben und Werk 1904–1914*, Vienna and Munich 1983

Tate Gallery, London, Kunsthaus Zürich, Solomon R. Guggenheim Museum, New York. Exhibition catalogue 'Oskar Kokoschka 1886–1980', 1986

Whitford, Frank. *Oskar Kokoschka, a Life*, London and New York 1986

KOLLWITZ

Kollwitz, Hans, ed. *Käthe Kollwitz, Tagebuchblätter und Briefe*, Berlin 1949

Krahmer, Catherine. *Kollwitz*, Reinbek bei Hamburg, 1981

Schneede, Uwe M. *Käthe Kollwitz – das zeichnerische Werk*, Munich 1981.

MEIDNER

Grochowiak, Thomas. *Ludwig Meidner*, Recklinghausen, 1966

MODERSOHN-BECKER

Busch, Günter, and Liselotte von Reinken, eds. *Paula Modersohn-Becker in Briefen und Tagebüchern*, Frankfurt am Main 1979

NOLDE

Nolde, Emil. *Jahre der Kämpfe*, Berlin 1934

Sauerland, Max, ed. *Emil Nolde, Briefe aus den Jahren 1894–1926*, Berlin 1927

SCHIELE

Comini, Alessandra. *Egon Schiele's Portraits*, Berkeley 1974

Mitsch, Erwin. *The Art of Egon Schiele*, London 1975

Nebehay, Christian M. *Egon Schiele. Leben, Briefe, Gedichte*, Salzburg 1979

Whitford, Frank. *Egon Schiele*, London and New York 1981

SCHOENBERG

Freitag, Eberhard. *Schönberg*, Reinbek bei Hamburg 1973

Vienna. Exhibition catalogue 'Arnold Schönberg Gedenkausstellung', 1974

LIST OF ILLUSTRATIONS

Numbers given refer to pages. Dimensions are given in centimetres, then in inches, with height before width.

MAX BECKMANN (1884–1950)

57 *Self-Portrait as Medical Orderly*, 1915
Canvas, 55.5 × 38.5 (21⅞ × 15⅛)
Von der Heydt Museum, Wuppertal

58 *Self-Portrait with a Red Scarf*, 1917
Canvas, 80 × 60 (31½ × 23⅜)
Staatsgalerie, Stuttgart. Inv. 2327

59 *Self-Portrait in Tuxedo*, 1927
Canvas, 138.4 × 95.9 (54½ × 37¾)
Busch-Reisinger Museum, Harvard University, Cambridge, Mass. Purchase – Museum Association Fund

98 *Self-Portrait in Bowler Hat*, 1921
Etching, 31 × 24.4 (12¼ × 9⅝)

99 *The Family*, 1919
Lithograph, 76 × 46.5 (30 × 18⅜)

100 *The Barker (Self-Portrait)*, 1921
Etching, 34 × 25.6 (13⅜ × 10)

101 *Self-Portrait*, 1922
Woodcut, 22.2 × 15.5 (8¾ × 6⅛)

131 *Max Reger*, 1917
Canvas, 100 × 70.5 (39⅜ × 27¾)
Kunsthaus, Zürich. Inv. 1946/10

178 *Woman with Candle*, 1920
Woodcut (later state), 30.3 × 15.3 (12 × 6)

179 *Woman with Candle*, 1920
Woodcut on a smooth vellum (proof, first state), 30.2 × 15.5 (11⅞ × 6)
The Saint Louis Art Museum, St Louis, Missouri. Purchase, Friends Fund

181 *Group Portrait, Eden Bar (Eden-Hotel)*, 1923
Woodcut, 48.5 × 49.2 (19 × 19⅜)
© 1987 The Art Institute of Chicago. All Rights Reserved. Gift of the Print and Drawing Club, 1946.64

RUDOLF BELLING (1886–1972)

146 *Portrait of Alfred Flechtheim*, 1927
Bronze, 18.7 × 12 × 13 (7⅜ × 4¾ × 5⅛)
Minneapolis Institute of Fine Arts, Minneapolis. The John R. Van Derlip Fund

UMBERTO BOCCIONI (1882–1916)

14 *The Street enters the House*, 1911
Canvas, 70 × 75 (27½ × 29½)
Niedersächsische Landesgalerie, Hanover

PAUL CÉZANNE (1839–1905)

18 *Ambroise Vollard*, 1899
Canvas, 39⅜ × 31⅞ (100 × 81)
Petit Palais, Paris. Photo Giraudon

LOVIS CORINTH (1858–1925)

133 *Julius Meier-Graefe*, 1917
Canvas, 90 × 70 (35⅜ × 27½)
Musée d'Orsay, Paris. Inv. PF 1977–109. Photo Réunion des Musées Nationaux

OTTO DIX (1891–1969)

53 *Self-Portrait as a Soldier in a Red Shirt*, 1914
Oil on paper, 68 × 53.5 (26¾ × 21)
Galerie der Stadt Stuttgart

54 *Jazz Band (To Beauty)*, 1922
Graphite, 49.9 × 49.9 (19⅝ × 19⅝)
Kupferstich-Kabinett, Staatliche Kunstsammlungen, Dresden

55 *To Beauty*, 1922
Canvas, 140 × 122 (55⅛ × 48)
Von der Heydt Museum, Wuppertal. Photo A. Zafra, Madrid

86 *Self-Portrait Grinning, Head on Hand*, 1917
Charcoal, 39.5 × 38 (15½ × 15)
Private Collection

86 *Self-Portrait*, 1915
Charcoal, 44 × 34.3 (17⅞ × 13½)
Graphische Sammlung, Staatsgalerie, Stuttgart. Inv. GL.1002

87 *Self-Portrait in a Fragment of a Broken Mirror I*, 1915
Black chalk, 44.1 × 34.4 (17⅞ × 13½)
Private Collection. Photo Otto Dix Archiv

141 *The Dermatologist and Urologist Dr Hans Koch*, 1921
Canvas, 100.5 × 90 (39½ × 35½)
Museen der Stadt Köln, Wallraf-Richartz Museum/Museum Ludwig, Cologne. Inv. ML 2739

143 *The Poet and Painter Adolf Uzarski*, 1923
Canvas, 110 × 76 (43⅜ × 30)
Kunstmuseum, Düsseldorf

Nuremberg. Inv. Gm 1667
Copyright by Dr Wolfgang
and Ingeborg Henze,
Campione d'Italia

39 *The Painter, Self-Portrait*,
1919–20
Canvas, 90.8 × 80.5 (35¾ × 31¾)
Staatliche Kunsthalle, Karlsruhe.
Inv. 2340
Copyright by Dr Wolfgang
and Ingeborg Henze,
Campione d'Italia

89 *Self-Portrait*, 1915
Drawing, 37 × 32 (14½ × 12½)
Private Collection, Campione
d'Italia. Photo Galleria Henze,
Campione d'Italia.
Copyright by Dr Wolfgang
and Ingeborg Henze,
Campione d'Italia

90 *Head of the Sick Man (Self-
Portrait)*, 1917
Woodcut, 57.7 × 27.5
(22¾ × 10⅞)
Copyright by Dr Wolfgang
and Ingeborg Henze,
Campione d'Italia

91 *Self-Portrait under the Influence
of Morphine*, 1917
Reed pen and ink, 50 × 38
(19⅝ × 15)
Private Collection, Berlin. Photo
Staatliche Kunstsammlungen,
Kassel
Copyright by Dr Wolfgang
and Ingeborg Henze,
Campione d'Italia

109 *Erich Heckel at the Easel*, 1907
Oil on cardboard, 70 × 50.5
(27½ × 19⅞)
Private Collection
Copyright by Dr Wolfgang
and Ingeborg Henze,
Campione d'Italia

111 *A Group of Artists: Otto Mueller,
Kirchner, Heckel, Schmidt-
Rottluff*, 1926–27
Canvas, 168 × 126 (66⅛ × 49⅝)
Museen der Stadt Köln, Wallraf-
Richartz Museum/Museum
Ludwig, Cologne. Inv.
ML/WRM 2862
Copyright by Dr Wolfgang
and Ingeborg Henze,
Campione d'Italia

167 *The Composer Klemperer*, 1916
Woodcut, 52 × 41.5 (20½ × 16⅜)
Copyright by Dr Wolfgang
and Ingeborg Henze,
Campione d'Italia

168 *Head of van de Velde, Dark*, 1917
Woodcut, 50 × 40 (19⅝ × 15¾)
Copyright by Dr Wolfgang
and Ingeborg Henze,
Campione d'Italia

169 *Head of van de Velde, Light*,
1917
Woodcut, 50 × 40 (19⅝ × 15¾)
Copyright by Dr Wolfgang
and Ingeborg Henze,
Campione d'Italia

170 *Professor Dr Ludwig Binswanger*,
1917–18
Woodcut, 51.8 × 26 (20⅜ × 10¼)
Copyright by Dr Wolfgang
and Ingeborg Henze,
Campione d'Italia

171 *Head of Dr Ludwig Binswanger
and Little Girls*, 1917–18
Woodcut, 44.2 × 66 (17⅜ × 26)
Copyright by Dr Wolfgang
and Ingeborg Henze,
Campione d'Italia

172 *Head of Ludwig Schames*, 1918
Woodcut, 56 × 25.5 (22 × 10)
Copyright by Dr Wolfgang
and Ingeborg Henze,
Campione d'Italia

173 *Head of David Müller*, 1919
Woodcut, 34.1 × 29.2
(13⅜ × 11½)
Copyright by Dr Wolfgang
and Ingeborg Henze,
Campione d'Italia

PAUL KLEE (1879–1940)

74 *Young Man Resting (Self-
Portrait)*, 1911
Indian ink and brush, 14 × 20
(5½ × 7⅞)
Private Collection

74 *Portrait of the Artist (Self-
Portrait)*, 1919
Pen and ink, 23 × 13.5 (9 × 5⅜)
The Pasadena Art Institute,
Pasadena, California

75 *Meditation (Self-Portrait)*, 1919
Etching, 30.5 × 20.3 (12 × 8)
Paul Klee Stiftung,
Kunstmuseum, Berne

OSKAR KOKOSCHKA
(1886–1980)

6 *Auguste Forel*, 1910
Canvas, 70 × 58 (27½ × 22⅞)
Kunsthalle, Mannheim

40 Illustration for *Mörder, Hoffnung
der Frauen*, 1910
Line illustration
From *Der Sturm*, 14 July 1910

41 *Self-Portrait (Poster for 'Der
Sturm')*, 1910
Colour lithograph, 70 × 46.5
(27½ × 18¼)

43 *Self-Portrait*, 1917
Canvas, 78 × 62 (30¾ × 24⅜)
Von der Heydt Museum,

Wuppertal. Photo A. Zafra,
Madrid

77 *Man and Woman at the Cross-
roads (Meeting)*, 1913
Lithograph, 31 × 29 (12¼ × 11⅜)
From *Columbus Bound*, 1913

78 *Man and Woman*, 1914
Lithograph, 48.2 × 31.5
(19 × 12⅜)
From *Bach Cantata*, 1914

79 *Self-Portrait*, 1914
Lithograph, 45.4 × 30.5
(17⅞ × 12)
From *Bach Cantata*, 1914

112 *Adolf Loos*, 1909
Line illustration
From *Der Sturm*, 30 June 1910

113 *Adolf Loos*, 1909
Canvas, 74 × 93 (29⅛ × 36⅝)
Nationalgalerie, Staatliche
Museen, Preussischer
Kulturbesitz, Berlin (West). Inv.
1482. Photo Jörg P. Anders

114 *Hans Tietze and Frau Erica
Tietze-Conrat*, 1909
Canvas, 76.5 × 132.2 (30⅛ × 53⅝)
Collection, The Museum of
Modern Art, New York. Abby
Aldrich Rockefeller Fund

115 *Peter Altenberg*, 1909
Canvas, 76 × 71 (30 × 28)
Private Collection. Photo Galerie
Welz, Salzburg

116 *Herwarth Walden*, 1910
Line illustration
From *Der Sturm*, 28 July 1910

117 *Herwarth Walden*, 1910
Canvas, 100.6 × 69.3 (39⅝ × 27¼)
Staatsgalerie, Stuttgart. Inv. 2749

119 *Tilla Durieux*, 1910
Canvas, 55 × 65 (21⅛ × 25⅝)
Museen der Stadt Köln, Wallraf-
Richartz Museum/Museum
Ludwig, Cologne. Inv.
ML/WRM 2753

152 *Karl Kraus II*, 1912
Black crayon and charcoal,
44 × 28 (17⅜ × 11)
Private Collection

153 *Karl Kraus I*, 1910
Line illustration
From *Der Sturm*, 19 May 1910

155 *Alma Mahler*, 1912
Black crayon, 44.5 × 30.7
(17½ × 12⅛)
Folkwang Museum, Essen

156 *Alma Mahler*, 1913
Black crayon, 49.7 × 34
(19⅝ × 13⅜)

© 1987 The Art Institute of
Chicago. All Rights Reserved.
Anonymous Gift in Honor of Dr
John Gedo, 1979. 120

157 *Paul Scheerbart*, 1910
Line illustration
From *Der Sturm*, 1 September
1910

KÄTHE KOLLWITZ
(1867–1945)

65 *Self-Portrait*, 1905
Charcoal, 36.7 × 31.4
(14⅜ × 12⅜)
Kunsthalle, Hamburg

66 *Self-Portrait, c.* 1920
Charcoal, 43.7 × 45.5 (17¼ × 18)
Kunsthalle, Hamburg

66 *Self-Portrait*, 1934
Lithograph, 20.8 × 18.7
(8⅛ × 7⅜)
Kupferstichkabinett, Staatliche
Museen, Preussischer
Kulturbesitz, Berlin (West). Inv.
82-1967

67 *Self-Portrait*, 1938
Charcoal, 63 × 47.5 (24⅞ × 18¾)
Kupferstichkabinett, Staatliche
Museen, Preussischer
Kulturbesitz, Berlin (West)

ÉDOUARD MANET (1832–83)

17 *Emile Zola*, 1867–68
Canvas, 146 × 114 (57½ × 45)
Musée d'Orsay, Paris. Inv.
RF2205

FRANZ MARC (1880–1916)

25 *Fate of the Animals*, 1913
Canvas, 196 × 266 (77⅛ × 104¾)
Öffentliche Kunstsammlung,
Basel

LUDWIG MEIDNER
(1884–1966)

9 *The Poet Theodor Däubler, c.*
1910
Etching, 17.8 × 14 (7 × 5½)
Los Angeles County Museum of
Art, The Robert Gore Rifkind
Center for German Expressionist
Studies

49 *My Night Visage*, 1913
Canvas, 67 × 49.5 (26⅜ × 19½)
Collection Mr and Mrs Marvin
L. Fishman, Milwaukee,
Wisconsin

50 *Self-Portrait as a Prophet (Self-
Portrait with Prayer Shawl)*,
1918
Reed pen and brush, 52.4 × 44.3
(20⅝ × 17 7/16)

INDEX